# HANS RICHTER

# HANS RICHTER

## ACTIVISM, MODERNISM, AND THE AVANT-GARDE

edited by
### Stephen C. Foster

Published in collaboration with
the University of Iowa Museum of
Art, Iowa City

The MIT Press   Cambridge, Massachusetts   London, England

This book was set in Helvetica by Graphic Composition, Inc. and was printed and bound in the United States of America.

Library of Congress Cataloging-in-Publication Data

Hans Richter : activism, modernism, and the avant-garde / edited by Stephen C. Foster.
    p. cm.
Includes bibliographical references and index.
ISBN 0-262-06196-1 (alk. paper)
    1. Richter, Hans, 1888–1976—Criticism and interpretation.
I. Foster, Stephen C.
PN1998.3.R535H36   1998
700'.92—dc21                            97-31931
                                              CIP

# CONTENTS

# List of Illustrations

All illustrations by Hans Richter, unless otherwise indicated.

## Acknowledgments

If I remember correctly, the beginning of this project dates from a phone conversation with Wendy Hawley-Ruppel. Although I cannot recall the exact content of the conversation, it prompted me to call Hans Ruppel and Ursula Lawder, son and daughter of Hans Richter and executors of the Hans Richter Estate. It was at that point, on the eve of the Richter centennial, that plans were first discussed for a monograph and retrospective exhibition.

As in all such ventures, this book project has relied on the advice and encouragement of many parties—individuals, galleries, and institutions—without whose help the project would not have been realized. Foremost among these, I wish to thank Ursula Lawder and Hans Ruppel for the complete support of the Estate. At a point when the lack of such cooperation is legendary, their facilitating role, enthusiasm for the project, and complete trust in its direction have been truly remarkable. Also deserving of special thanks is Marion von Hofacker, long identified as a leading Richter expert and instrumental in most past Richter exhibition projects of significance; she contributed enormously to this book.

The University of Iowa Museum of Art lent crucial support to this book and the upcoming exhibition through the

acquisition of a National Endowment for the Arts grant. The Museum also gave generously of the leadership and staff time required for the success of these projects. I am particularly grateful to Stephen Prokopoff, Director of the University of Iowa Museum of Art, Pam Trimpe, Curator of Painting and Sculpture, and Robin Braun, assistant to Ms. Trimpe, for their invaluable assistance throughout the project's development.

Substantive assistance in research and editing came from four students in the University of Iowa graduate Art History program. They are Dan Siedell (currently Curator at the Sheldon Memorial Art Gallery and Sculpture Garden), who attended to all aspects of the project in its early stages; Curt Germundson, who was responsible for coordinating all work in my office and between my office and the museum; Sarah Warren, who assumed the role of preliminary copy editor; and Kirsten Strom, who was responsible for the final stages of the editing.

Finally, I wish to acknowledge Roger Conover of the MIT Press and his assistant Julie Grimaldi for their expert supervision of this book's publication; the National Endowment for the Arts for providing substantial funding for the project; and the office of the Vice-President for Research of the University of Iowa.

# HANS RICHTER

STEPHEN C. FOSTER

# Hans Richter: Prophet of Modernism

It is common knowledge that artists are submitted to a variety of historiographical fates that are too frequently the result of factors extrinsic to the artist or his/her work, such as the point in time and place from which the history emerges, trends in scholarship, and late reevaluations of early careers by the artists themselves, among many more.

Recent American scholarship has typically formalized the work of early twentieth-century European movements in ways that decontextualize the works and diminish access to their historical significance. For decades the analysis and evaluation of these movements has subjected them to normative procedures that sidestepped political issues and guaranteed their conformity to the separation of art and pointed social purpose that was pioneered by the modern academy of the 1940s, fifties, and even sixties. This work has been disproportionately aestheticized in such a way that the losses for cultural history exceed the gains for art's formal and craft

history. In the course of such aestheticization, as but one example, the futurists were removed from the center of modernism and relegated to the fringe. Some artists have been treated more kindly. Thus, Marcel Janco looms larger than life because of his important involvement in Zurich Dada although, and very understandably, Janco himself minimized his early years in order to serve his late career as an artist. The case of George Grosz is more complex. Always a major factor in the arts of the World War I era, his later silence concerning, what sometimes seems to be his disavowal of, the early years was based more on political disillusionment than on special care for his later career. Others, such as Johannes Baader, were consigned to complete oblivion. In all the above respects, Hans Richter (Johannes Siegfried Richter, 1888–1976) is no exception (**fig. 1.1**). Indeed, our perception of him is the result of a particularly complex set of American historiographic circumstances. There seems to be considerable merit in detailing these circumstances here and in briefly discussing their ramifications for the Richter literature; how he has been structured into the historical fabric of the twentieth century, especially by American historians and critics; and what this has meant for our assessment of his significance.

One of the interesting, although by no means incorrect, results of his Americanization is something of an imbalance in the literature that favors Richter the filmmaker. This is based in part on the sociology of midcentury academics and, in part, on Richter's assimilation into an American historiography of European modernism in which Europeans participated (with the exception of French sources) only marginally. There are a variety of good reasons for this situation: primarily, that Richter's most significant work during the eight years preceding his emigration to America in 1941 was largely in film, for which activity he became best known as a contemporary American artist. Understandably, those writing about Richter belonged to the community of critics rather than to the community of historians. This was inevitable for an artist, then still very much alive, who was exerting a considerable influence

on the American art scene. Even Richter himself paid rather little attention to his "history" until the late years when he published the influential and still standard text *Dada: Kunst und Anti-Kunst,* 1964 (*Dada: Art and Anti-Art,* 1965).

There is nothing "wrong" with any of this, in and of itself. Richter's achievements as a filmmaker and documentarian are truly impressive. His impact on American art as a teacher, artist, and administrator was considerable. He continued to produce "major" work (**fig. 1.2; plate 1**). However, this repu-

tation did have the inadvertent and unintentional effect of presenting his earlier career as "background" for his later career. It is to help restore Richter's earlier European career to the context of cultural history that this exhibition and monograph have been prepared.

Hans Richter's centennial (1988) provided the perfect occasion for beginning a reassessment of his early work, this time from the perspective of a broader cultural history. Richter has been reexamined at a time when the very concept of modernism is being closely scrutinized and subjected to more sophisticated analysis. The careful historical examination of the origins of the twentieth-century avant-garde has become more pivotal than ever to the modernist debate. The crucial questions—the place of art in culture, the "crisis" of modernism, etc.—have been restored to the early twentieth-century points from which they emerged. In the process, the importance of Richter's later years seems to have receded (not, it should be stressed, in terms of the significance of the art, but in terms of its value in centering *our* most pressing questions). However, Richter's major importance in these early years, in particular how his activities and works ramified them, has been disproportionately understudied, a deficiency only now being corrected. Certainly, some of the literature on Richter offers valuable building blocks for the present undertaking, as our citations will show. This is particularly true of *Hans Richter: Malerei und Film* (Deutsches Filmmuseum, Frankfurt am Main, 1989) and *Hans Richter: 1888–1976* (Kunsthaus Zürich, 1982). Yet something still needs to be added to further contextualize Richter's central role in the constitution of early twentieth-century modernism itself.

It is somewhat understandable that Richter's star should rise as others' once considered masters are on the wane. This entails, in part, the reconception of an artist's career, now seen less as the cumulative production of great (good) works than as an effective configuration of visual moves, understandable largely in terms of the specific con-

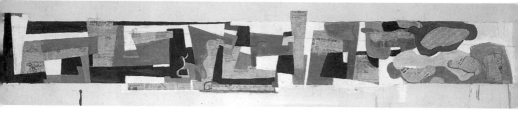

texts in which they were made. And this is but a footnote to the erosion of artistic authorship, in general, in favor of the concept of "author functions" (Foucault). Less inclined to concentrate on the uniqueness of the author's voice (who is speaking?), present interests focus on the use of authorial authority as a strategy for achieving particular objectives.

"Creator culture," by means of which we have erected our pantheon of the great twentieth-century artists, is dissolving in the face of questions and concerns involving the "culture of creation." This reversal of the terms is a corollary to the demise of idealist aesthetics. The significance of an artist, rather than being measured by the standards (any standards) of quality and the coherence of his/her oeuvre, is now assessed in terms of the constitutive potential of the presented work in the context of competing visual discourses. At any given time, it is the visible participation in, interception of, and, more importantly, influence on the creation of a place within a contending discourse (a place in the culture of creation) that will secure an artist's activity as historically important.

Understandably, the establishment has a considerable stake in resisting such a perspective, based on its investment in stable cultural/artistic canons and the industries by which they are sustained and perpetuated. And such resistance, based on these investments (museums, galleries, university curricula, art publications, and other dimensions of our

modernist institutions), go far to explain why Richter has been consigned to a somewhat minor place in the history of twentieth-century art. For some, that is, his works satisfy standards of quality less well than others (a few of his contemporaries that dominate the textbooks), betray a trajectory in his career that may be viewed as dependent on "pioneers" (this is, of course, less true of his work in cinema), and appear to be somewhat opportunistic (in terms of more contemporary thinking, strategizing his moves). Richter is perceived as more a function of a period's authorship than a great self-created author who speaks universal truths.

More an individual who sought power through use of authorship—one whose interests revolve around the deployment of authorial power—Richter, notwithstanding objections from the academy, compellingly embodies our contemporary concept of a politically motivated artist. He assumes a pivotal place in what could be described as the politics of cultural creation. It is precisely in this respect that Richter can be separated from most of his contemporaries: George Grosz, the political artist, Raoul Hausmann, the *Kunstkritiker,* et al. Consciously or not, Richter subscribed to an open-ended concept of culture where one's position was described less as "for" or "against" than "in relationship to"—that is, where "for" and "against" are understood better as strategies (pragmatics) than as metaphysical imperatives. It was within this context that Richter prepared the ground for action "for" or "against" rather than the mere pronouncement "for" or "against." For Richter, even film was created as an instrument—the constituting means—of critique, and was driven by its content in only a secondary way.

If one is to understand Richter, it must be through his transaction of politics by art, and in his manipulation of art in the interest of cultural politics. He was more concerned with utilizing available "concepts of revolution" than in being "revolutionary" (the former, as a deployment of a concept of revolution, is the way his involvement in Munich's Second Council Republic should be understood). Richter stepped into (or was

invited into) roles of others' creation, occupied positions available for use and from which action could be taken, positions from where culture could be constituted. The positions he occupied were, for Richter, not culture, and the creating of the position (and the creation of works of art) would not have meant the creation of culture (as it would have then, and continues to, for the academy).

It follows that there is limited value in describing Richter's work in terms of genre (painting, drawing, film, etc.), since genres were developed more for their strategic than for their stylistic or rhetorical power. More akin to alternative positions, or potential coordinates within competing artistic discourses, "ways of making art" collapsed into strategies of "taking sides."

One stands to learn less about Richter from modernism than one does about modernism from Richter; that is, ironically enough, while modernism makes Richter smaller, Richter makes modernism larger. Richter is challengeable, and has been challenged, on precisely and only the grounds upon which being a modernist is presently faulted or, if not faulted, perceived as limited and dated. At the same time, Richter describes a radius for modernism that far exceeds the disapproving grounds of his critics. Indeed, he illustrates the variousness of modernism and underscores the significance of some of its agendas for the present; in short, he becomes part of "our" modernism and the dimension of modernism that we can still embrace.

This book is constituted to reflect a series of paradigm shifts within which Richter's objectives were redefined and restrategized. These correspond roughly to the expressionist and Dada years (one could defend their separation), the immediate postwar revolutionary years (including his short tenure in Munich), his involvement with international constructivism and the development of the nonobjective cinema, the politicization of film in the late twenties and thirties that he pursued in the context of Nazism and, arguably, Richter's first ten years in the United States.

In concentrating on these periods, we make every attempt to contextualize Richter's career securely between his early training in modernism and his later American years, but the latter, for all practical purposes, are omitted from the present project. This decision rests on the nature of questions currently being addressed to modernism, understood in relationship to Richter's pivotal early and middle careers. In no way does it constitute a judgment on the aesthetic merit of the artist's earliest (student) and latest work.

Richter's European and early American career describes a clear and paradigmatic course of development, from his initiation into modernism through his acquaintance with the Berliner Sezession, the Blaue Reiter group, and the 1913 "Herbstsalon" (**fig. 1.3; plate 2**), to his involvement with Herwarth Walden's *Der Sturm* and the radicalization of his art based on his affiliation with Franz Pfemfert's journal *Die Aktion*. It was particularly for his contributions to the latter that he became known as one of the first expressionists to politicize his art heavily (Richter was the subject of a special issue in 1916). The journal, for all intents and purposes, defined the most influential anti-war stance among German artists and authors (in part based on its negative relation to the politically uncommitted but successfully art-world-based activities of Walden's *Der Sturm*), and became one of the German publications most completely identified with the "crisis of Expressionism."

Richter's subsequent involvement in Zurich Dada, heir in many respects to Hans Leybold's *Revolution* (**fig. 1.4**) (Hugo Ball and Richard Huelsenbeck, key founding members of Zurich Dada, were initially involved in the group), was crucial. Equally significant were his contact with Theodor Däubler and the political radicalism evidenced by his contact with radical socialist Ludwig Rubiner, and his formulation of the Radical Artists Group, an organization based in Dada's perception of the significance of the Russian Revolution of 1917. These activities coincided with the initial experiments

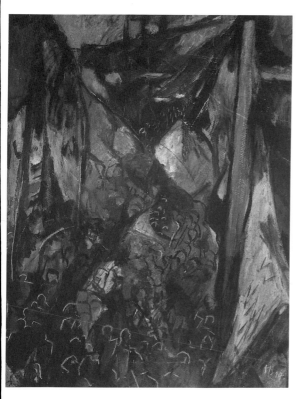

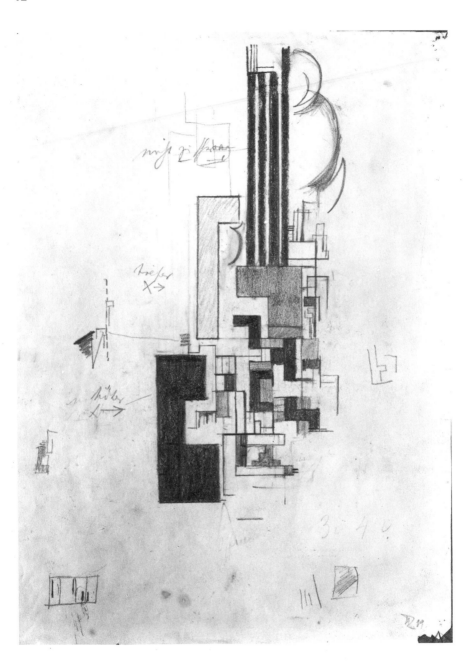

1.5
Study for *Präludium*, 1919
Pencil on paper, 54 × 39 cm
Kupferstichkabinett, Staatliche
Museen zu Berlin

in Zurich that were to lead to the formulation of a nonobjective cinema with Viking Eggeling.

Richter's chairmanship of the Action Committee of Munich's Second Council Republic, for which he was sentenced to a five-year term of imprisonment (suspended through the mediation of influential friends), represented the peak of his directly revolutionary activities and immediately preceded his move to Berlin (with Viking Eggeling) in 1919.

His subsequent work in the areas of both the plastic arts and filmmaking aligned itself with the experiments of Dutch De Stijl and international constructivism (**fig. 1.5**). These formal and theoretical sympathies expressed themselves eloquently in his publication of the journal G (*Gestaltung*) between 1923 and 1926 (other contributors included Hans Arp, Theo van Doesburg, Ludwig Mies van der Rohe, Kurt Schwitters, Naum Gabo, Friedrich Kiesler, and Man Ray; in his involvement with conferences at Düsseldorf (Werner Gräff, Raoul Hausmann, van Doesburg, Cornelis van Eesteren, Schwitters, El Lissitzky, et al.) and Weimar (Schwitters, Arp, Max Burchartz, van Eesteren, van Doesburg, et al.); and in the films from 1921 through 1926 (*Rhythmus 21* through *Filmstudie*). The end of this period is marked by a planned film collaboration with Russian suprematist Kasimir Malevich, a project never produced but for which some sketches do exist.

The years 1927 and 1928 witnessed the politicization of Richter's cinema (*Inflation,* 1927–28; **fig. 1.6**), which achieved its most advanced statement in the uncompleted *Metall* of 1931–1933. Although little work exists from between 1933 and 1941, the years of his German exile, plans for a series of uncompleted films (*Candide,* 1934, et al.) demonstrate the extent to which Richter's role as an artist had been, more than ever, radically politicized. At this point, he approached his films as weapons of political efficacy; they were separated from his other work not on generic but on instrumental grounds. Less concerned with "inventing" (creating) nonobjective cinema, alternative filmmaking, or political

filmmaking, he saw the cinema as an option to be explored for its transactional usefulness in a period of acute political crisis. It is remarkable that this is verified most completely in the unrealized political film projects of the late twenties and thirties (*No Time for Tears* and *The Lies of Baron Münchhausen,* among others). It is these "noncreations," ironically enough, that achieved the greatest political potency, that revealed themselves as pure cultural transactions, and that best underscored film as a position for negotiating culture.

Based, in large part, on the nature of these experiences, Richter made an enormous contribution to modernism in the United States following his arrival in 1941, and he functioned as an important conduit between American and European art communities. His influence on the American film community, and on American art in general, was in part the function of his directorship of The Institute of Film Techniques in New York and his close involvement with Peggy Guggenheim's Art of This Century gallery.

Few have participated as completely as Richter in the major issues of early twentieth-century movements, and few reveal in their work an equivalent historical logic. Richter, as well as any artist and better than all but a few, epitomizes the mission, aesthetic strategies, and historiographic directionality of early twentieth-century modernism. Part of a generation of artists that passionately believed in the power of art to change the complexion of social and cultural affairs, he assumes greatest significance in relationship to what has been aptly characterized as "the heroic years" of the European avant-garde. Richter is deserving of a major catalogue, written from the perspective of cultural history, that provides his work with the historical texture required of any full appreciation of its significance; and one that rehabilitates the artist's original intentions as serious and sophisticated advocacy of the early twentieth-century avant-garde.

TIMOTHY O. BENSON

# Abstraction, Autonomy, and Contradiction in the Politicization of the Art of Hans Richter

The radical within him makes his

gift thrive all the more. The

more he notches into the problem of

modernity, the more his artistic

circumspection grows.

Critic Theodor Däubler's commentary on his colleague Hans Richter's first significant exhibition, a group show at the Galerie Hans Goltz in Munich in June 1916, captures the significance of Richter perhaps more essentially than either critic or artist could have imagined at the time. Däubler was enthralled by Richter's patient but progressive exploration of picture surfaces (*Bildfläche*) and his creation of space in entirely new ways beyond the traditions of aerial or linear perspective, beyond even cubism. When he portrayed street workers (**fig. 2.1**), it was the artist who was "shoveling and prospecting the surfaces." A cello player (**fig. 2.2; plate 3**) was "nothing other than rhythm in space"; the "angular movements" of musicians (**fig. 2.3**) created "geometric crystals in space." For Däubler, Richter's advancement of modernity was laudable for its openness, its proceeding with "no program." In his statement for the exhibition catalogue, Richter similarly underscored creativity as distinguishing his enter-

prise from the mere "activity" (*Tätigkeit*) of "bourgeois cow-
ardice."[1] Even after his experiences of the horrors of trench
warfare—and perhaps by contrast to them—it was, pro-
claimed Richter, "exciting to be a painter." Within the next two
years this confidence in pure artistic enterprise, and with it
modernity as Richter and Däubler knew it, would be put to
the test by political events in Germany.

Within three months of the Goltz show Richter would
move to Zurich and discover Dada. A year later he would en-
counter Ludwig Rubiner's Tolstoian attitudes there and even-
tually he would find his way from Zurich into the political furor
of the Munich Soviet of 1919. Would modernity still be able to
convey politically subversive intent, as it had when Richter
first encountered it, merely by virtue of its progressive aes-
thetic production? After the war broke out in 1914, the pro-war
fervor had extended even to the avant-garde and lasted as

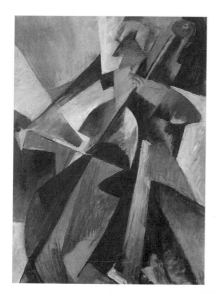

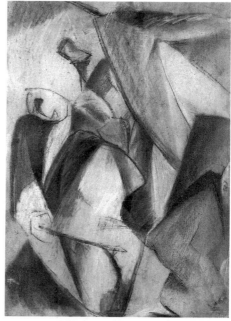

late as Herwarth Walden's January 1916 "Hohes Lied des Deutschentums" (Prussian Song of Songs). Thus, by simply refusing to praise the war in his poetry in *Die Aktion,* a pacifist poet such as Däubler could be perceived as rebellious.[2] Analogously, abstraction, as it was gradually being understood and defined in the mid-teens, could also in and of itself appear to be defiant. This helps to explain why the more overt politicization of the avant-garde accomplished in 1917–1919 fell far short of the absolute rejection of modernism that the far left in the political arena might have hoped for. Even as the Munich Soviet was under way in 1919, the most influential left-leaning art critic on the Munich scene, Wilhelm Hausenstein, would take a relatively moderate stance, declaring that "art rests in itself, not in its connections to power."[3] And Richter, who had returned to Munich to be the leading artist of the Action Committee [Aktionsausschuß] of Revolutionary Artists, brought to it a similar appreciation for the autonomy of art.

The defining moment for Richter had occurred just a few days earlier when the Zurich Radical Artists circle, cofounded by Richter, Marcel Janco, and others in 1919,[4] produced the following statement for its (unpublished) journal *Zürich 1919:* "The means that serve abstraction are of a synthetic, anorganic, [and] impersonal sort, meaning an operation with formal and sensual essences. The abstract is the primary form of art. Abstractions are the essential human abilities slumbering in everyone. Abstract art means the enormous broadening of the feeling (sentiment) of freedom of man."[5] Assumed to have been authored largely by Richter,[6] this statement thrust abstraction in the face of those who would have condemned it as inaccessible, such as the anarchist poet Rubiner, who had been an essential mentor to Richter's politicization.[7] Such contradictions attend to Richter's abstraction from its very beginnings and bind his work inextricably to modernism. This essay will explore the meaning and origins of Richter's conception of abstraction.

Richter's first encounter with an alternative to the veristic, academic procedures in which he had excelled since his

days at the gymnasium (e.g., *Selbstporträt [akademisch]*, **fig. 2.4**) occurred while he was attending the Art Academy in Weimar. Having just executed several hundred rapid figural sketches in 1910 and 1911 for an ill-fated publication of Giovanni Boccaccio's *Decameron* in an awkward yet spontaneous style, he began to explore masters of the past and present: Dürer, Velázquez, Tintoretto, Rubens, Manet, Leibl, and Lenbach, among others.[8] His first encounter with modernity came with a surprise discovery around 1912 of Cézanne's *Bathers*. After an initial reaction of displeasure, says Richter, "suddenly something struck me, a kind of musical rhythm."[9]

It was a feeling for rhythm—associated in Richter's recollections with music—that had drawn him to the workers in the street that he portrayed (perhaps by coincidence with an ungainliness reminiscent of early Cézanne) in his *Arbeiter* (Workers) series.[10] In a group of etchings made at the same

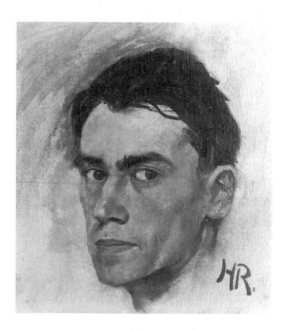

**2.4**
*Selbstporträt (akademisch)*, c. 1912
Oil on canvas, 37 × 33 cm

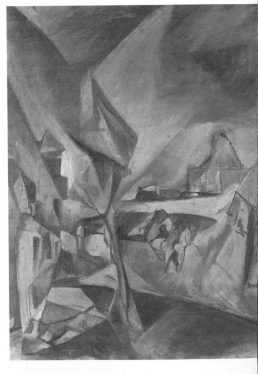

**2.5**
*Ku'damm*, 1913
Oil on canvas, 53 × 38 cm
Neuberger Museum of Art, Purchase

**2.6**
*Landschaft—Schlittenfahrt*, c. 1915
Oil on canvas, 80 × 59 cm
Collection Inge Dambruch-Gütt,
Frankfurt

**2.7**
*Ätherisch*, c. 1918
Gouache, 63 × 46 cm
Collection Inge Dambruch-
Frankfurt

time he explored horses, musicians, and other subjects that would endure through much of his early work.[11]

It may have been this early sensitivity to the "musical" potential of art, inherent in its nonrepresentational or autonomous qualities, that led Richter to simplify his compositions into sweeping rhythmic forms. This direction was clearly strengthened by his empathy with the expressionist tendencies then on view in Herwarth Walden's Sturm galleries in Berlin. In a series of studies of Berlin's Kurfürstendamm (**fig. 2.5; plate 4**), as well as in contemporaneous landscapes leading up to *Landschaft—Schlittenfahrt* (Landscape— Sleigh Ride, c. 1915, **fig. 2.6; plate 5**), he suddenly conceived the entire spatial context of figure and ground as one.

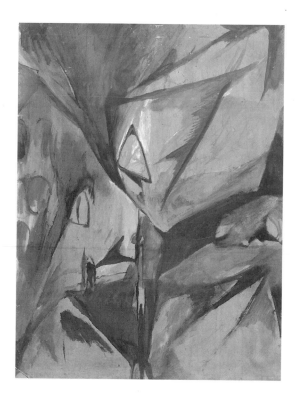

The impetus for this breakthrough was most likely the works of Blaue Reiter artist Franz Marc that Richter saw at a 1912 exhibition on the advice of painter Walter Rössner, an acquaintance of Richter's family.[12] That Richter was impressed by a painting by Marc entitled *The Deer*—"an enormous painting, in all colors, but you couldn't find the deer"—may be evident in a landscape painting (probably from around 1912) on the verso of *Landschaft—Schlittenfahrt.*[13] In the foreground Richter portrays horses whose forms are attenuated to harmonize with a curving hill in the background, much like Marc's animal pictures. Marc's organizational principles, taken with a crystalline fracturing of the sky and nervous tentative facture reminiscent of Brücke artist Erich Heckel, were deeply absorbed by Richter and are still perceptible in *Landschaft—Schlittenfahrt* and *Ätherisch* (c. 1918, **fig. 2.7**).

Further cues for an overall compositional procedure were derived from the cubist paintings on display at Walden's 1913 Herbstsalon exhibition. Continuing the motif of a concert he had begun at least two years earlier,[14] Richter employed "the structure of Cubism, Cubism as a constructive principle" to reach his first mature approach in a series of cello players and concerts.[15]

Richter now had a means for disciplining the spontaneous gesture long present in his drawings (evident for example, in the Kurfürstendamm series). However, the gesture drawings remained instrumental in deriving the cubist compositions, as is shown by the many sketches done in conjunction with the cello players.[16] The 1916 painting *Konzert* (Concert) derives directly from such a gestural pencil sketch of the same year.[17] Yet, "Cubism awakened a new sense of harmony, performed a quiet, more powerful music," and helped Richter to establish balanced compositions where the subject matter had become increasingly arbitrary.[18] Indeed, for Richter, while cubism offered "constructivism and all [that] derives from it,"[19] it also shared with Marc's animal paintings an assault on representation that fascinated him: "What influenced me in Cubism was not only the new form of expres-

sion but the courage, the audacity to dare this step. They jumped from the world of natural objects into the fragmentation of objects, so I jumped too."[20] Hence, beyond his admiration for the constructive principles in cubism was an absorption with the abstract or autonomous forms it presented, forms that could be composed in a way analogous to music.

When Richter joined the more politically active group around Franz Pfemfert, a pacifist anarcho-communist whose periodical *Die Aktion* offered an antipode to Walden's politically uncommitted *Sturm* circle, he brought his new attitudes toward modernism with him. Nor did his service on the Eastern Front during the first few months of the war, which resulted in severe injuries and extended hospital care, shake his commitment. His rejection of representation and a search for constructive principles propelled the woodcuts and drawings he produced for Pfemfert's journal ever closer to abstraction. His *Die Aktion* portraits of his colleagues, Däubler and the poet Ferdinand Hardekopf, resemble craggy mountainscapes.[21] The extreme polarities between black and white, between positive and negative spatial clues are intensified in the severely simplified linocuts appearing in the special March 1916 issue of *Die Aktion* devoted to Richter (**fig. 2.8**).[22] These scenes of musicians and animals anticipate his later *Dada-Köpfe* (Dada Heads) (**fig. 2.9**). Two more linocuts, equally advanced towards abstraction, appear in the June 1916 catalogue for the exhibition at Hans Goltz's Munich gallery mentioned above in which Richter's strongest endorsement of abstraction to date appeared.[23] On the eve of his departure for Zurich (where Dada was by now well under way) Richter continued to reject the tradition of "nature seen through temperament" of those "backseaters [who] make nothing more than a visual reproduction of an apparently 'objective reality'. . . . They do not believe in the possibility of weighty judgment by a painter. Their idea of development is confined; that someone arrives at making constructions after having done natural looking things, that is for them a matter

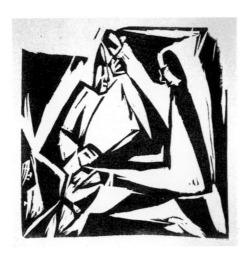

of deep anxiety (in fact it is just the opposite; it is a final libera-
tion, a sovereign rule in unexperienced realms)."[24]

After contriving to have a doctor who was treating his
war injuries advise him to seek special medical treatment in
Zurich, Richter was able to fulfill a compact—purported to
have been made at a farewell party held when he was drafted
in 1914—that should he survive the war, he would reunite
with his friends Hardekopf and Albert Ehrenstein "at the Café
de la Terrasse in Zurich . . . on 15th September 1916, at three
in the afternoon."[25] Soon thereafter Richter found his way into
the vortex of Zurich Dada, which had been launched the pre-
vious spring at the Cabaret Voltaire, a venue for poetry read-
ings, dance, and cabaret numbers founded by Hugo Ball and
Emmy Hennings.

Although the cabaret, with its provocative performance
events, was in dissolution by the time Richter arrived, Zurich
Dada's other enterprises were thriving: "If the [Café] Odéon
was our terrestrial base, our celestial headquarters was
Laban's ballet school."[26] Richter portrayed members of the
group holding court at the Café Odéon in a sketch that is so
gestural as to absorb (and obscure) the individual identities
within a bustling bundle of lines and scratches (**fig. 2.10**). The
sitters have been variously identified as Hardekopf, Hans
Arp, Hennings, Simon Guttmann, and Oskar Grechberg.[27] No
doubt Richter has portrayed the Dada contingent (the group
also included Ball, Richard Huelsenbeck, Marcel Janco, and
Tristan Tzara), which sat at a different table from the expres-
sionist poets' camp that, according to Arp's account, included
Ehrenstein, Leonhard Frank, Rubiner, and René Schickele.[28]
Just as in Berlin at the Café des Westens, the boundaries
were always fluid between such groups as friendships and
alliances were forged and broken. Yet under pressure of aes-
thetic or political circumstances, the distinctions became
greatly significant (as would become apparent in Zurich dur-
ing the summer of 1917). Richter would have found encour-
agement for the evolving abstraction within his work from his

associates in both groups, albeit they would have held dif-
fering attitudes towards its meaning and purpose.[29]

The Dadas soon launched a series of exhibitions at the
gallery of Han Corray, himself another favorite subject of
Richter's portraits (**fig. 2.11**). Corray's operation was quickly
taken over by Ball and Tzara and renamed Galerie Dada.
Richter participated in the first of these exhibitions, which
opened on 12 January 1917 and for which he and Janco cre-
ated posters.[30] In a lecture that was excerpted as a catalogue
foreword, Tzara praised the works on display by Arp, Giorgio
de Chirico, Janco, Oskar Lüthy, Max Oppenheimer, Otto van
Rees, and Richter for such qualities as "symmetry" (Arp),

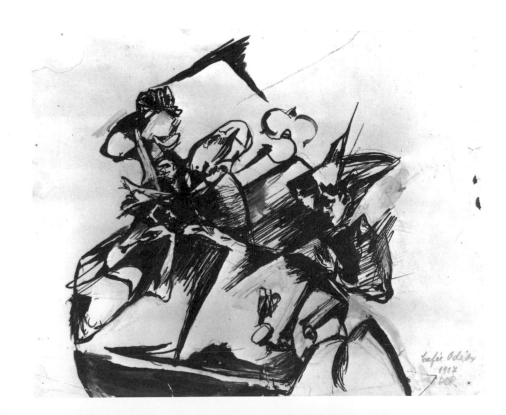

"rhythm of grace" (Oppenheimer), "harmony of colors" (van Rees), and "the life of music, expression of movement, intelligence in the gathering of forces" (Richter).[31] During the months following this exhibition Richter would have found further affirmation of his exploration of form and abstraction. During April an exhibition from the Sturm galleries in Berlin (as had been previously arranged by Corray) was presented at the Galerie Dada. It included works by Johannes Itten, Wassily Kandinsky, Paul Klee, Georg Muche, and Maria Uhden. Among the lectures taking place in the gallery during the spring was Ball's now famous celebration of Kandinsky in a lecture of 7 April.[32] Ball found in Kandinsky's abstraction not

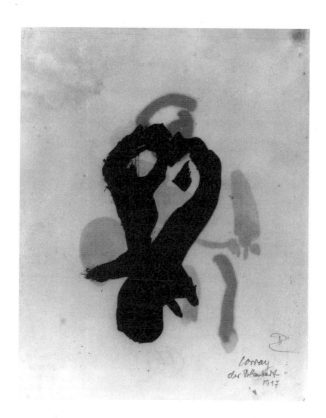

only a step beyond futurism, expressionism, and cubism, but a moral purpose. Quoting Kandinsky's essay "Über die Formfrage" (On the Question of Form), he emphasized that, far from "anarchy" the new painting, and "present state of music" as well, actually constitute "regularity and order created . . . by the *feeling for the good*" (Kandinsky's emphasis).[33]

By May 1917, however, opinions concerning abstraction were beginning to shift. In his somewhat idiosyncratic interpretation of Kandinsky, Ball had recounted the danger of the "entirely abstract," which could produce "ornament consisting of allegories and hieroglyphs that have ceased to say anything."[34] Now he was expressing further doubts in his diaries while fending off attacks from Rubiner, who strongly believed in a politically engaged art.[35] Albeit for different reasons, at this point Rubiner and Ball were both skeptical of abstraction.

Although not a participant in this exchange, Richter may also have felt the contradictory implications for the practice of abstraction. On the one hand he had rejected the "visual reproduction of an apparently 'objective reality'" in favor of the autonomous forms and fragmentation of cubism in his foreword to the 1916 catalogue. On the other hand, Richter remained tied to the political commitments he had established in Berlin, specifically the opposition to the war of Pfemfert's *Die Aktion* circle. In early 1917, he sent two portrait drawings of Rubiner to be included in the 17 April issue honoring this anarchist poet who had now become editor of *Zeit-Echo,* a Munich-based pacifist journal that had been forced into exile in Zurich. As a recent convert to Rubiner's political zeal, Richter became *de facto* art editor of *Zeit-Echo*'s first exile issue of May 1917.[36]

Richter shared with Rubiner the anarchist views of Peter Kropotkin and Mikhail Bakunin, the latter's conveyed by Bakunin's disciple Luigi Bertoni to a loose circle of adherents that included Richter. Richter made several contributions to the "Schwarzweisses Volksblatt" (Black and White People's Page) included by Rubiner in the summer issues of the jour-

nal in accordance with his Tolstoian views that art should be a popular means of political education. Earlier, in his *Revolution* (1914) and *Aufstand* (Rebellion, 1915), which he subsequently said was dedicated to Pfemfert,[37] Richter had already conveyed the theme of social unrest. His earlier worker types had become thronging masses amid a tumult of buildings, somewhat suggestive of Ludwig Meidner's cityscapes. But in his role as "court painter" to the *Die Aktion* and other Berlin expressionist circles, he had concurrently produced many individual portraits based on his personal acquaintance with such figures as Walden,[38] Pfemfert,[39] Salomo Friedländer,[40] Johannes R. Becher, Carl Einstein, Walter Hasenclever, Hardekopf, and other frequenters of Däubler and René Schickele's circle at the Café des Westens. Indeed, portraits of Däubler, Pfemfert, and Berlin Dadas Johannes Baader and Raoul Hausmann, had made up much of the 1916 exhibition at Hans Goltz's gallery in Munich. In his *Zeit-Echo* "Volksblatt" drawings, Richter returned to generalized references to produce his reminiscences of the war, later gathered around the theme of "the Ox and the Swine." In the resulting series, *The World between the Ox and the Swine,* he based his "disgust for the war" on visceral recollections of "pigs eating human corpses," endeavoring in sketches with such titles as "On the Field of Honor" to be "very realistic."[41] But he also brought to this enterprise both his gestural approach and a newfound ambiguity and fragmentation of the subject that could lend it forceful symbolic meaning. By the time they appeared in *Zeit-Echo,* his fragmentary images had become abstracted by the process of copying and overlaying, and were arrayed about the page symbolically. Their personal associations were jettisoned in favor of a political iconography.[42] Similarly, in such other images as *Groteske* (Grotesque, **fig. 2.12**), the head of an ox, representing the "stupid and self-assured," is laid over the sun, and the pig's head, representing the "cunning and the devouring," is placed over the moon to indicate that "between the pig's night and the ox's day, there is nothing left for man."[43]

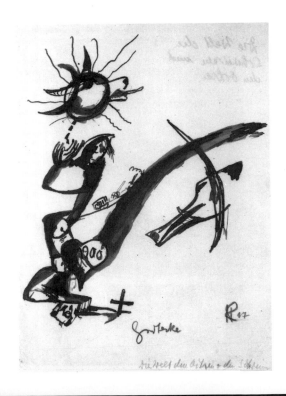

Richter's transition from the spontaneous and personal (often rendered immediately in gestural ink drawings) to the abstract and political (abbreviated fragments copied and overlaid symbolically in an iconographic array) is at work in *Kaiser Wilhelm II* (1917) and *Wilhelm als Befehlshaber des Todes* (Wilhelm as the Commander of Death, 1917, **fig. 2.13**). Through the commanding gesture and the placement of a prison in the background Richter conveys the message "you are dead or you are in prison, as in the background. That's your choice."[44] A variant of the Kaiser with sword and outstretched arm appears in the midst of broken and consumed bodies in *An die Mütter Europas* (To the Mothers of Europe) in *Zeit-Echo*.[45]

In an essay published in the June 1917 issue of *Zeit-Echo*, entitled "A Painter Speaks to Painters," Richter sought to give art a moral and political mission while repudiating the elitist world of art professionals and the vanguard "-isms" produced merely for consumption.[46] In a clear anticipation of his *Zürich 1919* statement above, he implores artists to "do something" against the war, insisting that "art is exclusively *the* human achievement that consciously demands from man the realization of moral earthly existence. . . . Non-art is *the* human expression, which does not have this demand as a goal, [which] plays, finds things beautiful, lets instinct stand, observes itself, instead of willing itself."[47] Echoing Rubiner's motto that appears at the end of each *Zeit-Echo* issue—"the periodical is not a bibliophilist, but rather a moral concern"[48]—Richter insists, "painting serves the idea of humanity, which it has to make clear to one and all, unmistakable to hearts and minds."[49] Of the heart in his *Ox and Swine* series (*Groteske*, fig. 2.12) Richter recalled "a heart, that is us!"[50] The painter must strive for the "simplest formulation" of "good and evil."[51] To do this the painter must attend to the "realization of belief" (*Verwirklichung des Glaubens*) by respecting the "non-symbolic" function of the picture, leaving nothing to

chance.[52] This conviction suggests that ultimately the conventions of symbolic meaning in art could not be depended upon, allowing an important role for the forceful, autonomous forms of abstract art. Abstraction might permit universal principles of ordering to be explored. In his anti-war drawings for *Zeit-Echo* Richter had abbreviated the references to such an extent that deciphering could produce variant orders, just as his scribbling technique produced a preconscious order that might "transcend the barriers of causality."[53]

Over the course of his Zurich period Richter, who later said there was "no conflict at all" between his political and artistic roles,[54] developed abstraction to transcend the description of the particular. For him, abstraction conveyed precisely that universality in opposition to the personal that Rubiner insisted upon but was never able to perceive in Richter's work. This expectation, that the autonomous elements of art held a power of embodiment capable of transcending the particular, found a greater resonance among the Zurich Dadas, especially Arp, whose chance operations and search for a language of "paradise" are given large play in Richter's retrospective accounts of Zurich Dada.[55]

During 1917, Richter's painting broke away entirely from cubism in his "Visionary Portraits" (**figs. 2.14, 2.15; plate 6**). His drawings had already become gestural to the point of near illegibility in 1916.[56] Now he intentionally painted at twilight when the colors "were almost indistinguishable" and when he could find himself in "a sort of auto-hypnotic trance. . . . Thus the picture took shape before the inner rather than the outer eye."[57] This procedure, in a way analogous to Arp's use of chance, allowed Richter to transcend the individual identities of his subjects to attain a more generalized image, potentially a more transcendental image of the "Mitmensch" (co-man) than the drawing of that title (one of many by Richter on this theme) that accompanied Rubiner's proclamatory "Mitmensch" essay in the May issue of *Zeit-Echo*.[58] The spontaneous visionary portraits make up the bulk of what he exhibited at the September 1918 "Die neue

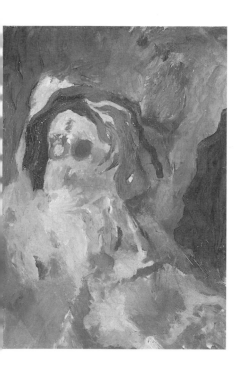

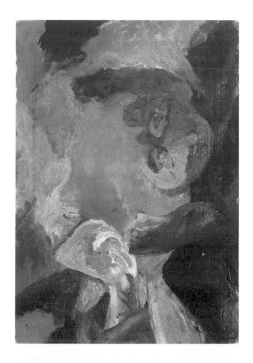

Kunst" exhibition at the Kunstsalon Wolfsberg in Zurich (Arp and Janco were also included). These orgies of gesture mark the culmination of a subjective, expressionist endeavor that freed him from the past but required a new procedure for ordering: "In 1917 I could produce nearly a hundred of my so-called 'visionary portraits,' three or four a day. . . . But the euphoria of these wild months did not last."[59] During 1918, Richter encouraged an architectonic structure to emerge in a series of carbon paper sketches of Arp, one of which would appear in 1919 in the last little magazine of Zurich Dada, *Der Zeltweg*.[60] Despite having been impressed by the fully abstract pictures of van Rees and the severely abstract and carefully ordered compositions of Sophie Taeuber upon arriving in Zurich in 1916 (as is seen in his *Herbst* series), Richter took his cues for bringing order to his drawings more directly from music.[61] Perhaps because Richter tended not to copy forms or styles but rather to seek solutions "internally" as he evolved his aesthetic strategies, the Italian composer Ferruccio Busoni's suggestion that he explore counterpoint in the preludes of Bach led to an immediate response within his work. The balance of black and white he had sought in the *Ox and Swine* drawings now reached a new clarity in the greatly simplified *Dada-Kopf* compositions beginning in 1918: "These studies helped me enormously and gave me the idea that it could be done on a piece of paper. There is also the up and down, there is also strong and weak, a movement and counter-movement. So then I used the paper like a musical instrument."[62]

The *Dada-Kopf* series show Richter departing entirely from naturalism and attaining an exacting abstraction that could yet convey a generalized and universal, harmonically ordered icon of humanity: "What I tried to find was not chaos but its opposite, an order in which the human mind had its place but in which it could flow freely."[63] Soon he was using this approach across all media, in painting and woodcuts. Richter credits this experience with preparing the way for his fruitful collaboration with the Swedish painter Viking Eggeling

whom he met in 1918 through Tzara. Eggeling was among the artists exhibiting with Das Neue Leben (New Life), a group founded by artist Fritz Baumann in Basel in April 1918, which now opened an exhibition in November, just after the revolution had begun in Germany.[64] Other members included Arp, Janco, and Taeuber.

But the "period of 'balance' within Dada" was by now over.[65] Not only were the internal dynamics of the Zurich group shifting (Francis Picabia arrived soon after his works were seen in the Kunstsalon Wolfsberg show, and he injected a new nihilist energy into the group); but in addition, the aesthetic concerns of the art world could no longer be disentangled from political events. Richter now also intensified his political activities, traveling in February 1919 to the Second Socialist International in Bern where he sketched portraits of the participants at the request of Schickele, the colleague from the Berlin circle around Hardekopf who was editor of the prominent literary journal *Die Weißen Blätter* (The White Pages). On the occasion of this conference Richter may have met political activists such as Felix Fechenbach, who knew Ball.[66] Immediately after the conference Richter is thought to have been in Munich during the tumultuous aftermath of the assassination of Kurt Eisner, the leader of the Independent Social Democrats (USPD) who had led the first provisional government in the Bavarian capital.[67] Richter's brother Richard (then a university student) and Rubiner's wife, Dr. Frida Rubiner, member of the editorial board of the Communist Party organ *Die Rote Fahne,* would have been among Richter's many contacts there. In sharp contrast with Zurich Dada, the setting in which Richter found himself in Munich was seriously politically engaged. Upon his return to Zurich he joined with many of the members of Das Neue Leben to forge the Zurich Radical Artists (Radikalen Künstler) circle, which lasted only for a few weeks during the spring of 1919.[68]

As has been suggested in the scholarship, the declamatory tone of the Radical Artists manifesto (quoted above) that Richter brought back with him to the Action Committee

in Munich was a reaction to the nihilism of the eighth Dada soirée at the Saal zur Kaufleuten in Zurich on 9 April 1919.[69] Indeed, Richter brought the manifesto to Zurich on 12 April,[70] just three days after the last riotous soirée of the Zurich movement. On that occasion, "a very serious speech about elementary *Gestaltung* and abstract art" by Eggeling had given way to a simultaneous poem by Tzara ("performed b twenty people"), Richter's attack on "Ernsthaftigkeit" (ser ousness) in "Gegen ohne für Dada" (Against, without, fo Dada), Arp's *Wolkenpumpe* (Cloud Pump) poems, and Wal ter Serner's thoroughly nihilistic "Letzte Lockerung" (Fina Dissolution) manifesto.[71] Richter had often made portraits ol Serner, the Austrian writer and "cynic of the movement" who had edited the proto-Dada periodical *Sirius* and would include Richter's work in *Der Zeltweg*.[72] With Tzara, Serner represented the extreme nihilistic wing of Zurich Dada, and his performance of "Letzte Lockerung" (read with his back to the audience) had driven the large audience to riot.

But despite the contrasts between Zurich and Munich, Richter's faith in abstraction does not simply convey a political commitment to art in the service of revolution. It also marks a resolution (if only a temporary one) in Richter's artistic development which had hitherto been characterized by simultaneous pursuit of the two contradictory strategies of illustration and embodiment, *both* perceived as capable of supporting political objectives. Even as he had made his first advances toward the embodiment of constructive principles in the *Dada-Kopf* series, he had simultaneously continued his series of didactic illustrations of political gesture. Inspired by the lively anarchist meetings where Rubiner had held forth,[73] Richter had then been spurred on by the general strike in Zurich to create his *Revolution* sketches of 1917–1918 (**fig. 2.16**). The demonstratively thrusting arms and shouting faces of the figures were codified into various versions of the *Orator* and the *Freie Verlag* drawings (**fig. 2.17**). The latter was a series of images begun in 1917 for a vignette for the radical Bern publishing firm operated by Ball and Herman Röse-

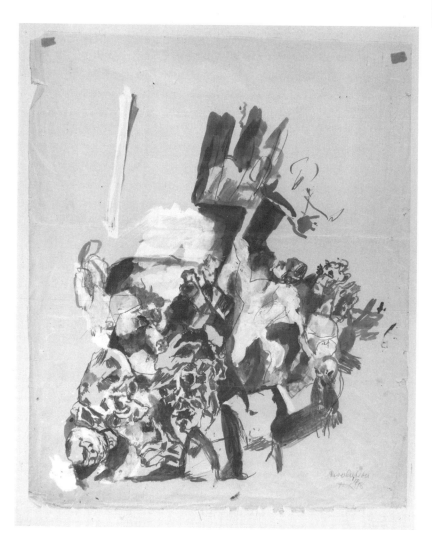

**2.16**
*Revolution*, 1917–18
Blue-gray ink and white on paper,
42.5 × 34.5 cm

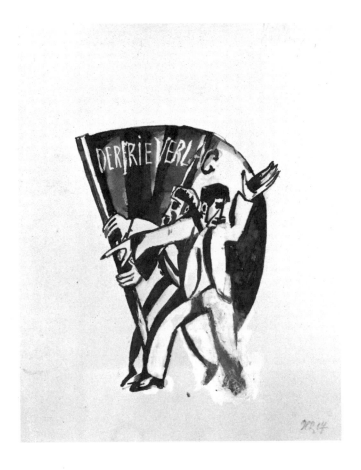

meier, Der freie Verlag. Characteristically, Richter began with sketches similar to his *Kaiser Wilhelm II*, "the style of sensitive lines I was born with,"[74] and then progressed to the "broadside style in the drawings I made for *Die Aktion* and *Zeit-Echo*" seen in the Kunsthaus Zürich example (fig. 2.17; Richter would correct the spelling in a later version). The printed vignette appears on the cover and title page of the *Almanach der freien Zeitung: 1917–1918* (published in 1918) and on the title page of Hugo Ball's 1919 book published by Der freie Verlag, *Zur Kritik der deutschen Intelligenz*.[75] The

2.17
*Der Fr(e)ie Verlag*, 1917
Pen and brush in ink and white on vellum, 27.8 × 21.8 cm
Kunsthaus Zürich, Zurich
Gift of Frida Richter

image conveys crisp contrasts between black and white that are carefully balanced to amplify the demonstrative gestures of the foremost figure into an icon of political commitment. Works such as this, that retained both representation and didactic purpose in their abbreviation of form and content, would have been far more accessible to the factious social setting than his emerging abstraction. Nonetheless, had the provisional government not ended with the invasion of *Freikorps* and federal units on 1 and 2 May (leading to Richter's brief arrest), his *Präludium* series would probably still have been made, for they were not a product of resignation but the result of a conscious decision about the capabilities of modernism, principled embodiments of his belief that through abstraction he could reach a point where artists "will paint and act for humans in so indivisible a way, that they will no longer shoot at each other."[76]

**Notes**     **Epigraph:** Theodor Däubler, "Künstlerische Neuerscheinungen Hans Richter," *Die Aktion* 6 (25 March 1916), cols. 181–182.

1.  Hans Richter, "Vorwort," in *Neue Kunst. XXIX. Kollektiv-Ausstellung* (Munich: Hans Goltz, 1916), 3–4, trans. in Cleve Gray, ed., *Hans Richter by Hans Richter* (New York: Holt, Rinehart and Winston, 1971), 26.

2.  Thomas Rietzschel, *Theodor Däubler* (Leipzig: Reclam, 1988), 153–155.

3.  Wilhelm Hausenstein, "Kunst und Revolution," *Ostern 1919,* Galerie Flechtheim, Düsseldorf (Potsdam, 1919), 28, trans. in Joan Weinstein, *The End of Expressionism: Art and the November Revolution in Germany* (Chicago: University of Chicago Press, 1990), 191.

4.  Raimund Meyer, "'Dada ist gross Dada ist schön': Zur Geschichte von 'Dada Zürich,'" in Hans Bolliger, Guido Magnaguagno, and Raimund Meyer, *Dada in Zürich* (Zurich: Arche, 1985), 53, and Harry Seiwert, *Marcel Janco: Dadaist, Zeitgenosse, wohltemperierter morgenländischer Konstruktivist* (Frankfurt am Main: Lang, 1993), 113–140.

5. "Die Mittel, deren sich die abstrakte Kunst bedient sind syntethischer anorganischer, unpersönlicher Art, bedeuten ein Operieren mit Quintessenzen formal und empfindungsgemäss. Das Abstrakte ist die Grundform der Kunst. Abstraktionen sind die wesentlichen menschlichen in jedem schlummernden Fähigkeiten. Die abstrakte Kunst bedeutet die ungeheure Erweiterung des freiheitlichen Gefühls des Menschen." Marked galley sheets for *Zürich 1919,* Foundation Arp, Clamart. I am grateful to Raimund Meyer for this reference. The first page of this document is reproduced in Raimund Meyer, Judith Hossli, Guido Magnaguagno, Juri Steiner, and Hans Bolliger, eds., *Dada Global* (Zurich: Limmat Verlag, 1994), 128. See also the variant ms. in Seiwert, *Marcel Janco,* 572–574.

6. Justin Hoffmann, "Hans Richter und die Münchener Räterepublik," in *Hans Richter 1888–1976: Dadaist, Filmpionier, Maler, Theoretiker* (exh. cat., Berlin: Akademie der Künste, 1982), 22. The words "(siehe Ausführungsprogramm)" were added after the words "abstrakte Kunst." See "Protokoll der Sitzung vom 11.4.19 bei Janco 8 Uhr" in Seiwert, *Marcel Janco,* 570–571.

7. Hans Richter, *The World Between the Ox and the Swine: Dada Drawings by Hans Richter* (exh. cat., Providence: Rhode Island School of Design, Museum of Art, 1970), 11–13.

8. Manet's *The Execution of the Emperor Maximilian* (Städtische Kunsthalle, Manheim) is the source for an etching of 1913 in the artist's estate.

9. Gray, *Hans Richter by Hans Richter,* 22.

10. Ibid., 20.

11. The etchings are now in the artist's estate, New Haven, Connecticut.

12. Gray, *Hans Richter by Hans Richter,* 24.

13. Richter continues, "Finally after searching for a long time you could discover the deer off in a little corner." This statement suggests that Richter may be referring to *Reh im Walde I* (1911) or *Reh im Walde II* (1912), nos. 159 and 160 in Klaus

Lankheit, *Franz Marc: Katalog der Werke* (Cologne: Verlag M. DuMont Schauberg, 1970), 55.

14. The concert was the subject of one of Richter's etchings of 1911, artist's estate, New Haven.

15. Gray, *Hans Richter by Hans Richter*, 24.

16. See ibid., 27, and Roberto Sanesi, in *Hans Richter: Opera grafica dal 1902 al 1969* (Pollenza: La Nuova Foglio, 1976), 162–163, 170–173.

17. Illus. in *Hans Richter: Opera grafica*, 164.

18. Ibid., 168.

19. Gray, *Hans Richter by Hans Richter*, 24.

20. Ibid.

21. Reproduced in *Die Aktion* 6, nos. 14–15 (8 April 1916), col. 192, and nos. 11–12 (18 March 1916), title page.

22. *Die Aktion* 6, no. 13 (25 March 1916).

23. These linocuts, entitled *Cellist* and *Theodor Däubler* are reproduced in Richter, *Dada: Art and Anti-Art* (New York: McGraw-Hill, 1965), 29.

24. Richter, "Vorwort," trans. in Gray, *Hans Richter by Hans Richter*, 26.

25. Richter, *Dada: Art and Anti-Art*, 27.

26. Ibid., 69.

27. Cf. Bolliger, et. al., *Dada in Zürich*, 133, and *Dada: Eine internationale Bewegung, 1916–1925* (exh. cat., Zurich: Limmat, 1993), 232.

28. Hans Arp, *Unsern täglichen Traum . . .* (Zurich: Arche, 1955), 56–57, discussed in J. C. Middleton, "Dada versus Expressionism or the Red King's Dream," *German Life and Letters* 15, no. 1 (October 1961): 37–52.

29. Cf. Middleton, "Dada versus Expressionism," 40–41.

30. Richter's poster was never printed. See Justin Hoffmann, "Künstler und ihre Revolution," in *Süddeutsche Freiheit: Kunst der Revolution in München 1919* (exh. cat., Munich: Lenbachhaus, 1993), 43.

31. Tristan Tzara, "Conférences sur l'art moderne," German trans. by Hugo Ball repr. in Bolliger, et. al., *Dada in Zürich*, 259.

32. Hugo Ball, "Kandinsky," in *Flight Out of Time: A Dada Diary,* introduction and ed. John Elderfield (New York: Viking, 1974), 222–234.

33. Cf. Wassily Kandinsky, "On the Question of Form," in *The Blaue Reiter Almanac,* ed. Klaus Lankheit (New York: Viking, 1974), 157.

34. Ball, "Kandinsky," 230; cf. Richard Sheppard, "Kandinsky's Early Aesthetic Theory: Some Examples of Its Influence and Some Implications for the Theory and Practice of Abstract Poetry," *Journal of European Studies* 5 (1975): 19–40.

35. Ball, *Flight Out of Time,* 114–115; cf. Middleton, "Dada versus Expressionism," 42.

36. Gray, *Hans Richter by Hans Richter,* 30; cf. Middleton, "Dada versus Expressionism," 37.

37. Gray, *Hans Richter by Hans Richter,* 30.

38. *Hans Richter: Malerei und Film* (exh. cat., Frankfurt am Main: Deutsches Filmmuseum, 1989), 50.

39. *Hans Richter: Opera grafica,* 15, 17.

40. Friedländer's portrait appears in *Die Aktion* 6, nos. 39–40 (6 September 1916), col. 546.

41. Richter, *The World Between,* 13–16 and fig. 6, p. 12; Gray, *Hans Richter by Hans Richter,* 30.

42. For example, the drawing *Die Erde ohne Vernunft* (The Earth Without Sense, 1917, illus. in Gray, *Hans Richter by Hans Richter,* 30) is copied in the lower center of *An die Mütter Europas* (To the Mothers of Europe) in *Zeit-Echo* 3 (June 1917): 15.

43. Richter, *The World Between,* 17, 19, and fig. 14, p. 20. The drawing is in the Kunsthaus Zürich (inv. no. Z1977/50).

44. Ibid., 10.

45. *Zeit-Echo* 3 (June 1917): 15. Cf. Paul Klee's more reserved 1918 drawing *Der Feldherr* (Commander-in-Chief), illus. in Weinstein, *End of Expressionism,* 176.

46. Hans Richter, "Ein Maler spricht zu den Malern," *Zeit-Echo* 3 (June 1917): 19–23; a partial translation appears in Gray, *Hans Richter by Hans Richter,* 31.

**47.**    "Kunst ist nur *die* menschliche Leistung, die bewußt von den Menschen die Verwirklichung moralischen Erddaseins fordert. Künstler—der Mensch, der dazu hilft. Nichtkunst ist *die* menschliche Äußerung, die diese Forderung nicht als Ziel hat, spielt, schön findet, Naturtrieb gelten läßt, sich beobachtet, statt sich zu wollen." Richter, "Ein Maler spricht," 21.

**48.**    "Die Zeitschrift ist keine bibliophile, sondern eine moralische Angelegenheit."

**49.**    "Malerei dient der Idee des Menschen, die sie dem Einzelnen und allen klar, eindeutig dem Herzen und Verstand machen muß." Richter, "Ein Maler spricht," 22.

**50.**    Richter, *The World Between,* 17.

**51.**    Richter, "Ein Maler spricht," 23.

**52.**    Ibid., 22.

**53.**    Richter, *Dada: Art and Anti-Art,* 57.

**54.**    Richter, *The World Between,* 18; cf. Gray, *Hans Richter by Hans Richter,* 30.

**55.**    See Richter, *Dada: Art and Anti-Art,* 50–64.

**56.**    See the Akademie der Künste catalogue *Hans Richter 1888–1976,* nos. 53–55, and *Hans Richter: Opera grafica,* 10.

**57.**    Richter, *Dada: Art and Anti-Art,* 55.

**58.**    Ludwig Rubiner, "Mitmensch," *Zeit-Echo* 3 (May 1917): 10–13, 15.

**59.**    Gray, *Hans Richter by Hans Richter,* 33.

**60.**    *Der Zeltweg* (November 1919), 23; cf. Gray, *Hans Richter by Hans Richter,* 34.

**61.**    During 1916–17 Richter explored the metaphors of growth and formation in two studies and an oil painting, now in the Kunsthaus Zürich, inv. nos. Z1977/41, Z1977/42, and 1977/28, illus. in Bolliger, et. al., *Dada in Zürich,* 134–135.

**62.**    Gray, *Hans Richter by Hans Richter,* 37.

**63.**    Ibid., 68.

**64.**    Seiwert, *Marcel Janco,* 97.

**65.**    Richter, *Dada: Art and Anti-Art,* 71.

**66.**    Hoffmann, "Künstler und Ihre Revolution," in *Süddeutsche Freiheit,* 43.

67.  Ibid. It can be surmised that Richter had recently been in Munich on the basis of his postcard to Tzara of 13 March 1919, in "Thirty-three Letters, Telegrams and Cards from Hans Richter to Tristan Tzara and Otto Flake (1917–1926)," ed. Richard Sheppard, *New Studies in Dada: Essays and Documents* (Driffield, UK: Hutton, 1981), 131.

68.  Seiwert, *Marcel Janco,* 113–114.

69.  Richard W. Sheppard, "Ferdinand Hardekopf und Dada," in *Jahrbuch der Schiller-Gesellschaft* 20 (1976): 158, n. 80; cf. Ball, *Flight Out of Time,* xxxv, on the undeniable nihilism of the Zurich event.

70.  Seiwert, *Marcel Janco,* 571.

71.  Richter, *Dada: Art and Anti-Art,* 77–80; the program is also reproduced in Bolliger, et. al., *Dada in Zürich,* 267.

72.  See Richter, *Dada: Art and Anti-Art* for an account of Serner.

73.  Richter, *The World Between,* 23.

74.  Richter, *The World Between,* 45. Several sketches he made for *Die freie Zeitung* using gestural lines in crayon on graph paper in a style very close to *Kaiser Wilhelm II* are found in the artist's estate in New Haven.

75.  Bolliger, et. al., *Dada in Zürich,* 186.

76.  "Dann wird malen und für die Menschheit handeln so untrennbar sein, daß man nicht mehr auf Menschen schießt." Richter, "Ein Maler spricht," 23.

JUSTIN HOFFMANN

# Hans Richter, Munich Dada, and the Munich Republic of Workers' Councils

translated from the German

by Timothy Slater

Even before the advent of Zurich Dada, Hans Richter went to Munich in April 1919 to become chairman of the Aktions- ausschuß revolutionärer Künstler (Action Committee of Rev- olutionary Artists), and there were numerous links between Zurich Dada and the Munich artists' milieu.

Some of the roots of Dada sprang from Munich in the period just before the First World War. The most important of these precursors was the artists' group Der Blaue Reiter (Blue Rider). Hans Arp participated in the activities of the group and its famous almanac contains a brush drawing and three vignettes by Arp.[1] Hans Arp also participated in the sec- ond exhibition of Der Blaue Reiter in Hans Goltz's gallery in 1912. The Swiss artists' group Moderner Bund (Modern League), of which he was a founding member, exhibited their works in the same gallery a year later.[2]

An initiator of the Cabaret Voltaire, Hugo Ball (**fig. 3.1**), also had very close ties to the capital of Bavaria. From 1912

on, he was literary and artistic director of the Munich Kammerspiele theater. In the fall of 1912, he met Richard Huelsenbeck in that city, and he brought him to Zurich after the opening of the Cabaret Voltaire. He also met his partner and later wife, Emmy Hennings, in Munich's Simplicissimus cabaret. Owing to the outbreak of the war, Ball was not able to fulfill his wish to establish an artists' theater in Munich, where the different art forms could be displayed effectively. What he missed in the Simplicissimus, the sensational and extraordinary, he was able to offer the audiences in the Cabaret Voltaire. The dancer Marietta, star of the "Simpl," who had moved to Switzerland, also performed there.[3] In the Dada Gallery, opened in the spring of 1917, painters from Munich were exhibited more often than any others, with the exception of the Zurich residents. The separate exhibition of works by the *Münchener* Paul Klee in May 1917, initiated by the Swiss critic Waldemar Jollos, is particularly noteworthy.

Another one of Dada's roots in Munich was the magazine with the provocative title *Revolution,* five issues of which were published by Heinrich F. S. Bachmair before the outbreak of the war. Some of the people who worked on this magazine, edited by Hans Leybold, later became Dada protagonists in Berlin: besides the Munich literary figures Erich Mühsam and Johannes R. Becher, the authors included Richard Huelsenbeck and Franz Jung, who edited the fifth issue of *Revolution* as a special edition for the release of his friend, the psychoanalyst Otto Groß.[4]

But Munich could only have developed into a center of Dadaism through Hans Richter's activities in April 1919. Well before this, however, Richter presented his first big exhibition in Hans Goltz's Galerie Neue Kunst in Munich. Furthermore, through his work for the Berlin periodical *Die Aktion* (**fig. 3.2**), Richter would have been able to meet people such as Ernst Toller, Erich Mühsam, Heinrich F. S. Bachmair, Georg Schrimpf and Alfred Wolfenstein (**fig. 3.3**), who were later leading figures in the Munich Republic of Workers' Councils and members of the Revolutionary Council of Artists. In Swit-

zerland Hans Richter had already formed links to socialist and anarchist circles, and belonged to the political wing of the Dada community. For this reason, he worked on several occasions with Hugo Ball, who commissioned him to design the title vignette for Ball's book *Zur Kritik der deutschen Intelligenz,* which was published in 1919 by the Bern publisher Freie Verlag. A copy exhibited in Zurich in 1985 bears a handwritten dedication to the socialist youth leader and personal assistant to Kurt Eisner, Felix Fechenbach, and reads, "For Mr. Fechenbach with friendly greetings, Hugo Ball."[5] This dedication alone would suggest a link between the artists in Zurich and the political events in Munich. But the hypothesis is also supported by other facts. The contact between Hans Richter and Bavarian politicians may have come about at the International Workers' and Socialists' Conference for the Reconstruction of the Second International in February 1919, in Bern, at which Kurt Eisner was the dominant personality.[6]

According to Richter himself, he was commissioned by René Schickele, the editor of the pacifist journal *Die Weißen Blätter,* in which Wolfenstein and Burschell also published, to make portraits of the participants—although no illustrations appeared in this journal during 1918–19.[7] It was probably his own political interest that took him to this conference, at which Eisner convinced even former wartime enemies with his peace policy. It is not unlikely that in the intervals of this conference there were conversations between Richter and the young Socialist leader Ernst Toller, both contributors to *Die Aktion.* Two months later, they were to champion jointly the Republic of Workers' Councils in prominent positions in Munich.

Soon after the conference, Richter left for Munich. His stay there fell within the period overshadowed by the assassination of Kurt Eisner; it is not known how long he stayed. It is very likely that he made contacts with revolutionary-minded artists and politicians on this occasion. On 13 March 1919, Hans Richter wrote to Tristan Tzara from the Continental Hotel in Berlin, "Time is flying past here. Since Munich I have

been out of touch with you. Didn't you receive my letter? How far along is the book? Please let me know. Adieu."[8]

In Berlin, Richter probably met with members of the November Group, among them perhaps Raoul Hausmann, who calls him his friend in letters to Tzara.[9] In the sixties, at any rate, Richter claimed to have been a member of the November Group from the start.[10] After his stay in Berlin, he returned to Switzerland. There, he was concerned with the founding of the Bund Radikaler Künstler (League of Radical Artists) and of a periodical titled *Zürich 1919*. However, this publication never appeared, as Marcel Janco reports: "In 1956, I think it was, I took the only copy of the periodical *Zürich 1919* to Arp, the first issue, which our radical group had prepared for publication, but which did not appear, because of your hasty departure for Munich."[11]

Richter's departure can be dated fairly accurately, since he took part in the eighth Dada soirée on 9 April 1919 in Zurich. Among his baggage was a manifesto of the Radical Artists, which was published in several Swiss periodicals in

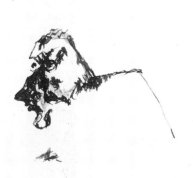

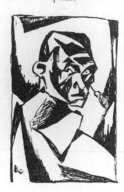

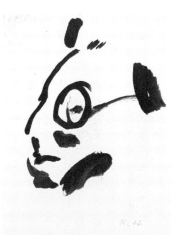

3.1
*Portrait of Hugo Ball*, 1917
Pen drawing with ink over pencil,
18.5 × 16 cm

3.2
Cover of *Die Aktion*, 1916, Hans
Richter issue
Photo courtesy of Marion

3.3
*Dada-Kopf* (Alfred Wolfenstein), 1917
Watercolor on paper, 26.7 × 20.3 cm
Neuberger Museum of Art, Purchase

May of 1919.[12] His journey is also documented by a letter of 19 April 1919, from his friend Ferdinand Hardekopf to Olly Jacques: "I wrote a few lines to Mrs. E[lisabeth] Richter: asking about when she expects Mr. Hans back, and saying that you would be glad to put her up in Muzzano.—The Richters intend to settle in Munich, Serner confirmed to me. Richter's latest journey there was due to a telegram of his artistico-political friends there (Munich), saying he should come, that his presence is necessary. (Probably these are people whom he made friends with during his first stay in Munich.) Thereupon he left for Munich again."[13]

Who were Richter's artistic/political friends in Munich? According to Hans Richter's brother Richard, at that time a student at the University of Munich, he came there at the request of Dr. Max Levien, who was a member of the Executive Council during the Communist Republic of Workers' Councils (13–27 April 1919). He was also a founding member of the Communist Party of Germany (KPD) in Munich, and had lived in Zurich as a student.[14] But Richter may also have made Levien's acquaintance in Germany. In addition, there were other people whom Richter had met in Switzerland who were already living in Munich and actively supporting the Republic of Workers' Councils. These included the Russian envoy, Tovia Axelrod,[15] and above all Frida Rubiner,[16] the wife of the poet Ludwig Rubiner, for whose periodical, *Zeit-Echo* (**fig. 3.4**), Richter made antimilitaristic prints in Switzerland in 1917. Rubiner, who was corresponding with Erich Mühsam at the time, tried to win Richter's sympathy for his political aims. "Rubiner introduced me to several anarchist groups and such. He was politically oriented and didn't have anything much to do with Dada as such. He disliked it."[17] Under Rubiner's influence, Richter turned increasingly to politics. In his art, he devoted himself beginning in 1917 to the topics of war and revolution in particular (**fig. 3.5**).[18] The Rubiners returned to Germany in February 1919, and moved to Berlin, where they both joined the Communist Party early in 1919. While Ludwig Rubiner took a job as an editor at the Kiepen-

heuer publishing house, his wife went to Munich on assignment for the Party.[19] Dr. Frida Rubiner joined the editorial staff of the Munich *Rote Fahne* (Red Flag), and worked in the Propaganda Committee of the Republic of Workers' Councils under the nom-de-guerre "Friedjung." She is later reported to have said in court that she had been received with open arms by all Communist leaders upon her arrival in Munich on 9 April 1919, because of her good reputation, and that it would only have cost her a word to be given the post of a minister of education and culture or similarly prominent position by the Communist leadership.[20]

The members of the Action Committee of Revolutionary Artists must have considered Hans Richter, who arrived in Munich from Switzerland shortly afterward, of similar importance. Richter appeared in public as the spokesman and chairman[21] of this organization several times in April 1919. His joint statement with Titus Tautz[22] of 16 April 1919, in which they emphasized the idealistic motives of the Action Committee, is especially interesting.[23]

The earliest evidence of Hans Richter's presence in Munich is probably his letter to Tzara of 12 April 1919. Richter writes, "Dear Master Dada, Enclosed find the sole linocut I have to send to you. My wife has the article, and is supposed to send it to you at once. Please print it on my page if at all possible—but only without cuts. Au revoir, Yours, Hans Richter. My greetings to Dr. Serner."[24]

The publication to which Richter refers here can only be *Dada 4/5,* which appeared in Zurich on 15 May 1919. The linoleum block print by Richter published there, which was later entitled *Dada-Kopf,* is thus presumably the only Dada work he produced in Munich (**fig. 3.6**).

**Hans Richter in the Action Committee of Revolutionary Artists of Munich**

If we may believe the description by Oskar Maria Graf in his novel *Prisoners All,* a revolutionary council of artists was established in Munich in 1919 as part of the Central Council, in reaction to the murder of the prime minister of the new Commonwealth of Bavaria, Kurt Eisner, on 21 February 1919.[25]

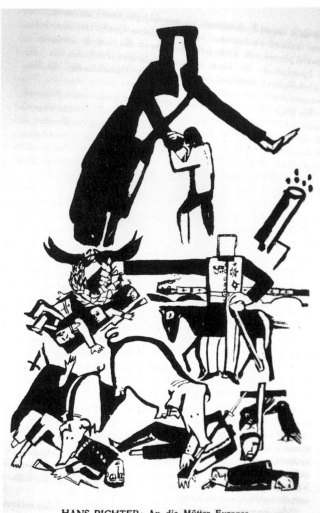

HANS RICHTER: An die Mütter Europas

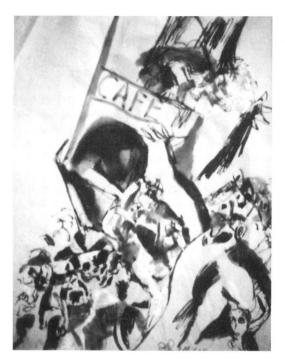

On 7 April, the Republic of Workers' Councils of Bavaria was proclaimed by supporters of the Independent Social Democratic Party (USPD), the Social Democratic Party (SPD), and the anarchists. The People's Commissar for Popular Enlightenment, the author Gustav Landauer, appointed the Action Committee of Revolutionary Artists of Munich as an executive body for his program of cultural policy; the Committee retained this function after the Communists took power on 13 April 1919. Although Richter had only come to Munich in early April, he rapidly became one of the leading elements of the Action Committee, presumably thanks to his reputation as an important avant-garde artist.

The name of Hans Richter appears in connection with the Action Committee for the first time as a signatory to the "Reply of the Action Committee of Revolutionary Artists to the appeal of Russian progressive painters and sculptors to their German colleagues." The date of publication, 9 April 1919, indicates his links to Munich before April.

The new Russian government has called on all young creative forces to help establish a new life, and entrusted government direction in matters of art to these movements. For only the new creative work that began shortly before the events that shook the world can be in harmony with the rhythm of the newly formed life.

There is finally a chance for joint creative work that transcends narrower national awareness, and will serve an international commerce. The Russian artists turn first to their nearest neighbors, their German colleagues, and call on them to join in consultations and an exchange of news within the scope of the artistically possible. As a practical measure for implementing such relations, we propose a congress of representatives of the German and Russian artistic communities, which would form the beginning of a later world conference of art, and which should immediately initiate a commerce in the artistic sphere be-

tween the two peoples, extensive activities in the fields of exhibitions, publishing, the theater, and music as well. Moscow, 30 November 1918. Signed, D. P. Sterenberg, chairman of the college of artists in Petersburg and Moscow, signed [signatures of members of the International Bureau of Painters].

The Action Committee of Revolutionary Artists answers the above appeal, which only reached Germany recently, as follows:

We welcome the appeal of our Russian brethren of November 1918 to build a new life. With the proclamation of the Bavarian Republic of Workers' Councils, we want to create the possibility of realizing our plans, which coincide entirely with yours. We hope for joint work, and will strive to establish links with you soon. We wish to see the conference announced take place, and look forward to an announcement of the time and place soon.

The Action Committee of Revolutionary Artists of Munich: Heinrich Bachmair, Max Bethke, Friedrich Burschell, W. Ludwig Coellen, Georg Kaiser, Walt Laurent, Otto Lerchenfeld, Wilhelm Petersen, T. C. Pilartz, Hans Richter, Fritz Schaefler, Georg Schrimpf, Felix Stiemer, Stanislaus Stückgold, Titus Tautz, E. Trautner, Aloys Wach, Alfred Wolfenstein.[26]

The Action Committee covered a wide ideological spectrum, including Christians, utopian and other socialists, communists, and what we might call yippies and new-agers as members, and could not be considered the organ of any single party. What the members did have in common was the demand for a radical democracy, for a republic of workers' councils and the elimination of a capitalist system that could produce world wars. How little uniformity of opinion there was within the Action Committee is demonstrated by two declarations published at an interval of two days in the bulletin of the Executive Council of the Workers' and Soldiers' Councils:

> The Action Committee of Revolutionary Artists proclaims that it alone should be considered the representative of the artists of the city of Munich and of all Bavaria. It takes its stand on Communist principles, and recognizes the dictatorship of the proletariat as the true and sole path to implementing the proletarian republic of workers' councils and communism. (Signed:) Bethke, Georg Kaiser, Titus Tautz, Schrimpf, Pilartz, Schaefler, Schiner, Burschell, Sachs, Coellen, Wolfenstein, Wolf-Ferrari, Laurent, Trautner, et al.[27]

This was succeeded, only two days later, by the following statement:

> Revolutionary Artists' Council: The declaration of revolutionary artists published in the *Mitteilungen der Betriebs- und Soldatenräte* was not submitted in this form, and does not correspond to the wishes of the Action Committee of Revolutionary Artists. We declare: We are not the representatives of the Munich, Bavarian, or any other artists who belong to the capitalist age, we are the representatives and plenipotentiaries of an idea, and our goal is to participate in practice in the establishment of the new community and its intellectual development. We call on all who are of the same mind to help us. We expect this of our generation, not of the representatives of the older generation, who cannot help us. For the Action Committee of Revolutionary Artists: Richter and Tautz.[28]

Titus Tautz wrote later, concerning the apparently contradictory articles, "Of course, there were differing views that sought to avoid any uniformity. . . . There were almost certainly no narrow dogmatists, the ideological boundaries were fluid, but the common ground of the Left predominated. . . . The Artists' Council did not advocate any Bavarian particular-

ism, but quite rightly the establishment of the new social order!"[29]

The disparate interests of those involved in the Action Committee of Revolutionary Artists is also found in Richter's own influences. Richter presented the Zurich artists' manifesto, which he had brought with him, to the Munich artists as a possible aesthetic and theoretical basis for their work in the Action Committee. A section of the minutes of the meeting of 22 April 1919, reads, "Set agenda for Wednesday; Zurich manifesto to be read on that day—guideline revolutionary, radical, or not."[30] However, Richter had a dual purpose for his use of the Zurich Manifesto. In the first instance he wanted to ally the Action Committee with contemporary German revolutionary groups, who were interested in a radical redefinition of art and life.

> Manifesto of radical artists of Zurich. Deep, unified points of view must prevail if great decisions with long-term effects are to be made. Intellectually and materially, we present the following demands: We artists, as representatives of an essential part of the total culture, want to place ourselves in the midst of things, and share in taking responsibility for the coming development of ideas in the state. This is our right. We proclaim that the artistic law of motion of our era has already been comprehensively formulated. The intellectuality of an abstract art (see Program of Implementation) means a tremendous expansion of humanity's feeling of freedom. The objective of our beliefs is fraternal art: a new mission of humanity in community. Art in the state must reflect the spirit of the whole body of the people. Art compels clarity, should form the foundation of the new man and belong to each individual and no class; we want to gather the conscious power of the productive force of all individuals in the performance of their mission into unified achievement. We oppose energy-wasting unsystematical activity. Our foremost

viewpoint: striving for a universal basis for the intellectual purview. That is our duty. Such work guarantees the people the highest human values and unimagined possibilities. The initiative belongs to us. We will give expression to the mighty currents, and a perceptible direction to the scattered efforts.

(Signed:) Arp, Baumann, Eggeling, Giacometti, Hennings, Helbig, Janco, Morach, Richter. Radikale Künstler, Minervastrasse 97, Zurich.[31]

In the Zurich manifesto, demands are presented that are also to be found in other manifestos of this revolutionary period in Germany. The November Group's "Manifesto of the Novembrists"; the manifesto of the Arbeitsrat für Kunst; Pechstein's "Was wir wollen" (What We Want); Coellen's "Die neue Kunst" (The New Art); and Tautz's "Die Kunst und das Proletariat" (Art and the Proletariat) were all roughly contemporary. The political upheavals in Europe led to a demand for intervention in cultural policy by radical artists, for they now wished to share in responsibility and decision-making, and this, of course, required a certain degree of autonomy of artists from the government. What specific forms of organization and what authority the intellectual worker ought to have was not stated in the Zurich Manifesto—perhaps this was because political conditions remained stable in Switzerland in 1919, and being more specific would have sounded too utopian.

All the manifestos of the years 1918–19 mentioned above shared the concept of building a new human community. In this, the gap between workers and artists was meant to disappear; the new self-confidence of the worker should lead him to creative activity. Additionally, art and handicrafts were to establish a new relationship.

However, certain aspects of the Zurich manifesto clearly distinguish Richter's goals for the Action Committee from that of his above-mentioned contemporaries. In this second instance Richter used the Zurich Manifesto for its distinctive embrace of abstraction. The Manifesto of the Radical

Artists of Zurich differs from numerous other manifestos of revolutionary artists in 1918–19 in proclaiming the principle of abstraction as an emancipatory force, an extension of the human realm of freedom, and as a universally valid form: "The intellectuality of an abstract art . . . means a tremendous expansion of humanity's feeling of freedom. The objective of our beliefs is a fraternal art: a new mission of humanity in community."[32] The ideas of liberty and socialism were to be combined in abstract art. One can only speculate whether Hans Richter would have created political art by abstract means, in the style of the Russian constructivists, if the Republic of Workers' Councils had survived longer.

The scope of the Action Committee's activities in Munich in 1919 was very broad. As part of the Central Council, it was entrusted with almost all cultural responsibilities: the promotion of new art, the abolition of the bourgeois press monopoly, the reorganization of the art schools, the revolutionizing of the theater, the socialization of the movie theaters, the elimination of the shortage of artists' studios, and the confiscation of the *Residenz* (the royal palace and official residence), the Nymphenburg porcelain manufactory, the Schack gallery, the Villa Stuck, the Maximilianeum, etc., for social welfare needs. According to a transcript of the minutes of 22 April 1919, the Art Commissariat of the Action Committee consisted of the following persons: painting: Richter, Schäfler, Klee, Eggeling, Campendonk, Laurent, Holzer; commercial art: Schrimpf, Sachs; sculpture: Pilartz; exhibitions: Stückgold; architecture: Hansen, Janes.

During the period of the Republic of Workers' Councils, Richter championed in particular the restructuring of the School of Commercial Art (Kunstgewerbeschule). Hermann Esswein wrote in the *Münchner Post,* a daily newspaper sympathizing with the Social Democrats:

> The large shift to the left, the rule of the Communists, has now also given the most radical wing of the artists currently debating in Munich their chance, and I must admit

frankly that the spokesman of the Communist artists' commission, a Mr. Richter from Zurich as I understood it, pleased me better than the group discussed above. A clear standpoint, a definite Yes or No, is very valuable. And while there is no reason as yet to discuss certain demands and plans of Mr. Richter, the like-minded H. C. Pillarz, and their patrons in public, the main matter in whose name these gentlemen have come does merit a few words of explanation. The gentlemen spoke in the name of Expressionism, asserted the claims of the New Art, and of the young intellectual-revolutionary generation inspired by it. Can our Kunstgewerbeschule honor these claims?[33]

The journalist Esswein's idea that the widely propagated proletarian New Art should be equated with expressionism can be explained only as his own historical limitation, for it was Hans Richter in particular who attempted to oppose the subjectivity of expressionism with an objectivity of abstract forms. It is documented that Richter and the American Hermann Sachs, a member of the Action Committee of the Kunstgewerbeschule, wanted to speak to Levien about reforming this school, but did not manage to meet him.[34]

As chairman of the Action Committee, Richter also applied himself forcefully to a transformation of the entire system of colleges of art. In connection with this plan, he proposed that Marcel Janco and the systematist of an abstract language of imagery, Viking Eggeling, be made professors of the Munich Academy of Art.[35] For this purpose, Richter had brought works by these two with him to Munich. In a letter to Marcel Janco of 19 April 1919, with the letterhead "Action Committee of Revolutionary Artists, Parliament Building, Prannerstraße, Munich," Richter reports, "The Action Committee of Revolutionary Artists of Munich voices its full agreement with the painters Viking Eggeling and Marcel Janco on the basis of the works present, and requests that

they accept the membership which is offered to them unanimously. [Signed], Hans Richter, Chairman of the Action Committee of Revolutionary Artists."[36]

Either Eggeling had received a similar letter, and thereupon went to Munich, or he was already in the city. At any rate, two documents suggest that Viking Eggeling was in Munich in 1919. First, the transcript of the minutes of the meeting of 22 April, which contains a list of the people in the Art Commissariat, with Eggeling listed in the Painting section. Since, as far as we know, all the artists and architects listed there were living in Munich at that time, it is presumably true of Eggeling as well. The second indicator is found, surprisingly, in a text by El Lissitzky. In a necrological appreciation of Eggeling in the *Nachrichten der ASNOWA,* he wrote:

On May 19th, Vicking [*sic*] Eggeling died in Berlin. I first heard his name one night in 1920 in a room in the Lux (the hotel used by the Komintern) from a young German comrade who had just succeeded in getting through all the cordons to us. This was the first news from the West after six years of isolation. When telling me about Einstein and Spengler, he mentioned Eggeling, whom he had met in Munich during the days of the brief life of the Bavarian Republic of Workers' Councils. Eggeling, he explained, had discovered "absolute" film, was still working on it, and wanted to turn to Russia in order to obtain support for his work there.[37]

In 1919, from their theoretical concern with an abstract language of images, Eggeling and Richter developed a syntax of elementary shapes that was meant to be applicable to a wide variety of media. A new visual system of communication was to be developed for the new society. However, the artists were not able to realize this project in Munich.

After the army of mercenaries sent by bourgeois and conservative forces seized Munich on 1 May, many artists

who were members of the Action Committee were arrested and imprisoned for their significant political role in the Republic of Workers' Councils. For this purpose, the *Bürgerwehr* (home guard) searched all artists' studios in Schwabing, the artists' and university quarter.[38] Due to his prominent position in the Republic of Workers' Councils, Hans Richter was detained at the beginning of May. He himself never told about his political involvement and subsequent detention in Munich, but it is documented by several sources. The records of the "Hostage Murder Trial" before the *Volksgericht* mention in passing, "The chairman of the Rev. Artists' Council was a Mr. Richter from Zurich, last resident in the Hotel Vier Jahreszeiten. (Currently under arrest in the Corneliusstraße.)"[39] Furthermore, Richard Richter, who was also arrested, related that his brother had been sentenced to five years in prison because of his leading position in the Munich Republic of Workers' Councils.[40] Richter's friend, the author Ferdinand Hardekopf, wrote to Olly Jacques on 6 May: "Yesterday evening I spoke at length to Mrs. Elisabeth Richter. She is anxiously expecting Hans Richter back, who, according to a telegram from Ehrenstein in Vienna, will return to her via Austria."[41] Richter's mother, who came from one line of the Rothschild family, had influential friends among the judiciary, he reported, who had effected her son's release after two weeks' imprisonment. Since he was a Prussian, he was deported as an undesirable alien, in accordance with an order of the city military command. Hans Richter was given a new passport, and returned to Switzerland in June 1919.

**Notes**

1. Cf. Wassily Kandinsky and Franz Marc, *Der Blaue Reiter (1912)* (Munich: Piper, 1984), 125, 132, 189, 191.

2. Cf. Raimund Meyer, *Dada in Zürich: Die Akteure, die Schauplätze* (Frankfurt am Main: Arche, 1990), 15.

3. Ibid., 33. An important component of the Dada soirées was the performances of the dancers Sophie Taeuber, Katja Wulff, and Suzanne Perrottet from the Laban School. Rudolf von Laban first set up a summer school of his Munich school of

Hoffmann

dance improvisation in Ascona, Switzerland, before founding a school in Zurich in the spring of 1916.

4. Otto Groß's father had him committed to a mental hospital. The campaign against this detention, which was based on an expert opinion by C. G. Jung, among others, was championed by the periodicals *Kain* and *Die Aktion;* see also Hanne Bergius, *Das Lachen Dadas: Die Berliner Dadaisten und ihre Aktionen* (Gießen: Anabas, 1989), 68.

5. Cf. Hans Bolliger, Guido Magnaguagno, and Raimund Meyer, *Dada in Zurich* (Zurich: Arche, 1985), 186.

6. During World War I, socialist politicians from various countries who opposed the war had been meeting since 1915. In September 1915, Lenin, Radek, and Ledebour met in the Swiss village of Zimmerwald to proclaim international workers' solidarity. This grew into the "Zimmerwald Movement." In the tradition of these conferences, socialist politicians came to Bern in February 1919 to take part in the International Workers' and Socialists' Conference for the Reconstruction of the Second International. However, the original anti-war unity had already been lost by that time. The Communist Party of Germany (KPD), which called for a new, "Third International," explicitly rejected this meeting. The leadership of the Independent Socialist Party of Germany (USPD), on the other hand, decided to participate in the reconstruction of the old International, in conformance with the party's politically Western orientation, and against the views of a large part of its followers. Because of this internal conflict, Hugo Haase, the chairman of the party, left Bern before the conference had even begun. He was replaced by Kurt Eisner. This turned out to be a fortunate choice, because through his eloquence, Eisner succeeded in preventing the first meeting from splitting. He drew up a compromise proposal that enabled the conflict over who was guilty of starting the war to be resolved. Eisner's draft motion was accepted by the conference with only one dissenting vote. He also succeeded in persuading the French Socialist leader Pierre Renaudel to back a declaration on solving the prisoner-of-war question. The unanimously adopted Eisner-Renaudel resolu-

tion was the first joint German-French statement since the end of the war.

7. Hans Richter, quoted in *Hans Richter: Opera grafica dal 1902 al 1969* (Pollenza: La Nuova Foglio, 1976), 298–302.

8. Hans Richter, letter to Tristan Tzara, 13 March 1919, in "Thirty-three Letters, Telegrams and Cards from Hans Richter to Tristan Tzara and Otto Flake (1917–1926)," in *New Studies in Dada: Essays and Documents,* ed. Richard Sheppard (Driffield, UK: Hutton, 1981), 131.

9. Raoul Hausmann, postcard to Tristan Tzara, 19 February 1919, in "Nineteen Letters, Telegrams and Cards from Raoul Hausmann to Tristan Tzara (1919–1921)," in *New Studies in Dada,* 110.

10. Hans Richter, unpublished letter to Helga Kliemann, not dated (intended for Helga Kliemann's publication *Die Novembergruppe,* Berlin, 1969).

11. Marcel Janco, letter to Hans Richter, 27 May 1963, in Hans Richter, *Begegnungen von Dada bis heute* (Cologne: DuMont Schauberg, 1973), 12.

12. It appeared first in the arts section of the *Neue Zürcher Zeitung,* no. 655 (4 May 1919).

13. Ferdinand Hardekopf, letter to Olly Jacques, 19 April 1919, in Richard Sheppard, "Ferdinand Hardekopf und Dada," *Jahrbuch der Deutschen Schillergesellschaft* 20 (1976): 144 ff.

14. Heinrich Hillmayr, *Roter und weisser Terror in Bayern nach 1918* (Munich: Nusser, 1974), 187.

15. Richter mentions the little-known Russian revolutionary Axelrod twice in the same breath with Lenin, and reports that he heard Axelrod speak at a meeting in Bern. Cf. Hans Richter, *Begegnungen von Dada bis heute,* 96, and Hans Richter, letter to Richard Sheppard, 13 April 1975, 1. Archive of Mrs. Mupacker.

16. As we know from Hugo Ball, Frida Rubiner was one of the guests at the opening ceremony for the Dada Gallery in Zurich. Cf. Hugo Ball, *Die Flucht aus der Zeit* (Lucerne: J. Stocker, 1946), 145.

17. Hans Richter, *The World Between the Ox and the Swine: Dada Drawings by Hans Richter* (exh. cat., Providence: Rhode Island School of Design, Museum of Art, 1971), 42 f.

18. Richter's change of opinion is further confirmed in a text by Marcel Janco: "Of all the painters and sculptors, he was the only one who attended the 'literary' Dada evenings, but soon he also sensed the ridiculous and scandalous side, the intellectual weakness of these quixotries without sense or belief. At that moment, he made an about-turn, and became an active socialist, under the influence of some friends." Cf. Marcel Janco, "Dada-Erinnerungen 1966," *Du* (September 1966): 745.

19. Cf. Ludwig Rubiner, *Kameraden der Menschheit,* ed. Hans-Otto Hugel (Stuttgart: Akademischer Verlag, 1979), 180.

20. Cf. Munich Staatsarchiv, StAnw. Mü. I, 2877. Frida Rubiner was arrested in early May 1919 after someone informed against her. She was released in July and deported from Bavaria. After her husband's death in 1920, she lived with the composer Felix Holländer. In the twenties, she continued to be active in the Communist Party. In March 1925, she edited the pamphlet *Sowjetrußland von heute,* which was published by the *Rote Fahne.* In a letter from Hans Richter to Richard Sheppard of 7 March 1975, he writes that while shooting his motion picture *Metall* in the Soviet Union in 1932, he frequently met Frida Ichak (she had resumed her maiden name in the meantime) in Moscow.

21. Cf. the transcript of a statement by Otto Scheiner and Karl Schlawo before Munich prosecutors, 5 May 1919, in the Munich Staatsarchiv, StAnw. Mü. I, 2894a.

22. Titus Tautz was one of the acquaintances of Huelsenbeck and Hausmann. The first press release by the Club Dada in Berlin, printed in the *Vossische Zeitung* of 27 January 1918, listed him as a member of this group. Tautz was active in the anti-war movement in Germany. Together with Raoul Hausmann, Franz Jung, Ernst Neumann, Paul Guttfeld, Oskar Maria Graf, and Georg Schrimpf, he arranged for the illegal distribu-

tion during the First World War of Lichnowsky's publication, *Meine Londoner Mission 1912–1914*. Cf. Hanne Bergius, *Das Lachen Dadas*, 24. During the Republic of Workers' Councils, Tautz edited the newspaper *Münchner Neuesten Nachrichten.*

23. Hans Richter and Titus Tautz, "Revolutionärer Künstlerrat . . . ," in *Mitteilungen des Vollzugsrats der Betriebs- und Soldatenräte* (16 April 1919), repr. in Max Gerstl, *Die Münchener Räterepublik* (Munich: Verlag der "Politischen Zeitfragen," 1919), 64.

24. Hans Richter, letter to Tristan Tzara, 12 April 1919, in "Thirty-three Letters, Telegrams and Cards from Hans Richter to Tristan Tzara and Otto Flake (1917–1926)," in *New Studies in Dada,* 132.

25. Oskar Maria Graf, *Wir sind Gefangene* (Munich: Drei Masken, 1927), 456 ff. English translation by Margaret Green, *Prisoners All* (New York, 1943).

26. "Aktionsausschuß revolutionärer Künstler Münchens: Aufruf der russischen fortschrittlichen bildenden Künstler an die deutschen Kollegen," *Münchner Neueste Nachrichten,* no. 162 (9 April 1919): 3.

27. Gerstl, *Die Münchener Räterepublik,* 63.

28. Ibid., 70.

29. Titus Tautz, letter of 10 December 1978.

30. Cf. the transcript of the minutes of a meeting of the Action Committee of Revolutionary Artists of Munich in the parliament (Landtag) building in Munich, 22 April 1919; Reese Collection, Manuscript Division, Library of Congress, Washington, D.C.

31. "Radikale Künstler, Zürich: Manifest," *Neue Zürcher Zeitung,* no. 655, 4 May 1919.

32. Ibid.

33. Hermann Esswein, "Das Schicksal der Kunstgewerbeschule," *Münchner Post,* no. 99 (29 April 1919): 2.

34. Transcript of the minutes of a meeting of the Action Committee of Revolutionary Artists of Munich, in the parliament building in

Munich, 22 April 1919; Reese Collection, Manuscript Division, Library of Congress, Washington, D.C.

35. Cf. n. 11.

36. Hans Richter, letter to Marcel Janco, Munich, 19 April 1919, repr. in Marion von Hofacker, "Biographische Notizen über Hans Richter 1888–1976," in *Hans Richter 1888–1976: Dadaist, Filmpionier, Maler, Theoretiker* (exh. cat., Berlin: Akademie der Künste, 1982), 56.

37. El Lissitzky, "Viking Eggeling" (first published in *Nachrichten der ASNOWA*), in *El Lissitzky, Proun und Wolkenbügel: Schriften, Briefe, Dokumente* (Dresden: Verlag der Kunst, 1977), 205 ff.

38. Graf, *Wir sind Gefangene*, 506.

39. Cf. the transcript of a statement by Otto Scheiner and Karl Schawo to the Munich prosecutors, 5 May 1919, in the Munich Staatsarchiv, StAnw. Mü. I, 2894a.

40. Marion von Hofacker, conversation with Richard Richter, referred to in Marion von Hofacker, "Biographische Notizen über Hans Richter 1888–1976," 57.

41. Richard W. Sheppard, "Ferdinand Hardekopf und Dada," in *Jahrbuch der Schiller-Gesellschaft* 20 (1976): 148.

JUSTIN HOFFMANN

# Hans Richter: Constructivist Filmmaker

translated from the German

by Michaela Nierhaus

Generally, the films Hans Richter made from 1921 to 1927 are regarded as Dada.[1] This may seem a little odd at first glance, considering that according to art historical sources Dada only lasted until 1923. Hans Richter had lost close contact with the Dada movement by 1919, after his sudden departure from Zurich. The reason that his second abstract film (*Rhythmus 23*) was shown in July 1923 at the final Dada event in Paris, the "Soirée du Coeur à Barbe," was his friendship with Tristan Tzara. Other films shown that evening, e.g., documentary films by Paul Strand and Charles Sheeler, also cannot really be classified as Dada. Nonetheless, Rudolf E. Kuenzli tries to classify Richter's abstract films as Dada by coming to the (not unjustified) conclusion that there were two artistic streams in Dada: on the one hand, the provocative destruction of conventional artistic trends and, on the other hand, the reformation, in a productive sense, of the elements

yielded by this destruction. Thus, in Berlin and Zurich, Dada and constructivism were closely related.[2]

There are, of course, links and transitions. However, not every creation containing elementary, abstract forms (cf. Hans Arp, Marcel Janco) qualifies as constructivism. Constructivism is characterized by the systematization of forms in an anti-individualistic sense, a fixed syntax, and a logical composition. Richter and Viking Eggeling's efforts to develop an abstract language of forms cannot be explained by Dada, but rather strikingly coincide with similar attempts in the Netherlands (De Stijl, from 1917) and in Russia (suprematism, from 1915), despite the fact that the Great War prevented interchange between artists. Nonetheless, Hans Scheugl and Ernst Schmidt, Jr., maintain that Richter's Dada tendencies are best seen in his 1927 film *Vormittagsspuk* (Ghosts before Breakfast).[3] A Dada film that appeared four years after the demise of the movement seems a strange anachronism. Indeed, the animistic motifs and the dream sequences of this film point more to surrealism than to Dada. Scheugl and Schmidt state that there is no such thing as a constructivistic film. On the other hand, they concede that Richter's and Eggeling's films were produced according to constructivistic principles.[4] That these are simply single cases does not justify refuting their stylistic classification as constructivism, as indeed documents and sources from the 1910s and 1920s on Richter's oeuvre confirm.

Richter began turning away from the ideas and style of expressionism in 1917. During this period, he remarked to Claire Goll, "I want to paint completely objectively and logically, . . . according to principles like those in music, with long and short note values."[5] In his search for a visual sign language, he came upon music as an analogous system. In Zurich, he met the composer and musicologist Ferruccio Busoni, whom he had already admired as a student in Weimar. In their discussions, it became clear to Richter that his black-white experiments with positive and negative forms corresponded to the principle of counterpoint. Another significant

influence was Sophie Taeuber's work: "In my endeavor, at that time, to find the elements of a sign and picture language, Sophie's contributions were always very stimulating."[6] Even more decisive, however, was meeting the Swede Viking Eggeling. Richter had the impression that Eggeling was pursuing similar goals with lines as he himself was with opposite pairs of planes. However, Eggeling had already succeeded, according to Richter, in "setting up a whole syntax of form elements, when I was just starting with the ABC."[7] The elementarization of representational art was a fringe development of Zurich Dada. The destructive and action aspects of Dada did not interest Richter: a position that was not contradictory, for Dada, unlike cubism, was not a style but a movement. Its unifying factor was the fight against artistic conventions. This experimental phase was the spawning ground for many subsequent art concepts.

After vainly fighting for the cultural and political goals of the Munich *Räterepublik* and being jailed for two weeks for his efforts in 1919, Richter brought Eggeling to his parents' estate in Klein-Kölzig, Nieder Lausitz, Brandenburg, without contacting the Dadas in Berlin. The collaboration between the two artists grew more intense here, and together they developed the concept of a universal language.[8] Because it was impossible to exercise any influence on contemporary sociocultural conditions, they focused their interests on a utopian plane. Their premise was a new system of communication based on visual perception. Richter and Eggeling soon reached a point in their experimentation where they noticed that the elements of plane and line could assume a specific relationship to each other and thereby render a certain continuity. This continuity prompted them decisively to introduce the term *language*. "Every person would have to react to such a language and for the very reason that it was based on the human ability to see and record."[9]

In 1920, Richter and Eggeling drafted a proclamation entitled "Universelle Sprache" (Universal Language), sending this eight-page-long exposition to various influential

people. Unfortunately, there is no extant copy of this important manifesto of abstract art.[10] Referring to "Universelle Sprache," Richter wrote:

> This pamphlet elaborated our thesis that abstract form offers the possibility of a language above and beyond all national language frontiers. The basis for such language would lie in the identical form perception in all human beings and would offer the promise of a universal art as it had never existed before. With careful analysis of the elements, one should be able to rebuild men's vision into a spiritual language in which the simplest as well as the most complicated, emotions as well as thoughts, objects as well as ideas, would find a form.[11]

The best impression of the "Universelle Sprache" can be found in an article entitled "Prinzipielles zur Bewegungskunst" that appeared a year later in the journal *De Stijl*.[12] This article already addressed kinetics as a possible means of representation.

Richter and Eggeling called their drawing studies *Orchestrations*. They were struck by the similarity between their work and Chinese characters.[13] The Far East may also have inspired the two artists to copy their picture symbols onto long strips of paper in order to develop a theme in various steps, as in music. Music was also the source of the titles of the works *Präludium* (**fig. 4.1**) (Richter) and *Horizontal-Vertical-Orchester* (Eggeling). Single moments of these picture rolls were printed in issues of *De Stijl*. A person looking at one of these picture rolls follows the individual phases of a theme, comparing and stimulating active perception. The eye has to recall the form if it wants to record the process of development. Yet nothing actually moves on Richter's and Eggeling's picture rolls. Depicting single phases of a process, they automatically suggest a sense of time. Although the picture does not move, the viewer's eye does. In order to proceed with their experiments with time and motion to visual representa-

tion, it was natural that the two artists would turn to the medium of film.

The financial backing of a wealthy neighbor, the banker Dr. Lübeck, allowed them to realize their first film experiments in the trick film studios of the UFA (Universum Film A.G.) in Berlin.[14] Richter and Eggeling soon realized how little they knew about film techniques; transforming their complicated abstract drawings into visible motion proved to be much more difficult than they had anticipated.[15] They did produce a number of test film strips of which one, the filming of part of the *Präludium* roll, was later used in Richter's film *Rhythmus 23.* All told, however, the two were badly disappointed by the results of their work in the UFA studios when they saw the developed films. Richter came to the conclusion "that these rolls could not be used, as we actually had thought, as scores for films. If Eggeling did not share this opinion, I became more and more convinced with time. It seemed to me that the picture roll was an art form of its own that could not simply be considered scores and transferred to film."[16] However, the first film experiments attracted the attention of a number of artists and journalists. In 1921 Adolf Behne, a Berlin art critic and cofounder of the Arbeitsrat für Kunst (Work Council for Art), and Theo van Doesburg, editor of *De Stijl,* published Richter's and Eggeling's attempts.[17]

Van Doesburg's decision to illustrate his article with a joint work by the two artists is proof of his close collaboration with Richter and Eggeling at that time.[18] Van Doesburg's article was the result of a three-week visit to the Richter estate in Brandenburg. Shortly after this fruitful encounter, Richter began working on the film that he would later entitle *Rhythmus 21* (**fig. 4.2**).[19]

Meanwhile, it had become evident to Richter that he would have to base his film work on the vehicle of the forms— the screen or the frame—and use the film screen like the support of a painting. Giving up image depiction, Richter foregrounded the material and the affinity of film to forms: film was treated as film and no longer as a means of conveying

Hoffmann

non-filmic reality. As in onomatopoeia in poetry, the elimination of representation as a function resulted in a concentration of the medium's elementary components. The screen no longer opened like a window through which one watched what was happening, but rather became a precisely calculable form in its own right.[20] For his first film, Richter divided the rectangular screen into small sections for the purpose of orchestrating it.[21]

> These sections are the equivalent of the forms—elements that originally resulted in the rolls. So I gave up making a film of my roll *Präludium* and instead began shooting a film of several rows of paper rectangles and squares of all sizes, ranging from dark blue to white. In the rectangle and the square I had a simple form, an element, that was easy to control in relation to the rectangular shape of the screen. . . . So I made my paper rectangles and squares grow and disappear, jump and slide in well-articulated time-spaces and planned rhythms.[22]

This expanding and disappearing on a black or white background can generate immense spatial impressions on the viewer. At the beginning of the film, the picture divides into large areas of black and white. When the screen is finally covered by two white rectangles that are moving toward each other from left and right, the viewer sees himself traveling at great speed away from the opening of a high passage. Or a white square that is shrinking rapidly before a black background gives the impression of an abstract flying object that is slowly disappearing into the universe. However, black does not always represent depth and white proximity, for it is precisely the complexity of spatial illusion that interested Hans Richter in this experiment. Throughout the course of the film, varying the rectangular forms increases the ambivalence of the spatial situation, which is constantly changing. The viewer is always watching which forms determine the immediate figure-background relationship.

In order to emphasize these processes, which Richter called "Kontrast-Analogie" (contrast analogy), he used parts of a negative film in his first film, with the contrapuntal interplay of black and white being varied further.[23] In the negative film, the black, gray, and white areas have a different effect than in the positive film. In the negative, at the edges of the black rectangles there are shadows or framing fields that probably result from the overlapping papers. In the course of the film, about one and a half minutes long, the number of white, gray, and black formal elements increases. More than ten different rectangles may appear in a single picture. Toward the end of the film, two different compositions are projected over each other. The elements, therefore, not only grow or shrink but also dissolve into or penetrate each other.

Theo van Doesburg saw this film on his honeymoon in Berlin (spring 1921) and took it with him to Paris, where he showed it to some friends that same year. Anti-German sentiments were still high in France as a consequence of the First World War; as a precaution van Doesburg introduced Richter as a Dane at the premiere.[24] Meanwhile, Richter had set up

Hoffmann

a studio, and his wife, Maria von Vanselow, whom he had married during Theo and Nelly van Doesburg's stay, also had an apartment at Uhlandstrasse 118.[25] At the peak of postwar monetary inflation in 1922, the Richters lost their estate in Klein-Kölzig. During this financial crisis, Hans Richter and Viking Eggeling had a falling out about money, and each went his own way for a while. According to Richter, this difference of opinion was settled after about a year.[26] Evidence of this resolution is Richter's committed promotion of Eggeling's work in his subsequent journal *G.*

Richard Richter, the artist's brother, says that Hans Richter made small advertising films to support himself. One of these was for a florist by the name of Köschel. Richter set up a projector on the windowsill of his top-floor apartment and projected a trick film onto the sidewalk below the window. Fascinated, people stopped and finally had to be moved on by the police.[27]

In February 1922, Richter met Werner Gräff, a twenty-year-old former Bauhaus student recommended to him by van Doesburg as his best student.[28] There are various versions concerning their subsequent collaboration. Richter refers to Gräff as his adopted son whom he included in all his projects. Gräff, on the other hand, is of the opinion that Richter was only able to continue to produce film strips with the aid of Gräff's predominantly technical skills.[29] In any event, Richter was in the midst of making his film *Fuge in Rot und Grün* (Fugue in Red and Green) when he met Gräff. The film was later renamed *Rhythmus 23,* although according to Gräff it was completed in 1922.[30] The original title indicates that it was initially planned as a color film. As there was no colored film material available at this time, Richter wanted to color each frame red or green by hand, using conventional methods and hoping that the uneven coloring would not show on a black background.[31] However, Gräff pointed out to him that each colored stroke beyond a to-be-colored line or plane would be visible and convinced him of the futility of this project. The film remained black and white. What might be re-

garded as a failure nonetheless shows that Richter was already concerned with the phenomenon of color in film as early as 1922, perhaps inspired by his contact with van Doesburg.

Herman Weinberg calls the five-minute film *Rhythmus 23* an interplay of lines and planes.[32] Indeed, Richter returned in this film, contrary to his preceding one, to the constructive possibilities of lines. An interplay of line and plane that resembled the motifs on the picture rolls became its theme. It is not surprising, therefore, that his sequence from the *Präludium* roll was employed here.[33] By concentrating on the line, he lost the spatial effect of his first film. The action occurs predominantly in the plane, even if sometimes a background modulating from black to white appears.

*Rhythmus 23* premiered in Paris during "Le Coeur à Barbe" on 6 July 1923.[34] In this second film, Richter again adhered to a strict compositional concept of a picture and did not employ any curved or rounded forms. The diagonal position of the rectangles, which appears only in a brief passage in his first film, is the central motif of this one. The film starts with two white squares moving toward each other axially symmetrically on a black background until they finally dissolve into a large square. Then the reverse occurs: the large square splits into two shrinking squares, which are each confronted by a diagonal rectangle. Symmetry plays an important role here as in the rest of the film. The same sequence juxtaposing square and diagonal rectangle appears as a negative film at the end of *Rhythmus 23*. In between, the direction of the diagonal planes changes frequently.

Unlike Eggeling, Richter had given up trying to film his picture rolls. He continued to make rolls, though, because the roll format "could express perceptions that neither easel painting nor film could express. Perceptions that only the picture rolls could generate originate from the stimulation of the recalling eye when it wanders from detail to detail creating related sequences. In tracing the creative process, the viewer

Hoffmann

experiences the representation in a single stream, which easel painting could not offer."[35]

Richter's most productive year for roll pictures was 1923, in which two horizontal rolls, *Rhythmus 23* (**fig. 4.3; plate 7**) and *Fugue 23,* and a vertical roll, *Orchestration der Farbe* (Orchestration of Color) (**fig. 4.4; plate 8**), were created. After the unsuccessful experiment of trying to make a colored film, Richter hoped to solve the mystery of color with the picture rolls. He wanted to study the possibilities of a color scale using the same analytical methods as he had while studying the variation range and effect of forms. He therefore created "an orchestration of color in complementary, contrasting, and analogue colors, as a Magna Carta for colors."[36] Based on its lucid concept, the 1.4-meter-long roll *Orchestration der Farbe* may be considered a masterpiece of German constructivism. Another painting of this period was later shown at the infamous "Entartete Kunst" exhibition in Munich. This painting was titled *Farbenordnung* (Color Order) and, provided the information given by those responsible for this Nazi exhibition is correct, it had been bought for thirty Reichsmarks by the Landesmuseum Hannover in 1923. There is no clue what happened to it after the exhibition. Perhaps it suffered the fate of so many paintings shown at this shameful exhibition and was burned in the courtyard of the Berlin Main Fire Department in 1939.[37] We know Richter's painting *Farbenordnung* only from his black-and-white photograph of it. Striking in its composition is the use of trapezoidal planes, which are perspectively shortened and thereby convey the impression of space. The influence of El Lissitzky, who had lived in Germany since 1922, is quite evident.[38]

Hans Richter's devotion to constructivism during this time is not solely expressed in his pictorial creativity. At the First International Congress of Progressive Artists in May 1922, he had formed the International Fraction of Constructivism with van Doesburg and Lissitzky. In a declaration dated 30 May 1922 and published in *De Stijl,* this group ex-

plains why it left the event early under protest: "We define a progressive artist as one who denies and fights the predominance of subjectivity in art and does not create his work on the basis of lyrical random chance, but rather on the new principles of artistic creation by systematically organizing the media to a generally understandable expression. . . . The actions of the congress have shown that due to the predominance of individual opinion, international progressive solidarity cannot be developed from the elements of this congress."[39]

Shortly afterward, in August 1922, another manifesto by this group, which now called itself Konstruktivistische internationale schöpferische Arbeitsgemeinschaft (Constructivistic International Creative Workshop) appeared in *De Stijl* and was signed by Theo van Doesburg, El Lissitzky, Hans Richter, Karel Maes, and Max Burchartz. Richter's address in Berlin-Friedenau, Eschenstrasse 7, was given as the group's head office.[40] The newly gained international contacts encouraged Richter to publish a journal which he titled *G,* standing for *Gestaltung* (forming). He published a total of five issues from July 1923 to April 1926. The typography of *G* adhered essentially to constructivistic principles.

Richter's last rhythm film, *Rhythmus 25,* applied the color theory that he had developed while experimenting for the *Orchestration der Farbe* roll. His short paper "Color Notes" provides insight.[41] As in the roll, there are for Richter only two prime colors, red and green. "The scientifically denominated elementary colors, blue, red and yellow, do not have, aesthetically speaking, an absolute distance from each other. Red and yellow are nearer (warm); blue is opposite of yellow as well as of red, whereas green and red are incomparably unequal to each other. And if you want to use technical measure, green and red are together black. All other colors I consider more or less variations."[42] Richter used this conception to create his hand-made film *Rhythmus 25.* As at that time hand coloring was expensive and very time-consuming, he only made one copy of it, which was soon lost. Only col-

ored sketches have survived to give an impression of this work (**fig. 4.5; plate 9**).

In 1927, Richter was visited by Kasimir Malevich, one of the most radical representatives of the Russian avant-garde, who had come under increasingly sharp attack because of the changes in Soviet cultural policy in the second half of the 1920s. However, in 1927 Malevich was still granted permission to exhibit his work outside the country, and he traveled to the openings of his exhibitions in Warsaw and Berlin.[43] Malevich had seen the *Rhythmus* films and was impressed by the possibilities of abstract film.[44] He intended to use a film to demonstrate his concept of suprematism, and Hans Richter seemed to him to be the right man for this job (see fig. 5.5).

Malevich called his project an artistic-scientific film, because it was to combine aesthetic and didactic aspects. The title he chose was *Die Malerei und die Probleme der Architektur* (Painting and the Problems of Architecture) and below this title he placed the self-confident prognosis, "The future classic system of architecture." The first part of Malevich's film manuscript presents an outline of art history from impressionism to cubism, constructivism, and suprematism.[45] Examples of pictures are meant to visualize the logical consequence of this development. The second, larger part of the film concerns the two stages of suprematism, the two- and three-dimensional forms of representation. As in Richter's *Rhythmus* films, forms and structures are derived from simple fundamental elements. Even the form of a circular plane is created by Malevich by the movement of a square. The colors red and green offer additional creative possibilities besides black and white. The suprematist idea was raised further by applying it to spatial constructions. According to the same principles as in the planes, architectonic fragments are created, yielding for Malevich architectonic systems.

Richter and Malevich's joint film project was not realized. Having received disturbing news from home, Malevich returned to Leningrad. As a precaution he did not take home

Hoffmann

the work that was on exhibit in Berlin.[46] He appointed Richter the curator and the works were stored in Hannover.[47] In 1969, Hans Richter decided to film Malevich's script with his cameraman Arnold Eagle, because he believed "that he owed that to Malevich."[48] However, this attempt was doomed to fail; too much time had elapsed.

The heyday of constructivism had passed by the mid-1920s. Its concepts, however, were adopted in design, typography, and architecture. What still interested Hans Richter after 1925 was film that was independent of painting. The last issue of his journal *G,* the double issue nos. 5–6, dealt solely with this medium. Although he made another film in 1926, *Filmstudie* (Film Study), which is partially based on the language of abstract forms, it essentially returned to figurative elements. Richter departed from animation and shot instead a woman's face, birds, eyeballs, and a man hammering. Even if he altered these motifs by crossfading or by transforming them with trick lenses into ornamental constructions, he returned to the language of images that *cinéma pur* had already formulated. Richter explains the theory behind his use of objects in a symbolic and abstract manner in his book *Filmgegner von heute—Filmfreunde von morgen* (1929) (Film Enemies Today, Film Friends Tomorrow): "The means of association can be sheer magic, can alter things from their core, can bestow upon them new values, give them contents that they never had before. In association, one has elements of a picture-language-medium of film poetry."[49] From the mid-1920s on, Hans Richter reflected more consciously on the variety of expressive possibilities offered by the film medium. It was the rhythm of the film that now gave his works their form.

**Notes**   1.   Rudolf E. Kuenzli, "Introduction," in *Dada and Surrealist Film,* ed. Rudolf Kuenzli (New York: Willis, Locker and Owens, 1987), 1: "Most historians of avant-garde cinema regard Hans Richter's and Viking Eggeling's abstract films as Dada."

2.   Ibid., 2.

3. Hans Scheugl and Ernst Schmidt, Jr., *Eine Subgeschichte des Films,* vol. 2 (Frankfurt am Main: Suhrkamp, 1974), 749.

4. Ibid., vol. 1, 502 f.

5. Claire Goll, *Ich verzeihe Keinem* (Munich and Zurich: Knaur, 1980), 52.

6. Hans Richter, *Dada, Kunst und Antikunst* (Cologne: DuMont Schauberg, 1964), 46.

7. Hans Richter, *Hans Richter, Monographie,* ed. Marcel Joray for the series *Kunst des 20. Jahrhunderts* (Neuchâtel: Editions du Griffon, 1965), 24.

8. Ibid., 24.

9. Ibid., 24.

10. Standish D. Lawder, "Der abstrakte Film: Richter und Eggeling," in *Hans Richter 1888–1976: Dadaist, Filmpionier, Maler, Theoretiker* (exh. cat., Berlin: Akademie der Künste, 1982), 31. See the appendix of this volume for a version of the text.

11. Hans Richter, "My Experience with Movement in Painting and in Film," in *The Nature and Art of Motion* (New York: George Braziller, 1965), 144.

12. Richter, *Hans Richter, Monographie,* 24.

13. Ibid., 24.

14. Lawder, "Der abstrakte Film," 30.

15. Ibid., 31.

16. Richter, *Hans Richter, Monographie,* 29.

17. Adolf Behne, "Der Film als Kunstwerk," *Sozialistische Monatshefte* 27, no. 57 (Berlin, 15 December 1921); and Theo van Doesburg, "Abstracte Filmbeelding," *De Stijl* 4, no. 5 (1921): 71–75.

18. Van Doesburg, "Abstracte Filmbeelding," 74.

19. Hans Richter, unpublished manuscript in the Hans Richter estate, New Haven, Connecticut.

20. Anton Kaes, "Verfremdung als Verfahren: Film und Dada," in *Sinn aus Unsinn,* ed. Wolfgang Paulsen and Hellmut G. Hermann (Bern and Munich: Francke, 1982), 75.

21. Richter, *Hans Richter, Monographie,* 29.

22. Ibid.

23. Lawder, "Der abstrakte Film," 33.

24. Hans Richter, unpublished manuscript in the Hans Richter estate.

25. Hans Richter, *Köpfe und Hinterköpfe* (Zurich: Arche, 1967), 26.

26. Ibid., 12–14.

27. Marion von Hofacker, "Biographische Notizen über Hans Richter 1888–1976," in *Hans Richter 1888–1976*, 95.

28. Richter, *Köpfe und Hinterköpfe*, 30.

29. Ibid., 31, and Uwe Rüth, *Werner Gräff: Ein Pionier der Zwanziger Jahre* (exh. cat., Marl: Skuplturenmuseum, 1979), 23.

30. Rüth, *Werner Gräff*, 23.

31. Ibid., 23.

32. Herman G. Weinberg, "Filmindex," in Hans Richter, *Hans Richter*, 128.

33. Lawder, "Der abstrakte Film," 31.

34. Marion von Hofacker, "Biographische Notizen über Hans Richter," 101, n. 45.

35. Richter, "My Experience with Movement in Painting and Film," 146.

36. Richter, *Hans Richter, Monographie*, 37.

37. Marcel Stuwe, "Nationalsozialistischer Bildersturm, Funktion eines Begriffs," in *Bildersturm: Die Zerstörung des Kunstwerks*, ed. Martin Warnke (Frankfurt: Fischer Taschenbuch, 1988), 135.

38. Mario-Andreas von Lüttichau, "Deutsche Kunst und entartete Kunst: Die Münchner Ausstellung 1937," in *Nationalsozialismus und entartete Kunst: Die Kunststadt München 1937*, ed. Peter-Klaus Schuster (Munich: PUB, 1988), 148 f.

39. "Internationale Fraktion der Konstruktivisten, Erklärung," *De Stijl* 5, no. 4 (1922): 113–117.

40. "Konstruktivische internationale schöpferische Arbeitsgemeinschaft," *De Stijl* 5, no. 8 (1922): 113–117.

41. Cleve Gray, ed., *Hans Richter by Hans Richter* (New York: Holt, Rinehart and Winston, 1971), 85.

42. Ibid., 85.

43. Werner Haftmann, ed., *Kazimir Malevich: Suprematismus—die gegenstandlose Welt* (Cologne: DuMont Schauberg, 1962), 24.

44. Hans Richter, *Begegnungen von Dada bis heute* (Cologne: DuMont Schauberg, 1973), 43, 49.

45. Kazimir Malevich, *Die Malerei und die Probleme der Architektur* (film manuscript), 1927, 1.

46. Haftmann, *Kazimir Malevich*, 24.

47. Richter, *Köpfe und Hinterköpfe*, 109.

48. Hans Richter, letter to Dr. Robers, 2 November 1969, 1.

49. Hans Richter, *Filmgegner von heute—Filmfreunde von morgen* (Frankfurt: Fischer, 1981), 89.

Hoffmann

BERND FINKELDEY

# Hans Richter and the
# Constructivist International

translated from the German by Carol Scher

In 1919 Hans Richter sketched ten drawings as studies for his first scroll, *Präludium* (Prelude). Although scrolls, successive images depicting a story, number among traditional forms of expression, Richter and Viking Eggeling, who at this time were working closely together, saw themselves confronted with aesthetic problems that artists had yet to consider. "In general, our capacity for optical conceptualization rested on the static spatial form of the fine arts," stated Richter. This was also the reason why "the ability to think in optical series was still completely underdeveloped."[1] The scrolls demanded a new way of composing; the point was to arrange the individual images so that the scroll unwound in a well-devised progression. One needed to find principles for ordering the successive images and to endow them with an inner coherence. Problems of continuity had to be considered, a rhythm found.

Richter and Eggeling could have fallen back on the sequential photography practiced by Eadweard Muybridge and Etienne-Jules Marey since the 1880s. These two photographers had disassembled movement into a multitude of individual images; as soon as the images were put together into a series, they revealed movement composed in phases. But Richter and Eggeling had something else in mind, not to illustrate reality, but rather to create a new reality of images. "It is obvious that to get to the spirit, the idea, the inherent principle and essence one has to destroy the appearance," explained Richter; "not in a physical way as much as in one's own eye. To forget about the leaf and to study the oval; to forget about its color and to experience its sensation."[2] Richter and Eggeling wanted to invent an alphabet of abstract signs and forms for a "universal language." The foundation of this language, intelligible to all, was created by the *Generalbass der Malerei* (elements of painting) articulated by Viking Eggeling.

Richter had met Eggeling in 1918 during a visit to Switzerland. Because Eggeling, as Richter wrote, "was also involved in finding a general foundation to administer creatively the wealth of abstract forms, we became friends, spontaneously and immediately."[3] Both had studied principles of musical composition. Hans Richter reported that while he was in Zurich, Ferruccio Busoni had suggested that he explore the compositions of Johann Sebastian Bach. "I came to him with my problem; I explained how I was trying to achieve a balance and counter-balance of the white paper with the black spots of ink I made my drawings with, a balance so that white and black were both part of the same work. . . . I studied in [the preludes and fugues of Bach] the up and down, the movements and countermovements all leading to a definite unity," he wrote, concluding that the experience with Busoni and Bach "was really the basis of my further development."[4] Eggeling's *Generalbass* also rested on schemata of musical composition, explained Richter:

A principle of dynamic relations as in counterpoint, [it] comprehended every possible relation among forms without discrimination, including the horizontal-vertical relationship. . . . Its almost scientific method led him to analyze how elements of form "behaved" under various conditions. He tried to discover what expression a form would assume under the influence of different kinds of "opposites": small versus large, light versus dark, one versus many, above versus below, etc. In that he intimately combined external contrasts with analogous relations of form, which he named "analogies," he could produce an endless variety of relations among forms. Opposing elements were used to dramatize, to tighten the form complex; analogies were used to relate them again to each other.[5]

The *Generalbass* was laid out as the basic method for artistic *Gestaltung* (the German encompasses both design and planning); as Richter described it, "Every work is subjected to this mechanical law, the interplay of contrast and analogy; only improvisation can exist outside this law."[6]

From 1919 to 1922 both Richter and Eggeling lived and worked on the estate owned by Richter's parents near Berlin, in the village of Klein-Kölzig. Here Eggeling produced his scroll *Horizontal-vertikal Messe* (Horizontal-Vertical Mass, 1919), composed of linear elements, and Richter his scrolls *Präludium* (Prelude, 1919) and *Fuge* (Fugue, 1920). "They all start with a simple elementary pattern—rectangle or square—and develop such elementary forms to their maximum through all kinds of counterpoint variations and over different phases."[7]

As they worked on elementary signs, forms, and colors, to make them dynamic, to orchestrate them, almost inevitably their thoughts turned to filming the scrolls. "We had arrived at a crossroad, the scroll looked at us and it seemed to ask for real motion. That was just as much of a shock to us as it was a sensation. Because in order to realize movement

we needed film."[8] With support from the UFA, which provided a cartoon-film studio and a technician, they were able to produce a film based on the *Präludium* scroll.

> The simple square of the movie screen could easily be divided and orchestrated by using the rectangle of the cinema-canvas as my field of pictorial vision. Parts of the screen could then be moved against each other. Thus it became possible on this cinema-canvas to relate (by both contrast and analogy) the various movements to each other. So I made my paper rectangles and squares grow and disappear, jump and slide in well-articulated time-spaces and planned rhythms.[9]

During his pioneering work in abstract film, it became clear to Richter that only certain aspects of painting could be transferred to film; film confronted him with the "time" aspect. He recalled, "After our, as it appeared to me, unsuccessful attempts to set scrolls into motion, I recognized that the problem of film lies essentially in the articulation of time and only very secondarily in the articulation of form. The more I delved into the phenomenon of film, the more convinced I was that articulated time, namely rhythm, is to be regarded both as the elementary dimension of film and its inner structure."[10]

On 23 December 1920, Theo van Doesburg joined Hans Richter and Viking Eggeling in Klein-Kölzig. The Berlin critic Adolf Behne had arranged the contact, and less than a month later, on 17 January 1921, van Doesburg sent him an enthusiastic account. "You have probably already heard from Eggeling and Richter that I find their inventions excellent. They have let me see everything, it was all extraordinarily interesting."[11] Van Doesburg was especially fascinated by Eggeling's theory of the *Generalbass* with its astounding parallels to his own *Generalbass,* the "Elements of painting, sculpture, and architecture" defined in 1919. The significance he accorded to the film pioneers' work infused an essay soon published in *De Stijl.* There van Doesburg examined the com-

Finkeldey

positional and experimental possibilities of abstract film, pointing out that only a few technical problems still needed to be overcome: "The enormous enlargement through the lens betrays every weakness of the human hand, and because it is no longer the hand, but rather the spirit that makes art, and because the new spirit demands the greatest possible precision for its expression, only the machine in its absolute perfection, the modern machine, is in the position to realize the higher demands of the creative spirit."[12]

During the eleven days he spent in Berlin, Theo van Doesburg met other experimental artists and architects: Bruno Taut, Walter Gropius and his assistant Fréd Forbát, as well as Raoul Hausmann, Hannah Höch, and Kurt Schwitters. He also sought to establish contact with Paul Westheim from *Das Kunstblatt* and those who wrote for the periodical *Der Sturm* (**fig. 5.1**).

"What is more," observes Sjarel Ex, "Berlin was where the contact came about between the two countries in which the development of art was more radical and abstract than elsewhere: Holland and Russia."[13] On behalf of Anatoli Lunacharski, El Lissitzky came to Berlin in 1922 to open up dialogue with artists and provide information on the young Soviet Russia. To this end, he and Ilya Ehrenburg together published the trilingual periodical *Veshch-Objet-Gegenstand*. To Hans Richter, *Veshch* was a journal "that confronted the problems of our modern art and underscored the affinity between our artistic efforts and those in Russian art."[14] The periodical, conceived for both Russia and western Europe, advocated constructivist art with its goal, as Lissitzky proclaimed in the first issue, not to decorate life but to organize it.[15] Richter cultivated contacts both with Lissitzky and Ivan Puni, who lived with his wife, Xenia Boguslavskaya, near Nollendorfplatz, the center of the artistic Russian community in Berlin. Puni was, in Richter's opinion, one "of the first Abstractionists (and Dadaists) of the Russian art world."[16] Together with Raoul Hausmann, Hans Arp, and László Moholy-Nagy, Puni had written the "Aufruf zur elementaren Kunst"

(Call for Elementarist Art) in Berlin. In this proclamation, the artists demanded an art built upon its own elements alone, and not founded on individual whim.[17]

**Manifestoes—**
**Manifestoes—**
**Manifestoes:**
**Hans Richter at the**
**Congress for**
**International**
**Progressive Artists in**
**Düsseldorf**

In 1922 Richter and Eggeling had to leave their "paradise" in Klein-Kölzig after Richter's father sold the estate. Richter moved into a furnished apartment located at Uhlandstraße 118 in Wilmersdorf and rented a studio nearby, at Eschenstraße 7 in the Friedenau suburb southwest of Berlin, in which Eggeling lived. That same year, van Doesburg returned to Berlin and, together with his wife, spent several months with Richter. Van Doesburg was also the one who introduced Richter to Werner Gräff. Gräff had taken part in the De Stijl classes offered by Theo van Doesburg from 8 March to 8 July 1922, first in Karl Peter Röhl's studio and later

in his own studio in Weimar. Gräff also moved into Richter's apartment. As Richter notes, "I became very partial to the young person and took him with me to all my friends and colleagues, to studio evenings and gatherings."[18]

One gathering in 1922 took place in Gert Caden's studio. Hans Richter recalled that aside from Caden and himself, Theo van Doesburg, El Lissitzky, Ludwig Mies van der Rohe, Werner Gräff, and others were present that evening.[19] Gert Caden added a few more details of the gathering. "The evening took place in 1922 in my Berlin studio. . . . Colleagues from abroad also took part in founding the constructivist group," he wrote. "I can remember Lissitzky, Gabo, Altman, Pevsner, Kemény, Moholy-Nagy, Péri, Kállai, and the wives of Kemény and Péri."[20]

The most significant aspect of this evening gathering was that it brought together various groups of foreign artists: Russian artists living in Berlin, Dutch proponents of De Stijl, and Hungarian emigre artists from the circle around the periodical *MA*. They all were concerned with rationality versus expressiveness, with objectivity versus individualism and subjectivity, with the search for the elements necessary for a universal language with which to design and reshape life through the use of modern production methods. The consensus on artistic objectives reached that evening in Caden's studio spanned the nationalities of the artists present. Full of expectation, several of them left for the Congress for International Progressive Artists in Düsseldorf. The artists of Das junge Rheinland (The Young Rhineland) were host to the congress, held from 29 to 31 May 1922. The Berlin Novembergruppe, the Darmstadt Secession, the Dresden Secession, and the Schaffenden (worker-creators), also from Dresden, as well as a number of prominent private citizens were also behind the congress.

On 26 May several artists met in Theo van Doesburg's Weimar studio to discuss and synchronize their positions. Present were Hans Richter, El Lissitzky, Werner Gräff, Karl Peter Röhl, and Cornelis van Eesteren. Two days later they

traveled together to Düsseldorf. Hans Richter described the obstacles in their way: "With the greatest difficulty we rounded up the money for train tickets and reached, via fourth-class, the Christian Hostel in Düsseldorf, where we met Schwitters, Hausmann, and the Cologne painter Seiwert."[21] Also in Düsseldorf were Theo van Doesburg and Cornelis van Eesteren as delegates of *De Stijl,* El Lissitzky as representative of *Veshch-Objet-Gegenstand,* and most likely László Péri as envoy from *MA.*[22] Astoundingly, Werner Gräff, Hans Richter, Fritz Baumann, and Viking Eggeling signed in as members of the Constructivist International, which at this point had yet to be founded.

All shared a common purpose in coming to Düsseldorf, to help found an international association for progressive forces. As the congress unfolded, however, sharp differences divided the progressive artists who had gathered there. On 30 May, the second day of the congress, two issues rankled the constructivists. The second manifesto to be voted on defined the Union as an exclusively practical and economic association. The position paper of the Group Synthès, signed by Ivan Puni and the Lithuanian sculptors Arnold Dzirkal and Karl Zalit, stated that the association was consciously to refrain from discussing intellectual and artistic questions. Hans Richter spoke for the constructivist artists from Switzerland, Scandinavia, Rumania, and Germany. In the midst of heated debate, Richter objected to the establishment of an association restricted to mere organizational and economic ends. Counterposing his views to those in the manifesto and Group Synthès, Richter declared, "An International built on economic concerns misunderstands the necessity of an International. An International has not only to support its members, but also itself to document and create a new condition. If and how this new condition can be reached requires that we test, as comrades, collectively, the understanding that it takes our combined forces to create the new *niveau* of living that we so desperately need. That would be a real task."[23]

During the Düsseldorf congress, van Doesburg, Lissitzky, and Richter together founded the International Fraction of Constructivists. In their declaration, they noted that this designation was meant to express their opposition to expressionism and "Impulsivists."[24] It seems likely that they also wanted to distinguish themselves from the First Working Group of Constructivists founded in 1921 around Aleksei Gan, Konstantin Medunetski, Aleksandr Rodchenko, Varvara Stepanova, and Georgi and Vladimir Stenberg in Moscow. Hans Richter recalled that the term "constructivism" in Düsseldorf was meant not only to define boundaries, but was also a "password for those striving to achieve both lawfulness of artistic expression and tasks of meaningful actuality."[25] To Richter, one current objective was that art stop presenting itself in opposition to the world. During the Düsseldorf congress, he declared that constructivist artists had "overcome our own individual problem and reached the fact of an objective issue in art. This objective issue unites us in a common task. This task leads us (through the scientific investigation of the elements of art) to want something other than just a better image, a better sculpture: it leads us to reality."[26] In the words of the declaration, "Art is a common and real expression of the creative energy that organizes the progress of humanity, which means that art is the tool of the common process of labor."[27] The time had come, as these artists saw it, to establish an international union for truly progressive artists in which each person "denies and attacks the predominance of the subjective in art, and builds artistic works not upon lyrical whim, but rather on the principle of the new *Gestaltung* by organizing the means systematically into an expression intelligible to all."[28]

Their demand that a truly progressive artists' International must also develop a common artistic program was rejected by the majority at the Düsseldorf congress, who disrupted the speeches with heckles like, "Academy" and, "We don't want dictatorship!"[29] Fearing that the systematization of

artistic means would limit artistic freedom, the Group Synthès rebuffed the demand with the argument, "Feeling and intuition seem to be the source of creating. . . . Works of art that have been stripped of this strength are only manifestations whose allotted existence exhausts itself in a couple of years."[30]

The artists took a short break for lunch, a chance for the waves to subside so they could calmly debate the 149 paragraphs of the association's statutes. When they reassembled, the storm broke loose. The "Dadasoph Raoul Hausmann, his voice strengthened in many a Dada fracas,"[31] took aim against the stolidity and machinations and declared that he and his friends roundly dismissed the Congress and its results. He shouted out, "We are all cannibals!" about a dozen times and then left the room, together with Franz Wilhelm Seiwert, while singing the International.[32] Even Werner Gräff's scornful remark that the majority there were neither international nor progressive nor artists failed to shake the assembly; the group of constructivists hence walked out of the building. Irate, Theo van Doesburg explained their departure: "The Congress was called by *Das junge Rheinland,* a bunch of quacks, sheep-heads, and old maids who go about their work in good Prussian manner to force modern art into *their* International with a program of not less than 149 paragraphs. Naturally it ended with us having to leave the hall in heated protest. . . . In any event, we now know whom we can count on for the next congress. The futurists, dadaists, and others too walked out with us. We'll do it better the second time around. We have enormous support from the Russians! Lissitzky, who arrived not long ago from Moscow, is a splendid fellow of great consistency. The Germans just shit their pants in comparison."[33]

The promising candidates Theo van Doesburg had in mind for the next congress included his wife Nelly van Doesburg, Cornelis van Eesteren, Otto Freundlich, Werner Gräff, Raoul Hausmann, Hannah Höch, Stanislav Kubicki, El Lissitzky, Hans Richter, Franz Wilhelm Seiwert, Ruggero Vasari,

and possibly Marcel Janco, all of whom, in the Düsseldorf group photo, had placed themselves defiantly under the sign pointing the way "To the Trade Fair for Urban Sanitation and Waste Disposal" (**fig. 5.2**).

**Hans Richter and the Founding of the Konstruktivistische Internationale Schöpferische Arbeitsgemeinschaft in Weimar**

Upon their return from Düsseldorf, the artists began preparations for founding a Constructivist International. On 6 June 1922, van Doesburg could already report, "We are now hard at work on the International, which has to come off before winter. It is of the greatest significance."[34] Van Doesburg also proposed to Richter that they proceed together with the Dadaists Hans Arp and Tristan Tzara. Richter responded, "That you are warming up the Internat. again, fine. We need it: not only as a means to fight the reaction, not only to organize and market our works, but for both. . . . I am in complete agreement with the idea of proceeding together with the Dadaists."[35] Richter's studio at Eschenstraße 7 became the meeting place for like-minded artists; Hans Arp, Tristan Tzara, and Kurt Schwitters were frequent guests. In fact, Karl Peter Röhl, who had also participated in Theo van Doesburg's Weimar classes, lived in Richter's apartment for an extended period. The artists also met in various Berlin cafes, as well as in the apartments and studios of László Moholy-Nagy and Erich Buchholz. Here El Lissitzky, Werner Gräff, Raoul Hausmann, Hannah Höch, and Hans Richter gathered to discuss the new "gestaltende Kunst." As Sophie Lissitzky-Küppers recalled, "It was all about the new functionality, objectivity, utilitarianism. . . . Lissitzky told his German comrades about the great tasks for artists and architects that the revolution in Russia had brought about."[36] During such meetings, the artists also discussed the Constructivist International to be founded on 25 September 1922 in Weimar.

Starting on 19 September the participants began to arrive in Weimar, where they gathered in Theo van Doesburg's studio in Upper Weimar, at Schanzengraben 6. One group immediately went on to Jena, where they spent the evening of 24 September at the house of Walter Dexel, director of

the local art society. His guest book boasts the signatures of Tristan Tzara, László Moholy-Nagy and Lucia Moholy, Kurt Schwitters, Hans Arp, Theo and Pètro (Nelly) van Doesburg, Max Burchartz, Cornelis van Eesteren, and Werner Gräff. Karl Peter Röhl signed on the opposite page, adding a square—the sign of the constructivists and signet of van Doesburg[37] (**fig. 5.3**). The Jena group sent a letter to the gallerist Herbert von Garvens in Hannover announcing that Hans Arp, Tristan Tzara, Pètro and Theo van Doesburg, Raoul Hausmann, and Kurt Schwitters wanted to hold Dada evenings on 25 September in Weimar and on 26 September in Jena, as well as a "DADAREVON-evening" on 29 September in Jena, as well as a "DADAREVON-evening" on 29 September in the Galerie van Garvens in Hannover. Lissitzky, Röhl, Gräff, Burchartz, the Dexels, and the Moholys were also to attend the Hannover evening as guests.[38] This schedule is remarkable because, paradoxically, a Dada evening was planned for the founding of the constructivist International in Weimar.[39]

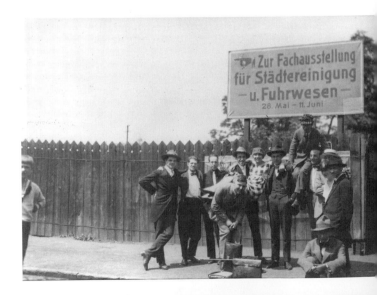

On 25 September the group left Jena for the assembly in Weimar. Gert Caden, who had followed the conversations in Berlin, described how the ideas of Richter, Lissitzky, van Doesburg, and Moholy-Nagy mingled, indicating a general accord on artistic objectives. Constructivists, according to Caden, went "to work as matter-of-factly as possible—we are far removed from any romanticism." He continued,

> Not the personal "line"—what anyone could interpret sub-jectively—is our goal, but rather the work with objective elements: circle, cone, sphere, cube, cylinder, etc. These elements cannot be objectified further. They are put into function; the painting also consists of complementary ten-sions in the color-material and the oppositions of vertical, horizontal, diagonal. . . . Thus a dynamic-constructive system of force is created in space, a system of innermost lawfulness and greatest tension. . . . That is the formal side of our efforts. More important, however, is the ideo-logical side: that these things agitate for a clear, simple plan for life, one of inner necessity with an exact balancing of forces. Here our goals meet the goals of the social revo-lution. So seen, our task is not party-political, it is rather a task of cultural politics.[40]

Indeed, the politics of the Constructivist International seem to have sparked off a heated altercation among Rich-ter, van Doesburg, Moholy-Nagy, and Kemény in Weimar (**fig. 5.4**). Particularly vehement was the opposition to the Hungarian constructivists' support of the proletariat and their efforts to propagate world revolution. As Kemény put it, "Con-structivist art has the will toward collectivity. A collective art is not, however, possible in the general anarchy of existing bourgeois society. It is reserved as the art of the future prole-tariat. First must come the world revolution of the pro-letariat."[41] Impulses from Soviet Russia also filled László Moholy-Nagy with enthusiasm. The "reality of our century is technology," he wrote, "Technology knows no tradition and

Willi Baumeister 5.5.22.

E. E. Scheyer . 5.7.22.

C van Beuren . Alblasanda Arolland . Alvin
A. van Jaw len Idy.

Kjebhard 5.6.22.

Max Peiffer Watenphul.

Rudi Diepl 10. — 14. Juli 1922

5.3
**Walter Dexel's guest book**
**Photos courtesy of Galerie Stolz,**

108

no class consciousness. Everyone can be master over the machine or its slave. Here lies the root of socialism, the final destruction of feudalism. The machine means the awakening of the proletariat. . . . That is our century: technology, the machine, socialism. . . . Constructivism is the socialism of the eye."[42] Even before the congress in Weimar, Theo van Doesburg had warned that Moholy-Nagy and Kemény "see things completely differently, namely communism as ideal principle. . . . They were concerned with subordinating art to communism; we were concerned with realizing the implications of the new art."[43] For this reason, van Doesburg reproached Moholy-Nagy for working against their cause. Later, Richter tried to smooth things over, writing in a letter to van Doesburg, "As for Moholy, I can't share your opinion

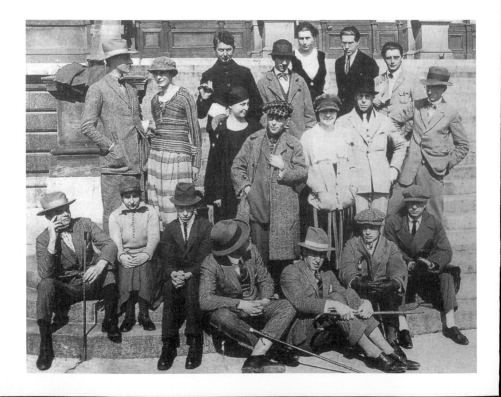

5.4
Participants of the founding congress
of the Constructivist International,
Weimar, 1922
Photo courtesy of Rijksdienst Beel-
dende Kunst, The Hague

completely. While I don't see the final point of what he's after, he is a person who thinks and leaves nothing untried. Already in Weimar I spoke out clearly against his lack of clarity; it can *never* lead to an international union . . . for class struggle and work, but one can't dismiss him as comrade."[44]

Erich Buchholz had followed the discussions in Berlin and found it impossible to mediate between the two positions: "Because the concept was so malleable, there were still bridges—a priori with Pevsner, Rodchenko, Péri, . . . bridges of attempts to discuss the definition while respecting the piers, for instance Lissitzky. . . . One met in the middle of the bridge, without, however, building a bridge to the two theorists from Hungary, Kállai and Kemény."[45] The assembly disbanded without having reached a consensus. In 1924 Moholy-Nagy made a reconciliatory overture to van Doesburg, at the same time branding Richter responsible for the failure of the congress in Weimar. In a letter to van Doesburg he wrote, "Our warm relationship came to an end when you departed from Weimar in the middle of unspeakably galling and stupid struggles on the part of Richter & company, and I was happy that I remained objective enough not to drop the objective possibilities of cooperating with my former comrades for personal motives."[46] Van Doesburg, on the other hand, did not mention personal motives in his assessment of the second day of the congress. "After a long exchange of words, the first Constructivist egg was laid by the International hen. The dynamic egg from Moholy is at the same time a chick."[47] With this term, he alluded to the manifesto "Das dynamisch-konstruktive Kraftsystem" (The Dynamic-Constructivist System of Force), published in December 1922 by Moholy-Nagy together with Alfréd Kemény,[48] that had been discussed during the congress. By contrasting two laid eggs, two manifestoes, he underscored the fact that the Weimar Congress could not settle the conflict surrounding artistic goals. Only van Doesburg, Lissitzky, Richter, Burchartz, and the Belgian Karel Maes signed the founding manifesto of the Constructivist International. There they spoke as the provisional administrative

committee of the Constructivist International in favor of the international union of all people who wanted to pursue the creative design of every area of life. In the words of the manifesto, "This International . . . does not arise simply from feelings . . . but rather is based on the same elementary non-moralistic conditions as science and technology, on the necessity to react in a collective creative rather than in an individual intuitive manner. To unfold and develop our individuality completely, we (and all) are forced to organize creative labor."[49] Richter's studio in Berlin-Friedenau acted as office and meeting-place for the Constructivist International.

The idea of an international union of constructivists gained new momentum with the "Erste Russische Kunstausstellung" (First Russian Art Show) in the Galerie Van Diemen in Berlin. The exhibition drew on works both from Russian artists living in Berlin as well as those who came to Berlin for the exhibition. Richter recalled, "Nathan Altman stayed at least one or two years with us before he moved on, first to Paris and then back to Moscow, as did Ilya Ehrenburg, who established his contacts with the international art world in the Romanisches Café in Berlin and later in the Café du Dôme in Paris."[50] Naum Gabo came with Altman to Berlin in order to set up the exhibition in the Van Diemen gallery. Richter was fascinated by the sculptures of Naum Gabo on display there: "A gigantic female nude made of metal sheets . . . [stood] in the middle of the first room, and a head of similar construction looked down on the nude. They were sculptures that lent spatial dimensions to the object from within, of an audacity and certainty that held me momentarily captive. . . . Gabo's work, his division of space and his musical orchestration, was very close . . . to me then, and we became friends."[51]

Hans Richter had special praise for the social engagement of the Russian artists. He became enthusiastic about what certain members of the Constructivist International were striving to achieve, what constructivists and productivists in

Finkeldey

Soviet Russia had long realized—the immediate design of reality. Richter summed up his reaction:

> Nathan Altman demonstrated how modern art in its most extreme, that is abstract, forms can contribute to the public life of a people. His decorations on the Red Square in Moscow, for the celebrations of the Revolution in Leningrad, etc., were more than just decorative. They were the expression of an optimism which swept the public along with it and promised to grant artists in the most free, abstract development a new, functional place in society. A rare moment in the history of a people, in which the efforts of government and people, artists and those who commission their works, are identical.[52]

**The Journal *G* as an International Forum for Constructivist Programs**

During van Doesburg's visit in December 1920 to Klein-Kölzig, the idea took hold in Richter's mind to publish a periodical. This plan was not realized until July 1923, when the first issue of *G. Material zur elementaren Gestaltung* (Material for an Elementary Design) appeared, in order, as Richter wrote, "to say what we could not endure," and "to create a forum for the ideas which after the Dada period and with constructivism had become a compilation of all cultural tendencies of this new time."[53]

In the tradition of *Veshch-Objet-Gegenstand, MA,* and *De Stijl, G* was, along with *ABC* and some issues of *Merz,* a forum for constructivist ideas. With publication of the first issue, however, the periodical had to face the reproach that it hobbled along behind the times and merely rewarmed old positions. Lissitzky found fault with *G,* complaining in a letter dated 8 September 1924 that "neither *ABC* nor *G* have anything new to say. Judging from the first issue, *G* is still a rather snobbish thing created in the atelier. Let us hope that it will improve and become more like a real American weekly."[54] Raging inflation and the devaluation of the Reichsmark combined to delay publication of the periodical. By chance Rich-

ter came into possession of a sum of money in 1923, and with the first issue he could finally publish contributions collected for over two years. "Lissitzky named it *G,* short for *Gestaltung.* The shape of a square behind this title honored Doesburg,"[55] recalled Richter. The first issue gathered manifestoes and programmatic articles on elementary *Gestaltung.* Richter and Gräff described the object of *G.* Van Doesburg published his thoughts on the elements of painting, sculpture, and architecture. Raoul Hausmann wrote about the object of his work, optophonetics. Richter demonstrated the elementary design possibilities in film. Ludwig Mies van der Rohe wrote about the office building. Lissitzky introduced his Proun Room, an environmental installation from the "Große Berliner Kunstausstellung" in 1923. Gräff devoted himself to the design and planning tasks of the new engineer. The first issue also contained excerpts from the 1920 Realistic Manifesto written by Naum Gabo and Noton (Antoine) Pevsner in Moscow.

A number of international constructivists published in the subsequent issues of the periodical (renamed *G. Zeitschrift für elementare Gestaltung* in the third issue). Richter described a variety of contributions: "Hilberseimer wrote about city-planning, Gabo about Constructivism; Arp contributed poems, Tzara poetic rhythms about Man Ray's *Rayogramms,* Schwitters about Schwitters's poetic theories, Hausmann about poetry, optophonetics, philosophy, fashion, world-ice-theory, the cosmos and himself; Kiesler wrote about theatre and architecture, Gräff about new techniques in a new society, Lissitzky about Proun."[56] Elsewhere, Richter named other editorial areas: "Raoul Hausmann, who worked from the first to the last issue as Dadasoph, . . . as optophonetician, as creator of fashion, writer, photomonteur, and painter; Werner Gräff, who scrutinized everything that had to do with automobile construction and new technology; Arp, Schwitters, Ernst Schoen, Hilberseimer, Métain, Walter Benjamin, Tzara, Man Ray, George Grosz, Heartfield,"[57] and

many others. Thanks to his exceedingly good connections to international constructivism and Dada, Richter was able to persuade many artists to write for his periodical and thus to bring together the Constructivist International. The five issues of the periodical appeared between 1923 and 1926 and contained more than simply programmatic writings. *G* also called attention to the achievements of technology and industry. The periodical introduced all areas of *Gestaltung,* combined painting with modern engineering, published exemplary works in architecture, city planning, theater technology, film, and photography. As Marion von Hofacker puts it, "*G* was the first German periodical to be concerned with the changing form and structure of presenting and perceiving aesthetic information. *G*'s artists tried to respond artistically to the immense technical advancement."[58]

In 1924 Richter published a farewell "To Constructivism" in the third issue, hurling a final javelin at Moholy-Nagy. He wrote:

What today passes by this name has nothing more to do . . . with elementary *Gestaltung.* Commercial oil painting has in the meantime appropriated the name and individualists march under constructivism. Arrangers, oil painters, decorators, the entire speculation.—As long as the slogan is in.—It already seems to be passé, at least the sprinter Moholy-Nagy, who has a fine nose for such things, now lets himself be termed a suprematist in *Kunstblatt;* perhaps he will have more luck there than with the erstwhile constructivists.[59]

A note of resignation also resonated in Richter's film work. In 1925 he no longer made purely abstract films. With *Filmstudie* (Film Study) of 1925–26, he was already mixing abstract forms with objects from everyday life. *Vormittagsspuk* (Ghosts Before Breakfast), made over the years 1927 and 1928, figures as a turning point; here Richter exclusively

filmed objects. He used the technological possibilities of his medium in a deliberate fashion. The time indicated by the clock is cut and reassembled; the theme here is the difference between filmed and filmic reality. Everyday objects become autonomous in film. They awaken to an unexpected existence of their own. Richter was applying the Dada-surrealist method of expanding the senses and turning things into riddles. He explained: "Without actually wanting to, the film became a truly Dadaist document. It showed rebellion of objects, hats, cups, ties, hoses, etc., against people. In the end the old hierarchy of person-master over the object-slaves reestablished itself. But for a short time, the public entertained a niggle of doubt about the general validity of the usual subject-object order."[60]

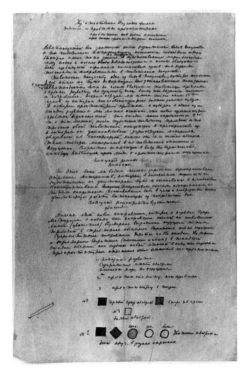
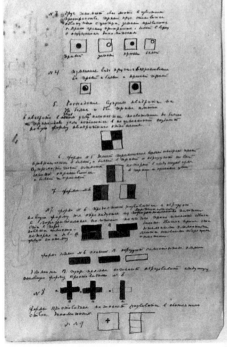

Finkeldey

**Hans Richter and Kasimir Malevich, Project for a Suprematist Film, March 1927**

Richter was again confronted with an abstract film project through Kasimir Malevich, who visited Berlin on 29 March 1927 for a personal show organized by the Reichsbund bildender Künstler of the "Große Berliner Kunstausstellung" in the halls near the Lehrter train station. In Berlin he negotiated with Moholy-Nagy about the publication of his written works.[61] He also met with Richter. "We negotiated through the kind Herr von Riesen [Malevich's host in Berlin] often and in detail, first about Malevich's book. Herr von Riesen must have translated it, because I read some chapters," Richter recalled. "But the main concern that connected Malevich and myself was to express his suprematist theory in continuity and in motion. He had seen my abstract films and found that we could

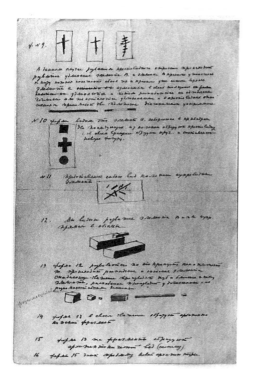

or should proceed together in realizing this dream. There is no question that we frequently met and worked on this project."[62]

The project was never realized. Later, Richter was to write that he never knew anything about the three-page film manuscript with color sketches dedicated to himself, found in the papers that Malevich left behind in Berlin when he left on 5 June to return to Leningrad (**fig. 5.5**).

**Notes**    1.    Hans Richter, "Dimension t. Bei 25 Meter in der Sekunde geht es nicht mehr um das schöne Bild," *G,* nos. 4–5 (1926): 114.

2.    Cleve Gray, ed., *Hans Richter by Hans Richter* (New York: Holt, Rinehart and Winston, 1971), 60.

3.    Hans Richter, *Köpfe und Hinterköpfe* (Zurich: Arche, 1967), 12.

4.    Gray, *Richter by Richter,* 37.

5.    Richter, *Köpfe und Hinterköpfe,* 11–12.

6.    Hans Richter, "Viking Eggeling" (obituary notice), *G,* no. 4 (1926): 97.

7.    Gray, *Richter by Richter,* 114.

8.    Ibid., 41.

9.    Hans Richter, *Hans Richter, Monographie,* ed. Marcel Joray for the series *Kunst des 20. Jahrhunderts* (Neuchâtel: Editions du Griffon, 1965), 29.

10.    Richter, *Köpfe und Hinterköpfe,* 117.

11.    Letter from Theo van Doesburg to Adolf Behne dated 17 January 1921. Archiv Behne, Berlin.

12.    Theo van Doesburg, "Abstracte Filmbeelding," *De Stijl* 4, no. 5 (1921): 73. *De Stijl* 4, no. 7 (1921) contains a supplement with excerpts from Eggeling's and Richter's scrolls as well as Richter's essay "Prinzipielles zur Bewegungskunst" (Principles of Kinetic Art).

13.    Sjarel Ex, "De Stijl und Deutschland 1918–1922: Die ersten Kontakte," in *Konstruktivistische internationale schöpferische Arbeitsgemeinschaft. 1922–1927. Utopien für eine europäische Kultur* (exh. cat., Düsseldorf: Kunstsammlung Nordrhein-Westfalen, 1992), 78.

**14.**   Richter, *Köpfe und Hinterköpfe,* 98–99.

**15.**   Ilya Ehrenburg and El Lissitzky, "Die Blockade Rußlands geht ihrem Ende entgegen," *Veshch-Objet-Gegenstand,* nos. 1–2 (1922): 2.

**16.**   Richter, *Köpfe und Hinterköpfe,* 99.

**17.**   Raoul Hausmann, Hans Arp, Ivan Puni, László Moholy-Nagy, "Aufruf zur elementaren Kunst," *De Stijl* 4, no. 10 (1921): 156.

**18.**   Richter, *Köpfe und Hinterköpfe,* 31.

**19.**   Hans Richter, "Bio-Filmographie," appendix to *Filmgegner von heute—Filmfreunde von morgen,* reprint of the 1929 Berlin edition by Hans Richter (Zurich: Verlag Hans Rohr, 1968), n.p.

**20.**   Letter from Gert Caden to Harald Olbrich dated 11 May 1976. A copy of the letter exists in the Sächsische Landesbibliothek, Dresden, Handschriftensammlung, Nachlaß Caden. It is impossible to tell exactly when this meeting took place. According to Winfried Nerdinger, Richter was unable in a letter to Nerdinger to provide more precise information about this group. See Winfried Nerdinger, *Rudolf Belling und die Kunstströmungen in Berlin 1918–1923* (Berlin: Deutscher Verlag für Kunstwissenschaft, 1981), 117. Richter wrote that this gathering had taken place in early 1922, in other words before the congress in Düsseldorf. See Hans Richter, "Bio-Filmographie," n.p. In February 1922, Moholy-Nagy and Péri held a joint exhibition in the gallery Der Sturm, and were therefore without doubt in the city. Nathan Altman and Naum Gabo arrived around the same time that spring to set up the "Erste Russische Kunstausstellung" (First Russian Art Show) in Berlin, which opened on 15 October. Richter remarked that he first met Gabo during this show. See Richter, *Köpfe und Hinterköpfe,* 98.

**21.**   Richter, *Köpfe und Hinterköpfe,* 46. Franz Wilhelm Seiwert, painter, sculptor, and graphic artist, was a member of the Cologne Gruppe progressiver Künstler (Progressive Artists Group).

**22.**   For the history of the Düsseldorf Congress see Maria Müller, "Der Kongreß der 'Union internationaler fortschrittlicher

Künstler' in Düsseldorf," in *Konstruktivistische internationale schöpferische Arbeitsgemeinschaft,* 17–22.

23. Hans Richter, "Erklärung vor dem Kongreß der Internationalen Fortschrittlichen Künstler Düsseldorf (Für die konstruktivistischen Gruppen von Rumänien, Schweiz, Skandinavien, Deutschland)" (Declaration before the Congress for International Progressive Artists in Düsseldorf, for the constructivist groups from Romania, Switzerland, Scandinavia, Germany), *De Stijl* 5, no. 4 (1922): 58.

24. Theo van Doesburg, El Lissitzky, Hans Richter, "Erklärung der Internationalen Fraktion der Konstruktivisten des ersten internationalen Kongresses der fortschrittlichen Künstler" (Declaration of the International Faction of Constructivists at the First International Congress for Progressive Artists), *De Stijl* 5, no. 4 (1922): 61–62.

25. Hans Richter, "An den Konstruktivismus," *G,* no. 3 (1924): 72.

26. Richter, "Erklärung vor dem Kongreß der Internationalen Fortschrittlichen Künstler Düsseldorf," 57–58.

27. Theo van Doesburg, El Lissitzky, Hans Richter, "Erklärung der Internationalen Fraktion der Konstruktivisten des ersten internationalen Kongresses der fortschrittlichen Künstler," 63–64.

28. Ibid., 64.

29. Letter from Theo van Doesburg to Antony Kok dated 6 June 1922. Papers of Theo van Doesburg, Rijksbureau voor Kunsthistorische Dokumentatie, Den Haag, 2205.

30. Ivan Puni, Karl Zalit, Arnold Dzirkal, "Proklamation der Gruppe von Künstlern über Fragen, die der Beurteilung des Kongresses nicht unterliegen" (Proclamation of the group of artists about questions that do not fall under the jurisdiction of the congress), *De Stijl* 5, no. 4 (1922): 53.

31. Richter, *Köpfe und Hinterköpfe,* 46–47.

32. See ibid.

33. Letter from Theo van Doesburg to Antony Kok dated 6 June 1922. Papers of Theo van Doesburg, Rijksbureau voor Kunsthistorische Dokumentatie, Den Haag, 2205.

34. Ibid.

Finkeldey

**35.**   Letter from Hans Richter to Theo van Doesburg, undated. Papers of Theo van Doesburg, Rijksbureau voor Kunsthistorische Dokumentatie, Den Haag, 168.

**36.**   *El Lissitzky. Maler, Architekt, Typograf, Fotograf. Erinnerungen, Briefe, Schriften,* ed. Sophie Lissitzky-Küppers (Dresden: Verlag der Kunst, 1992), 24.

**37.**   See *Schöne Tage im Hause Dexel . . . Das Gästebuch. Walter Dexel zum 100. Geburtstag* (exh. cat., Cologne: Galerie Stolz, 1990), 28–29.

**38.**   Letter from Kurt Schwitters (with addendum by Walter Dexel) to Herbert von Garvens dated 25 September 1925, as facsimile in Henning Rischbieter, *Die zwanziger Jahre in Hannover* (exh. cat., Hannover: Kunstverein Hannover, 1962), 140–41. Contrary to the date 26 September, given in the letter to Garvens, the Jena evening did not take place until 27 September because of the headlong rush of events in Weimar; the evening in van Garvens's Hanover gallery was probably held on 30 September. In any event, Schwitters invited his friends over for 30 September. Letter from Kurt Schwitters to Christoph Spengemann in Kurt Schwitters, *Wir spielen, bis uns der Tod abholt. Briefe aus fünf Jahrzehnten,* ed. Ernst Nündel (Frankfurt am Main: Ullstein, 1975), 74.

**39.**   Kai-Uwe Hemken argues that the entrance of the Dadaists Tzara and Arp was staged so that the congress in Weimar would fail. "Their appearance was thus a tactical instrumentalization of Dadaism to fend off any attempt to moralize art." See Kai-Uwe Hemken, "'Muß die neue Kunst die Massen dienen?' Zur Utopie und Wirklichkeit der 'Konstruktivistischen Internationale,'" in *Konstruktivistische internationale schöpferische Arbeitsgemeinschaft,* 63.

**40.**   Letter from Gert Caden to Alfred Hirschbroek, undated. Sächsische Landesbibliothek, Dresden, Handschriftensammlung, Nachlaß Caden.

**41.**   Alfred Kemény, "Die konstruktive Kunst und Péris Raumkonstruktionen. Einführungstext zu László Péris Linolschnittmappe" (Galerie Der Sturm, Berlin, 1922/1923). Reprinted in

Miklos von Bartha and Carl Laszlo, *Die ungarischen Künstler am Sturm. Berlin 1913–1932* (Basel: Edition Galerie von Bartha/Editions Panderma-Carl Laszlo, 1983), n.p.

42. László Moholy-Nagy, *Konstruktivismus und das Proletariat*, cited in Sibyl Moholy-Nagy, *Laszlo Moholy-Nagy ein Totalexperiment* (Mainz: Kupferberg, 1969), 30–31.

43. Letter from Theo van Doesburg to Antony Kok dated 18 September 1922. Papers of Theo van Doesburg, Rijksbureau voor Kunsthistorische Dokumentatie, Den Haag, 2205.

44. Letter from Hans Richter to Theo van Doesburg, undated. Papers of Theo van Doesburg, Rijksbureau voor Kunsthistorische Dokumentatie, Den Haag, 168.

45. Erich Buchholz, "Begegnung mit osteuropäischen Künstlern," in *Avantgarde Osteuropa 1910–1930* (exh. cat., Berlin: Deutsche Gesellschaft für Bildende Kunst [Kunstverein Berlin] and Akademie der Künste, 1967), 26.

46. Letter from László Moholy-Nagy to Theo van Doesburg dated 26 July 1924. Papers of Theo van Doesburg, Rijksbureau voor Kunsthistorische Dokumentatie, Den Haag, 132.

47. Theo van Doesburg, "Chroniek-Mécano," *Mécano,* red issue (1922), n.p.

48. Alfred Kemény and László Moholy-Nagy, "Dynamisch-konstruktives Kraftsystem," *Der Sturm* 13, no. 12 (1922): 186.

49. Theo van Doesburg, El Lissitzky, Hans Richter, Karel Maes, Max Burchartz, "Manifest der K.I. Konstruktivistische Internationale schöpferische Arbeitsgemeinschaft," *De Stijl* 5, no. 8 (1922): 114–115.

50. Richter, *Köpfe und Hinterköpfe,* 99.

51. Ibid., 97–98.

52. Hans Richter, "Begegnungen in Berlin," in *Avantgarde Osteuropa,* 14–15.

53. Richter, *Köpfe und Hinterköpfe,* 67.

54. Letter from El Lissitzky to Jacobus Johannes Pieter Oud dated 8 September 1924, in *El Lissitzky. Proun und Wolkenbügel. Schriften, Briefe, Dokumente,* ed. Sophie Lissitzky-Küppers and Jen Lissitzky, vol. 46 of *Fundus-Bücher* (Dresden: Verlag der Kunst, 1977), 126.

Finkeldey

55.  Gray, *Richter by Richter,* 40.

56.  Ibid., 40.

57.  Richter, *Köpfe und Hinterköpfe,* 69.

58.  Justin Hoffman, "G—The First Modern Art Periodical in Germany," in *G 1923–1926,* ed. Marion von Hofacker (Munich: Kern Verlag, 1986), n.p.

59.  Richter, "An den Konstruktivismus," 72.

60.  Hans Richter, *Dada, Kunst und Antikunst. Der Beitrag Dadas zur Kunst des 20. Jahrhunderts* (Cologne: DuMont Schauberg, 1978), 203.

61.  Kasimir Malevich, *Die gegenstandslose Welt,* trans. Alexander von Riesen, vol. 11 of *Bauhausbücher* (Munich: A. Langen, 1927).

62.  Richter, *Köpfe und Hinterköpfe,* 101–102.

MARION VON HOFACKER

# Richter's Films and the Role of the Radical Artist, 1927–1941

Forced to take leave of Munich in 1919 after the democratic form of government known as the *Räterepublik* had been overthrown, Richter resumed his role as a radical artist, however modified, in Berlin. Now reluctant to voice himself politically, he limited his ideas and ideals to his art. It was only when he had regained self-confidence about his political and social role as an artist that his work moved from pure abstract film to film that contained concrete images. New visual perspectives and film techniques, some of which he created himself, supplemented this film vocabulary. Richter took a significant step in a political direction when he turned to more narrative films that appeared to convey explicit messages. He was cautious and daring at the same time in this move away from abstraction. Initially, his messages were clothed in symbols and contained hidden meanings. Later he turned to new film forms, such as advertising, documentary, experimental, and essay film, that became instruments for expressing his political ideals.

By 1929 he had come forth into the public arena as an artist fighting for new film forms. His struggle to realize his vision as an artist and filmmaker required Richter to broaden his activities into other areas as well. He no longer addressed the public only through film but also through his writing on film, exhibitions he organized, film leagues he founded, film congresses he attended, and through his general spokesmanship for independent film. Between 1927 and 1931 he founded two avant-garde film forums, Gesellschaft für Neuen Film (1927) and Deutsche Film Liga (1931), which was an offshoot of the International Film League; wrote two theoretical works on experimental film, *Filmgegner von heute—Filmfreunde von morgen* (Film Enemies Today, Film Friends Tomorrow) in 1929 and *Der Kampf um den Film* (The Struggle for the Film), published in 1939; attended two Independent Film Congresses, 1929 in La Sarraz and 1930 in Brussels; organized a film exhibition in Stuttgart (1929); and gave a series of lectures at the Bauhaus.

Despite this significant and influential activist work, Richter's radical political spirit is manifested in the artistic vision of his film. While before 1925 his work had focused mainly on the abstract *Rhythmus* films, after 1925 these gave way to the semi-abstract images of *Filmstudie* (1926), and then to the more concrete images and narrative content of *Vormittagsspuk* (1927), *Zweigroschenzauber* (Two Pence Magic, 1928), and *Alles dreht sich, Alles bewegt sich!* (Everything Revolves, Everything Moves, 1928). His work eventually evolved into the most concrete forms of film, with actors and scripts, in advertising films and fiction documentaries. This is most notable in *Metall* (1931–33) and *Keine Zeit für Tränen* (No Time for Tears, 1933–34).

With the increasingly politically unstable years of the late twenties, Richter worked more and more with naturalistic forms. The shift away from abstraction was a result of his need for his message to be heard and understood. The troubled times during the second half of the Weimar period (1927 to 1933) brought forth advertising films that were more natu-

ralistic than abstract. After 1933 this tendency gave way to feature films with actors in which the image and the message were straightforward. This tendency was most obviously manifest in projects such as the uncompleted *Metall,* on which he collaborated with Friedrich Wolf. The violence of the political events in Germany that inspired *Metall* was most evident in the fact that the film was eventually abandoned for fear of those same forces. After giving up on the project for good, Richter left Russia for fear of the new political climate.

Richter never discussed the correlation between film and sociopolitical events. In an interview in *Das Echo* he explained that while experimental film was an appropriate film form during the silent film era, the story film requiring sound production was legitimate within a framework of industrial production.[1] In spite of his reticence on this matter, it would be difficult to overestimate the importance of Richter's role in the development and politicization of European avant-garde cinema. This was especially true during the Nazi years when, as an exile, he traveled throughout Europe, collaborating with various artists. Despite its undoubted significance for both Richter and many other members of the American and European avant-garde, there has never been a major study of his work during this period. The most pressing questions for Richter's interwar films and activism are centered around his role as a radicalized artist, the consequences of this role for his visual work, and the thematic correspondences of his advertising and documentary films.

> He [Richter] had a revolutionary mind; he was a socialist, had personally taken part in such activities in Germany, and he was dreaming of a new social art.[2]

Marcel Janco's description of Hans Richter as he knew him during the Dada years in Zurich from 1916 to 1919 is also a fitting and appropriate description of him during the 1920s and 1930s in Berlin. By 1923 Richter had stopped painting, and by 1925 he discontinued making abstract films of the

kind that had won him recognition as a pioneer in the art world and a champion of film. By 1926 the frustration and isolation of the animation studio no longer appealed to him.

The demise of Richter's interest in animation was one consequence of his meeting with Kasimir Malevich in 1927. Malevich came to Germany in that year, bringing paintings and sketches. Having realized that Socialist realism (Stalin's official aesthetic) was beginning to spread in the Soviet Union, he was attempting to rescue these objects from censorship in the USSR. He took this occasion to visit the Bauhaus and Wassily Kandinsky in 1927.[3] There Malevich was shown Richter's *Rhythmus* films. Finding Richter's kind of musical film expression comparable to what he had in mind for a film about his own work, he went to Berlin to see him. Malevich asked Richter to shoot a film that demonstrated his suprematist theory as it was outlined in the text, "Die Malerei und die Probleme der Architektur."[4] Malevich's choice of Richter for the project was logical. Malevich was a pioneer in search of a new formal language, as was Richter, who had developed a theory called "Universal Language" with Viking Eggeling in 1918–19. This search for a single language to transcend all cultures also corresponded to the De Stijl group in Holland around Theo van Doesburg, with whom Richter had already done significant work.

Although Richter had initially agreed to Malevich's film proposal, nothing came of the project. One can only guess at the reasons. For one, colored film did not yet exist. The film would have to be hand colored, no small feat as Richter well knew from his own experience with hand coloring *Rhythmus 25*. Second, Richter was in the process of re-discovering the figurative world, and was somewhat ambivalent about going back to studio experiments entailing the animation of abstract forms.

By 1926 Richter had added figurative imagery to his abstract film vocabulary. But within a year's time he eliminated all abstract images, working entirely with real objects and people for all future projects—a surprising choice for the

von Hofacker

Dada painter who had struggled for years to discard natural objects from his work until his final breakthrough in 1918–19, creatively associating them with traditional art and the past.[5] Added to this was the encouragement provided by the success of the Universum Film A.G. (UFA) program that ran under the title *Der Absolute Film,* in 1925 for the Novembergruppe. By virtue of his work for this program Richter was asked to make commercials and some special effects for feature films. The commercial studio was a place where the probing and radical nature of Richter's work as a filmmaker, in which he developed new cinematographic elements, was applied to the advertising films he made from 1926 to 1929, for Muratti cigarettes, Sommerfeld building contractors, and for Epoche, Berlin's leading advertising agency.

1926, in fact, marked the beginning of a marriage of artists with the film industry in general. The industry provided avant-garde artists with well-equipped modern studios, where they were given a free hand to experiment. This new set-up enabled the artists to emerge from the isolation of the private studio and operate within their social context. From the money earned making commercial films, avant-garde artists like Richter and Walter Ruttmann—also a painter turned experimental filmmaker—were able to continue their own noncommercial work.

In his 1927–28 *Inflation* Richter developed the essay film form (**fig. 6.1**).[6] Set during the period of German inflation, the film portrays inflation as a social/economic disaster that destroys peoples' lives. The subject is simple, with the images limited to two objects: paper money and the owner of that money. The inflated German mark grows and grows in size and value, demonstrated by means of increasing the number of zeroes until there are more than can fit on the screen. The picture of money is contrasted by pictures of an elegantly dressed male citizen who decreases in status and stature as rapidly as the zeroes increase, until at the end there is nothing left of the man but a thin pauper holding out his hat for a donation.

von Hofacker

Richter's *Inflation* is an essay film, a semidocumentary film form used to express concrete ideas and a form that Richter aptly applied to his first work addressing a social/ political subject. Every viewer recognized the message because it was everyone's story, a true story for hundreds of thousands of German citizens. It is told by solely formal means. There is no acting, no narrative, no story. The tragedy is clothed in wit and humor, and the theme is reduced to its bare essentials. The audience laughs at the end not because the film is funny but because the truth of the situation and the bad fortune that came of it. Richter later wrote that the models for such film humor included the French political satirist Honoré Daumier (1808–1879) and the popular German satirical humorist Wilhelm Busch (1832–1908).[7] *Inflation* was also an important formal triumph. Richter used new photographic and technical skills, such as extreme boom shots, zoom shots, enlargements, photo montage, extreme angles, transparency, and negative and multiple exposures.

Richter was not the only one experimenting with these new techniques. At the same time, László Moholy-Nagy was also exploring and developing new images of reality at the Bauhaus by means of new technical innovations and vocabulary under the title of Neues Sehen (New Vision). Art, in the form of easel painting, was dead. The time had come for photographers and filmmakers to replace painters; filmmakers should follow a new path that would allow art and technology to be fused. For the film and photography of tomorrow, Moholy-Nagy envisioned the application of constructivist principals to articulate rhythm, form, and movement, and the distortion of perspective by new photographic methods. In 1925 Moholy-Nagy authored *Malerei, Fotographie, Film* (Painting, Photography, Film). Although the camera had been considered solely a means for mechanical reproduction, some also considered it capable of extending the vision of the eye. Moholy-Nagy termed this possibility the New Vision, a new way of seeing that was unexplored, only vaguely familiar, and sometimes produced coincidentally. These are

photographs shot at extreme angles from above (bird's eye), below (frog perspectives), or diagonally from the side. Moholy-Nagy's aim was to intentionally perfect such extreme points of view with the camera as an extension of the eye.[8]

Examples of Moholy-Nagy's new vision for capturing the poetic and factual reality of German and Soviet life are also found in Walter Ruttmann's *Symphonie einer Großstadt* (Symphony of a Large City) and Dziga Vertov's *Kinoglas* (Filmeye) of 1924. These films use montage techniques and render the visual world in documentary form by means of new perspectives and new articulations of movement and rhythm.

Another of Richter's contemporaries, Guido Seeber, was a film pioneer of a different kind. Unlike Richter, Moholy-Nagy, and Ruttmann he was not an artist, although he had been inspired by the film *Ballet mécanique* by Fernand Léger (1924). Seeber had the reputation of being the most ingenious cameraman in Berlin and was known for his masterful use of trick photography and special effects. He had the best and newest type of equipment at his disposal at the commercial studio where he worked.

When the German film industry staged a huge exhibition in Berlin in 1925, known as the *Kipho* (abbreviation of "kino" and "photo"), Seeber was contracted to make the film that advertised the event. The form he chose for this project was a pictorial essay. The subject was the production of film, and the images he used were the objects composed of and related to film and photographic equipment.

Seeber's film caused quite a stir. It was declared a modern work by the critics, one that demonstrated brilliant shooting techniques, and the most advanced artistic vocabulary of its day. "It is not a film in the Absolute Film vernacular, but one concerned with a concrete subject—the nature of cinema and photography. And done in an entertaining manner as well."[9] It certainly must have come to the attention of the artists-turned-filmmakers in Berlin. Inspired by the direction film was going, other artists joined the film pioneers bringing forth well chosen examples from a wide variety of

sources to demolish every recognized rule of photography and prove that there was no rule for the camera to obey. "In order to teach men to gaze unconventionally," Russian filmmaker Alexander Rodchenko wrote in *LEF* in 1928, "it is necessary to photograph ordinary, familiar objects from totally unexpected vantage points and in unexpected combinations; new objects on the other hand are to be photographed from various perspectives, giving a full impression of their appearance."[10]

Two years after the *Kipho* exhibition Richter made *Vormittagsspuk*,[11] another work that pushed the boundaries of film. Although a literal translation of the title is "To Spook before Noon," or "Morning Spook," Richter titled the English film version "Ghosts before Noon" and "Ghosts before Breakfast." These translations sound better in English, but convey a different message than the original title (stemming from the verb "to spook," as opposed to the noun "ghost"). The film, dated 1927–28, is about anarchy during the post–World War I era and suggests the collapse of everything that is self understood, whether institutional, political, or social. Weinberg describes *Vormittagsspuk* as

> an experimental film for the International Music Festival, Baden-Baden, 1928. A humorous grotesque in which objects (hats, ties, coffee cups, etc.) rebel against their daily routine. "Objects are also people" and "(they) follow their own laws"—"the rhythm of the clock" (H.R.). At the stroke of noon they gladly return to their functional state. Hindemith's score was played by an orchestra in the theatre pit, whose conductor led them from a rolling score synchronized to the speed of the film. This pre-sound device was invented by Robert Blum.[12]

The story of *Vormittagsspuk* was originally intended to follow Werner Gräff's film script about the rebellion of revolvers. Richter opposed this idea, reasoning that revolvers that rebel do not shoot; therefore, not shooting is not an action.

Richter settled on a story about benign objects that rebel instead. "We all had bourgeois bowler hats on." The hats were attached to black strings on long poles and were swung from the top of a garage in front of the camera. "We tried to denaturalize the natural movement of the objects, and we studied their movements. In other words, we got into the swing of the thing, and into the swing of their lives. And we studied their lives and we conversed with them, so to say. In playing with them, in letting them do what they want, suddenly a kind of rhythm developed which became a kind of political satire."[13]

Today's viewer might question how rhythm can become a political satire, but at the time of the shooting of *Vormittagsspuk,* in the mid-twenties, the objects and images used in the film had meanings or connotations which would have been obvious to a contemporary viewer. On the one hand, the film projects images of people who are devoid of any individuality. Their movements are passive, automatic, functional, as if motorized, robot-like, and identical. People function as objects and are manipulated by the whims of these inanimate objects that have come alive, teasing, playing and tantalizing their masters, doing so in a light, graceful and funny manner as if it were a joke.

The reversal of roles for people and inanimate objects was subversive in itself, since the conventional role of objects was anchored in tradition. But this alone cannot explain how provocative *Vormittagsspuk* seemed in its original reception. The film's political overtones appeared obvious to censors and caused difficulties for Richter. The Nazis, too, saw the film as a political satire that was intended to convey destabilization of the status quo. This was significant as National Socialism was rapidly gaining ground in Germany, especially in the big cities. *Vormittagsspuk* was looked upon as an invitation for people to be critical, to ask questions and to keep watch on the way political events were developing.

*Vormittagsspuk* is full of hidden as well as obvious meanings, imagery anchored in the German romantic tradition. The hands of the clock showing five minutes to twelve is

a metaphor signifying danger. Danger is imminent, it is five to twelve, this is the last chance before noon. When the clock strikes noon, time is up and everything will be different. This is also expressed by a common German expression, "Five minutes to twelve." Politicians most often use this phrase to indicate that no more time can be lost; it is time to gather one's senses and prepare for change. When the clock strikes twelve no more can be done (**fig. 6.2**).

The flying hat is another potent metaphor that is central to *Vormittagsspuk* (**fig. 6.3**). For a period of 100 years beginning in 1827 the hat was commonly used as a symbol in German literature. A well-known example appears in the text of Franz Schubert's *Lieder* cycles *Winterreise* and *Lindenbaum*.[14] In the German culture of the nineteenth century, hats that fly from people's heads were a sign of existential danger looming in the near future. The hat was the quintessence of the bourgeois citizen and a symbol of the status quo. Pictures and words indicating that hats that no longer fitted well, and were threatening to slip off heads, indicated that society's stability was in danger. A more familiar twentieth-century image is cited by Walter Benjamin about Charlie Chaplin's trademark bowler hat: "His derby wobbles for a lack of a secure place on his head, giving away the fact that the reign of the bourgeoisie is wobbling too."[15]

Among other contemporary work this metaphor can be found in a 1920 collage by Max Ernst, *The Hat Makes the Man*. The man who doesn't wear a hat is no longer a citizen. Under the pretense of puppet-like conformity, the Dada-dandy is able to crack the rigid, paralyzed nature of society by means of subversive infiltration.

The flying hats also refer to a German linguistic pun. The German phrase meaning "being taken care of, protected, or shielded" is *behütet sein,* while the similar *behutet sein* means "wearing a hat." *Behutsam,* furthermore, means "wary, careful, or cautious."

The flying hat symbolically conveys that the innermost conditions of society are shaken to the core. But the two pre-

dominant symbols in *Vormittagsspuk,* the clocks at five min-
utes to twelve, and the hats, are particularly ominous in
combination. When a ghost in the morning causes hats to fly,
things are bad enough; but that is only the beginning: after
twelve, and the long night over Germany (here interpreted to
mean 1933), heads will also fly.

Richter's own essay "My Experience with Movement in
Painting and in Film" offers a rather different interpretation of
these symbols, which limits discussion to aesthetic consider-
ations: "mostly natural elements (real objects) articulated by
strong rhythmical movement. Clocks, legs, ladders, hats,
used as free forms, not respecting their conventional behav-
ior or significance, but, nevertheless, assembled with a be-
ginning (indicated by the clock at 11:50) and with an end (12
o'clock noon). These '10 minutes' are filled with totally irratio-
nal happenings . . . but they still make a kind of story."[16]

Characteristically, Richter does not describe the irratio-
nal happenings as subversive. On the contrary, he claims the

story is created by the flow of visual images which always make a story, whether there is one or not; "That is how our mind works." Although he does not talk about the role of the unconscious in his creative process, he concedes that there is a level that is not literal. "I did not look at natural objects as literal elements." In film "every object tells a 'story' and awakens some emotional or representational association, regardless of the context in which it is experienced." The emotional or representational association Richter talks about is not illuminated. However, it is significant that his film images do have more meaning than their simple, literal one (the one stemming from their mundane function). Beyond the emotional or representational association is the idea of an object as a kind of collective memory that society has in relation to an image. But Richter leaves these meanings up to his viewers. He says, "In addition to the emotional connotation of every object, I learned that there was an abstract, or purely visual, significance as well."[17] Ultimately, however, the abstract or purely visual meaning of *Vormittagsspuk* also contri-

6.2
Film still from *Vormittagsspuk*, 1928

6.3
Film still from *Vormittagsspuk*, 1928

butes to its subversive potential: the techniques and devices of *Neues Sehen* that create an 'unreal world' of close-ups/ long shots, tracking shots, unusual camera angles, quick cutting, slow motion, distortions, and soft focus photography.

The principles of New Vision are applied throughout *Vormittagsspuk*. For example, in the ladder sequence concrete forms take on an abstract character, becoming lines and patterns of shading by varying the perspective when photographing the object. Richter's film is also "technically significant because he's attempting to incorporate all plastic elements of cinematography known to cinematographers at that time into film using forward, backward motion, fast and slow, everything he could think of to jolt the spectator to make it as much of a disruptive experience as possible." Additionally, the "image of the clock is a reflexive image and has a certain temporal presence; and we're lulled into thinking when you see the image of the clock, that this is going to be a nice, stable, euclidean universe. And then, of course the film immediately subverts any kind of expectations you might have along those lines."[18]

This is typical of the avant-garde screen of the time, which did not confine itself to human interaction in the manner of commercial cinema, but abounded with close ups of inanimate objects and a preference for unfamiliar sights. Every shot in *Vormittagsspuk* is ultimately reversed: men climb up a ladder rung by rung, then down again; coffee cups are filled and emptied; hats levitate, people go looking for them, they settle again; pistols turn from one direction to the opposite direction, then multiply; hoses coil and then recoil. It is an irreverent film; casual, playful, and delightful.[19]

After *Vormittagsspuk,* Richter was hired to produce *Rennsymphonie* (1928–29).[20] This silent documentary was an introduction for the film *Ariadne in Hoppegarten* (Hoppegarten is a race track near Berlin). Richter's humorous documentary about this race track was meant to enliven the feature film. In *Rennsymphonie,* Richter broadened conventional methods of vision, allowing the viewer to form associa-

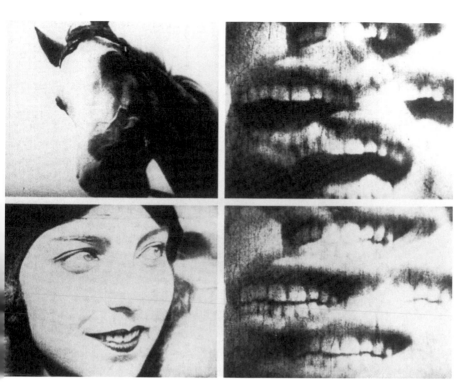

tions by fusing images that are normally far apart (**fig. 6.4**). For example, sliding shutters go up while the Hoppegarten sign is let down. There is a close-up of a horse's mouth, then a young woman's smile. A man strokes a woman's back, a hand pats a horse's mane; then appear horses' legs, men's legs, amid growing excitement, nervous horses, nervous bettors, fistfights, galloping horses, and, finally, toasts. This associative method developed by Richter contributed to the new mode of vision in the 1920s.

The purpose of the documentary film is primarily to report objectively and realistically on a chosen theme. There are several contemporary documentaries of German origin that use similar techniques, *Kipho* by Guido Seeber (1925),

*Prinz Achmed* by Lotte Reiniger (1926), and *Die Symphonie einer Großstadt* by Walter Ruttmann (1927) among them. Richter's *Rennsymphonie* goes beyond simple straight film reporting of the original scene and reveals the social ambience of the race track, the physical and emotional atmosphere there, and how people behave in relationship to each other and to the animals. It is a film of analogies and contrasts. Although this film form existed as early as 1895, the term documentary was coined and came into use only in 1929. Concerned at first with artistic ways of expressing events, Richter more and more emphasized content in the thirties documentaries. The new role he assumed was to disclose what he called the truth and this often revealed a political and social engagement. The more that facts are kept hidden in a society, the more important it becomes to have a clear picture of reality.

An even more pointedly industrial film was Richter's *Zweigroschenzauber* produced for the *Kölnische Illustrierte Zeitung* (1928–29). This silent eight-minute long film was a "little symphony" of movements taken from events in the illustrated newspaper. Despite its visual and textual media, its composition was in fact musical.[21] Although it was a commissioned work Richter was given a free hand in creating the story, the only stipulation being that the name of the newspaper appear once. The basic story involves visitors to a fair who pay two pence to have a look through binoculars focused on the moon. The moon's surface transforms to a man's bald head. In the midst of rapid cuts, there are shots of legs pedaling a bicycle, a child kicking, the flight of a small plane, a high diver, a looping plane, and a pigeon's flight. Another section shows a transition from two men shaking hands to two boxers shaking hands, and other similar juxtapositions. Richter's method was to establish relationships between similar and dissimilar actions by improbable association. Movement from frame to frame is continuous and the associations are surprising. The end shot is a close-up of the *Kölnische Illustrierte Zeitung*'s title page, and a view of

the paper's illustrations that had been liberated for the film. Even in his commercial films Richter used the principles of the New Vision. Evidence of this can be found in the aerial views, frog perspective, distant views, close-ups, and enlargements.

In 1929 Richter returned to documentary work. *Alles dreht sich, Alles bewegt sich!* was also his first sound film.[22] The title of the film (Everything Revolves, Everything Moves) is the circus barker's cry at a Berlin carnival. The film portrays a fantastic day at the fairground, "with all its brashness, noise and boisterous humor."[23] The merry-go-round, scooters and planes on roundabouts, the booths, the Ferris wheel, and the popular melodies at the fairground attracted Richter with their rich visual motifs and varied movements.

*Everything Revolves* was filmed in a wide negative (2 inches), a pre-requisite for early sound films in Europe. The first sound cameras used in Germany were so heavy that no tilt or pan shots could be made. Recording of certain consonants was poor and "synthetic" consonants had to be spliced into the negative sound track. This was not so problematic in Richter's work, as his music and words, as well as sound, were used as strong rhythmical elements, not naturalistically.[24]

Since Richter used a montage form for the sound track, a sequence of sound elements such as music from a barrel organ, spoken words, and unintelligible phrases, would be played in short intervals and in rapid succession. These served to underline the image on the screen. Even though the cumbersome new apparatus of sound film limited shooting possibilities, Richter was convinced that film sound was as important as the visual image because it had an equal share in creating rhythm. He overcame the limitations of sound filming by inventing convincing effects or filmic tricks. In a scene portraying coming and going, for example, he made his figures appear to be coming out of the ground one

after another and then disappearing again one after the other in a rhythmical sequence of cross fades. In an instance when a young man was meant to be looking for a girl he admired, the actor remained at a standstill moving his head up and down and shifting his weight from one leg to the other while Richter waved the camera rhythmically, conveying an impression of motion without any real movement.[25]

*Alles dreht sich* was one of the first sound films to be produced in Germany and marked the official end of the silent film era. Richter was given a free hand to film *Alles dreht sich* as he visualized it and was able to work without interference from Tobis, the film production company that commissioned the film. The only conditions the company required were the projection of the firm's name on the screen at some point, and that the sound quality be the best possible.

After its premiere in Baden-Baden, Richter reported that Sturmabteilung (SA) officers had viewed the film's modernism as a provocation and beat him up, declaring him a cultural Bolshevik. The film is indeed mischievous, but that in itself may not sufficiently explain the Nazi reaction.

Images in the early part of the film are varied and somewhat discontinuous. There are still pictures of half-naked models on a wall, a fat lady in a full skirt, two fat men in a sauna, and fat hands in a lap. These are followed by a parrot's beak, a stork, a German flag, a Berlin bear mascot, and a betting booth. Each scene comes to life revolving and rotating.

After a quick scene depicting some poverty-stricken people in the countryside, the film returns to the fairground where a young woman waits for her escort. As she flirts with a young man, her middle-aged, mustached escort pops out of the ground between them. He gives her a bouquet of flowers. She disappears; the young man looks for her, and finds her at a shooting booth with her escort. The young man has a shooting competition with the middle-aged man and the latter wins. Stars fall, women laugh. The young woman gets the shooting prize, a cuckoo clock packed in flowers, and the mustached older man laughs with a wide-open mouth.

He has crooked, broken, and ugly teeth. The young man is discouraged and sits down. Meanwhile, all the rides revolve in dizzying shots, with multiple exposures that create abstract patterns. A magician welcomes visitors to his crowded tent. Inside, a performer splits in two parts, and a woman emerges from the center. The split performer climbs a ladder, walks up the wall of the stage, and across the ceiling, corresponding to some upside-down shots of the theater. Just like Richter's world, everything is upside down. The young man in the audience punches someone in the face. Heads swivel as the fistfight starts. The young man is catapulted to the ceiling above the stage and is transformed into a wooden puppet. As he hangs in the air the mustached man appears in front of the curtain. Then the puppet falls. Nothing remains of him but a smoking dark spot on the stage floor.

The message of *Alles dreht sich* is obviously a caricature of the times. Everything spins. It is a story about coming and going, appearing and disappearing, aggressive versus peaceful behavior. When times are bad people say they could climb walls. The innocent become puppets on a string; they fall and burn. Themes of violence, magic, deception, and mystification are touched upon. If Richter's claim about the SA beating is true, then the SA may have known more about the intention of the film than seems probable. I suspect the SA aggression was directed more against Richter "the cultural Bolshevik" than against his film, especially since seven years later, in 1936, *Alles dreht sich* was awarded First Prize at the Lessing *Hochschule* for artistic merit. At this time Richter's name was suppressed from the film's credit line.[26]

As the political situation became more dire, Richter began to express his ideas through outlets other than film. Through contacts with other contemporary avant-garde filmmakers in Berlin, Richter soon found himself in the hub of filmmaking activities that supported and spread ideas through publications about new film forms. For a leading magazine he wrote an article declaring that avant-garde film was the only film form acceptable for public view and the only

film that could be taken seriously by critics. The fiction film coming from the film industry was unacceptable. Light entertainment was harmful to the public because the roles played on the screen did not represent real lives. There were questions that the public was concerned about, and it remained the obligation of filmmakers to address these subjects. He claimed as his model the documentary film productions in Russia, arguing that filmmakers in Russia were allowed to film what they wanted, according to their visions and individual sense of responsibility. They were not required to film what the industry wanted: "In Russia the most ingenious experiments in epic cinema take on a form that is understood by everyone right away. It has to do with the difference in the structure of society there. There is no avant-garde there because film is not made for entertainment, it is necessary for public life instead, and is needed for all questions about [this] life."[27] The Russian influence continued to grow, and the trend toward social films in the form of expressionist documentaries became stronger. By 1929 Richter was convinced that Russian film style even surpassed that of poetical films, which portrayed inner visions. It then became an urgent matter for Richter to see outer conditions portrayed.

It was with this conviction that Richter became a champion for socially responsible films. In 1929 Richter turned his attention to new possibilities in order to communicate with the public more satisfactorily than the studio had previously allowed. He began working in areas that made his ideas and the fundamentals he represented known more directly.

Named artistic director of the film section, he undertook to organize the international exhibition "Film und Foto" for the German Works Union Association of Stuttgart in 1929. This consisted of both a photo exhibition (18 May to 7 July) and a film presentation (13–26 June). The "Film und Foto" exhibition presented the work of some two hundred photographers and twenty-five filmmakers. The avant-garde filmmakers included Viktor Blum, René Clair, Joris Ivens, Man Ray, Viking Eggeling, Germaine Dulac, Charles Dekeukeleire, Jean Re-

noir, Lotte Reiniger, Marcel Duchamp, Walter Ruttmann, Sasha Stone, Etienne Beaumont, Charlie Chaplin, Fernand Léger, Adrian Brunel, Alberto Cavalcanti, Heinrich Zille, Georges Lacombe, André Gide, and Hans Richter himself.[28]

El Lissitzky organized the Soviet contribution to the film section, where films by Esther Schub, Alexander Dovschenko, Dziga Vertov, and Vsevolod Pudovkin were shown. Representation of Russian film was of special significance for the show, since the Russian montage style film, still only a few years old, was viewed as the newest and best artistic method for making film. It consequently fulfilled the demands of the avant-garde filmmakers in Europe. Vertov was appointed by Eisenstein to bring examples of the Russian film montage style to the exhibition. The international avant-garde film program, with its emphasis on the new Russian film, ran for 15 days.

A catalogue published for the occasion of the "Film und Foto" exhibition in Stuttgart contained articles calling the public's attention to contemporary developments in photography, emphasizing that the criterion for photographs selected for the exhibition required that the work employ new technical camera techniques and methods of the New Vision. Richter wrote an article for the catalogue entitled "Das Filmstudio," in which he called for film that did not conform to the wishes of the public nor to those of producers who only thought in terms of economic profit. He argued that since the people who enjoyed going to the movies did not want to see the bad films that were being offered at the theaters, large audiences were lost for the cinema. He claimed that there was more to film than economic considerations, contending that film had to be viewed as an art form. Rather than give in "to the whims of the public," filmmakers must lead the public, "because experts are in a better position to judge what is good and what isn't good. The expert is knowledgeable about the art of film." Richter also called for a new type of film entrepreneur, one who recognized that the time was ripe for the new kind of film, and that it was possible to reduce costs to a fraction of what

was normally spent making a movie. He guaranteed that such an entrepreneur of the new film would become a *Film-millionair.* The place for showing the *new film* was at film studios. It was the task of the film studio to find the best artistic films available according to artistic construction, intellectual content, and technical-economic form. Studios that supported films that were produced at a minimum of expense and a maximum of art would be financially successful for generations to come because those studios would always have the pick of the best films once they were created. Instead of showy films costing half a million, good films could be produced for 50,000.[29]

Richter's first book, *Filmgegner von heute—Filmfreunde von morgen* was originally a handbook for the film section of the exhibition. Werner Gräff coauthored the book and Richter coauthored Werner Gräff's book *Es kommt der neue Fotograph* (The New Photographer Is on His Way).[30] The two publications appeared simultaneously, and the layout of both books is designed according to the requirements of the new topography in montage style. Short, thematically related texts and illustrations of equal value are presented at brief intervals and supplement each other. Stills from a wide range of the period's favorite movies were set against stills from experimental films to demonstrate new methods of photography. This material was used by Richter to show the possibilities of camera movement, cutting and montage, overprinting and trick lenses, rhythm and contrasts, and the authenticity of untrained acting. In a humorous and sometimes bitingly satirical style, Richter attacked the deceptive realism found in German and American commercial movies, the exaggerated gestures of the actors, the overuse of popular stars, the artificial prettification of beautiful or handsome faces, and the treatment of people as dolls. He called for film that did not undermine the intelligence of the audience.[31]

Motivated by increasing artistic activity in the film community and public interest in film, Richter joined ranks with

twenty-five leading avant-garde filmmakers and representa-
tives of film at La Sarraz, Switzerland, to take part in the
meeting of the 1929 Congress of Independent Cinema (**fig.
6.5**). The aim of the meeting was to unite independent film-
makers in their commitment, and to rescue filmmaking from
the hands of the commercial film industry. The participants
made a resolution to establish an international filmmaking co-
operative, making it possible for artists to remain indepen-
dent of commercial film studios. "We all sought at once to
save it [independent film] and . . . carve a niche for ourselves,
by ingenuity and innovation." [32]

    The members decided to shoot a film during this ses-
sion at La Sarraz to express the theme of the meeting. It was

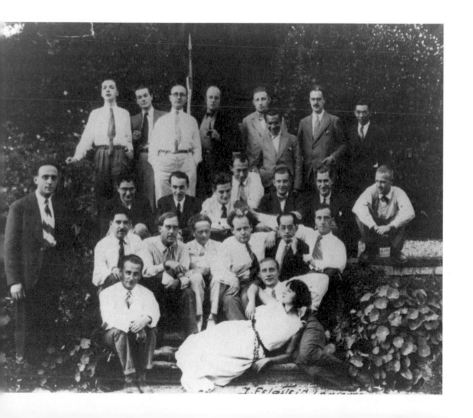

an impromptu project with Richter and Eisenstein directing. Eduard Tisse and Ruttmann were the cameramen, with Ivor Montagu assisting. Everyone had a role, whether dramatic or technical. The film was given the title *The Spirit of Cinema, Commerce, Liberators* (Montagu) or, *The Battle of Independent against Commercial Film* (Richter). It also appears as *The Storming of La Sarraz* (Richter). The subtitle and theme was "The Art of Cinema and its Social and Aesthetic Purposes."[33] It was a story about the war between the art of cinema and the demon of commerce (dressed in armor found in the castle), and the former's liberation by the avant-garde from the clutches of its adversary. Eisenstein played the part of the general of the independent film, Béla Balázs played the leader of commercial film, and Janine Bouissounouse portrayed the art of cinema. Richter arranged a dance by ghosts dressed in sheets that was performed on the lawn with Eisenstein riding an old projector, holding a spear with one hand and cranking the lever with the other.

After the congress ended the film soon disappeared. There are different versions concerning the whereabouts of the film, but the mystery of its location remains unsolved. Some insist that it disappeared when Richter took it to cut in Germany and left it at the train station; others say that fragments of the film still surface occasionally.[34] Richter was sure that Eisenstein intended to take the film to Praesens Film to be developed and probably left it somewhere along the way. Others think there was no film in the camera from the very start because Eisenstein didn't have enough money to buy it.[35]

Elated about the teamwork the filmmakers demonstrated and the success of the venture at La Sarraz, Richter accepted Montagu's invitation to join Eisenstein in London to conduct a workshop. At the time, Eisenstein was considered "the nearest thing to a universal genius . . . that the cinema has yet produced."[36] Richter's role in the workshop can be seen as primarily that of an ambassador. In London Richter shot a documentary called *Everyday,* with Eisenstein playing the part of an English bobby. The theme of *Everyday* is the

monotony of daily life. It poses very basic questions about the quality of life under capitalism. The bobby's life is repetitive, hectic, confusing, and exhausting. Like many of Richter's earlier films, it is political criticism cloaked in humor. Although *Everyday* was not finished until 1968, it is typical of Richter's revolutionary work. Similar to his other work from the twenties and thirties, *Everyday* posits that there is nothing more subversive than puzzling over life, since it is critical thinking that leads to change.

This focus on film as a political medium was continued in 1930 when the members of the Congress of Independent Film met again, this time in Brussels. Living up to his role as ambassador, Richter headed the German delegation. Foremost on the agenda was the question of how film could serve as a political weapon in the face of the rapidly growing threat of National Socialism. The answer to this question was addressed in Richter's previous activist work as well. Out of a sense of responsibility to support the European film movement, Richter was instrumental in forming two film clubs that were founded as platforms for experimental film in Germany. The first was known as the Gesellschaft für Neuen Film (Society for New Film) and was established in 1927 with Karl Freund and Guido Bagier. Richter modeled the Society for New Film along the lines of Armand Tallier's Studio des Ursulines in Paris, which had been the first theater to screen his *Filmstudie.* Keenly aware that the future of independent film depended on the availability of studios and theaters for gathering and viewing these geographically scattered films, Richter explained this undertaking:

Film is for everyone, and that is good. Right now, though, the only films that are being shown have been made specifically for everyone, and that is bad. For invention, experiment, for testing and for the values of tomorrow there is no room.

Films that are shorter than 10 minutes could be made, long enough to demonstrate an artistic attempt by young,

daring people. At this time, however, there is no possibility. We will try to make it happen.[37]

The Society for New Film soon folded. In 1931 Richter made a second attempt to contribute to the cause of independent film, establishing an organization called the Deutsche Film Liga. This was a more politically oriented undertaking and was also a branch of the International Film Liga, which was based in Paris and which supported a lively international exchange of films among Paris, Holland, and Berlin. Based in Berlin, the Deutsche Film Liga screened controversial films and held lectures by prominent guest speakers at the Rote Mühle theater. The Film Liga served artistic and political ends, often sponsoring events that challenged the authorities. Examples of such films shown were *The Earth* by Dovschenko, *Borderline* by Kenneth MacPherson, and *Der Mechanismus des Gehirns* (The Mechanism of the Brain) by Pudovkin, films that would not have been seen without the support of film clubs.[38]

Following the German Werkbund exhibition in Stuttgart in 1929, Richter, considered "the best film expert for the job,"[39] was called to Switzerland to direct a film titled *Neues Leben* (New Living), about modern life, design, and architecture, for the "Wohnen und Bauen" exhibition held in 1930 in Basel.[40] The organizers of the exhibition were representatives from the furniture industry and the Swiss Werkbund. The aim of the exhibition was to make the public familiar with good design for modern furniture and to stimulate sales for the furniture industry.

*Neues Leben,* also known as *Die gute Stube* (The Good Old Parlor), enlists propaganda for simplicity and functional elements. It calls for large windows that let in more light, sliding wall elements for saving space, clear forms, simple furniture, smooth surfaces, and interchangeable elements. The film echoes Bauhaus ideas and those advanced by Russian constructivists for factory and school design. Simplicity and utilitarian design were the bywords.

plate 1
*Stalingrad* 1946
Tempera and collage
94 x 512 cm
Galleria d'Arte del Naviglio,
Milan

plate 2
*Revolution* 1914
Oil on board
63.5 x 48 cm
Berlinische Galerie, Berlin

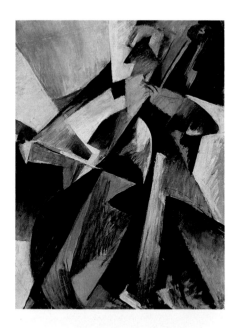

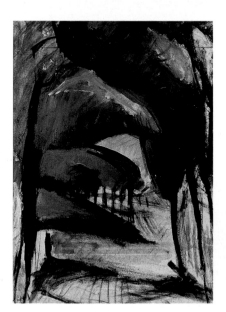

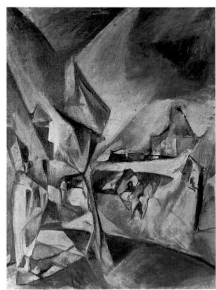

plate 3
*Cello* 1914
Oil on board
64 x 46 cm
Aargauer Kunsthaus, Aarau

plate 4
*Ku' damm* 1913
Oil on canvas
53 x 38 cm
Neuberger Museum of Art,
Purchase

plate 5
*Landschaft—Schlittenfahrt*
c. 1915
Oil on canvas, 80 x 59 cm
Collection Inge Dambruch-
Gütt, Frankfurt

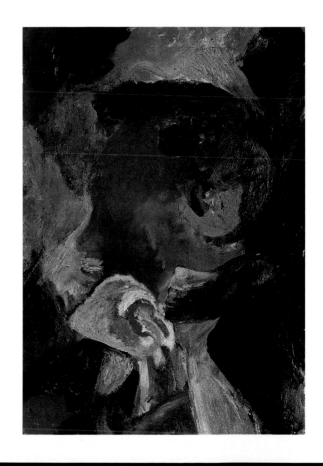

plate 7
*Rhythmus 23* 1923
Horizontal scroll, oil on canvas
70 x 420 cm
Museo Cantonale d'Arte,
Lugano

plate 6
*Lokomotivseele/Visionary Portrait* 1916–17
Oil on canvas
53.4 x 38.2 cm
Long-term loan from private collection
Museo Cantonale d'Arte, Lugano

plate 8
*Orchestration der Farbe*
1923
Serigraph
140 x 41 cm
Estate of Hans Richter

plate 9
Study for *Rhythmus 25*
1923
Pencil, colored pencil on
paper, 78 x 8 cm
Estate of Hans Richter

plate 10
*Liberation of Paris* 1944–45
Hanging scroll, oil and collage
on canvas
245 x 95 cm
Musée d'Art Moderne, Paris

The second part of *Neues Leben* invites the audience to throw out the parlor furnishings and cumbersome knick-knacks that were popular in Germany: the cuckoo clock, busts of German heroes such as Goethe and Friedrich II, and other bric-a-brac, in favor of modern design. The film demonstrates a compact kitchen, nesting chairs and stools, unit furniture, built-in closets, and glass and metal lamps as the ideal ambience, inviting air, sun, and nature to become a part of the interior.

*Die gute Stube* is a wonderful advertising film and carries Richter's indelible film signature: humor, wit, irreverence, montage, and film tricks. It enlightens and at the same time conveys its sponsor's plain message, all in a light-handed way. The film is divided into two parts: the first relays the Bauhaus message clearly and simply, and makes a visual statement of what is required. The second part is more complicated and interesting. It stands in opposition to the first part, using the old fashioned parlor as the essence of what is not wanted. The chaos, rigidity, and rules that are imposed in the parlor are exposed. The parlor is dark, there is not enough room; it is reserved for use on Sundays only; decoration clutters the space. The guest is served coffee; the lid of the pot plummets into the full cup. The glass figures perching on the mantelpiece flutter their wings, the cuckoo clock strikes, and the busts of Goethe and Friedrich II crash to the floor.

The film, looked upon as a valuable document that should not be limited to screenings at the exposition but should be seen in the movie theater as well, represents a new level of cooperation between independent and industrial film. As discussed earlier, avant-garde filmmakers turned to advertising films for several reasons: not only did it give them access to new studios and equipment, it also gave them a further-reaching influence on public taste. Between 1930 and 1938 Richter produced three industrial documentary films for Philips Radio, Eindhoven titled *Europe Radio, Hello Everybody,* and *From Lightning to Television.*[41]

The political balance in Russia and other parts of the world was slipping, and political problems in Germany had become pressing. The elation that Richter, as a political person, had experienced working with the Russian contingent at Stuttgart, and the gratifying teamwork of international filmmakers at the Congress of Sarraz, particularly with Eisenstein on the subject of war, convinced Richter to try his hand making a political film.

Naturally, Richter looked toward a Russian-based project. The cinema was the art about which the Communist Party cared the most, since it affected more people than any other art form. Even Lenin had pointed out its documentary and propaganda importance, and film had become extremely significant for Soviet propaganda abroad. Willy Muenzenberg, a German publicist who worked closely with Lenin in Zurich during the Dada years, created the Communist-run International Arbeiterhilfe (IAH) in Berlin. From 1925 to 1929 many of the greatest films shown in Germany were by the Russian filmmakers. More Soviet films were being exported to Germany than to any other country. The success of Russian film in Germany and elsewhere also caused a great surge of filmmaking in Russia.

A member of the German Bundesrat, Muenzenberg was appointed head of the German Communist Party propaganda apparatus in 1924. He took over a German production firm called Prometheus, which he turned into a distributor of Soviet films in Germany. As a result, there were several Russian/German co-productions. In 1929 Prometheus joined Mezhrabpomfilm, the latter a Russian cooperative film studio in Moscow that had encountered financial difficulties as a result of the New Economic Policy. The IAH had come to its aid, reorganizing the studio and giving it the name MezhrabpomRuss.

Little light has so far been shed on Richter's communist history. It is not known whether he had one or not, though it is probable that he did. He claimed that his entry into Germany after 1933 was impossible because he had been

stamped an *entartete Künstler* (degenerate artist), and not because of other counts against him, such as his Jewish heritage, his communist affiliations, or the project he was working on at the time. Upon applying for a visa to the United States, he denied having any communist affiliations. However, such a move was standard and cannot be taken too seriously. He had many close friends who were communists: Friedrich Wolf, his companion Margarete Melzer, Anna Seghers, Kurt Kläber, and Lisa Tetzner. This was nothing exceptional in Germany at the time. Yet Richter's interest in Russia had begun in Zurich, or even earlier. This historical question must be seen in context of the political reprisals Richter would have suffered had he not denied his communist affiliations.

The publicity over Richter's reported fight with SA officials at the premiere of *Alles dreht sich, Alles bewegt sich!* led Prometheus-Mezhrabpomfilm to invite Richter to make a film for them. Richter readily accepted this offer, and it can be assumed he did so for ideological reasons. The general atmosphere for making a full-length film in the USSR film industry was attractive for "left" artists like Richter, who, as a result of a constant shortage of money, were forced to make commercial films. In the USSR "left" artists and writers were allowed to make full-length films without difficulty. In Germany and France, Dada and constructivist movements remained confined to "a kind of avant-garde ghetto"[42] where film and money were scarce. It was in this context that Richter took on the *Metall* project.

Friedrich Wolf, author of the *Metall* scenario, was responsible for a collection of eight film scripts that appeared in the German Democratic Republic in 1959. In a credit line on the title page of the story of *Metall,* subtitled "Hennigsdorf," he names Richter as the originator of the idea and outline that he, Wolf, put into literary form.[43]

Trained as a medical doctor, Wolf was born the same year as Hans Richter and developed an early interest in film. In 1920 he had joined the progressive artists in their view that film is an independent art form and should not simply

be photographed theater. He also thought that at its best it should be used for propaganda. However, in the early 1920s German cinema was in wholly capitalist hands. This was partly because of the UFA's contract with American studios, giving Hollywood films fresh outlets throughout Germany. By 1925 Wolf was writing political scripts (e.g., *Kraftwerk Russelar*) that were critical of capitalism. In 1929 he organized the *Volksverband* for the *Filmkunst* section of the Stuttgart exhibition, where the new Russian films were presented and where Vertov presented his *Kinoglas*. In 1930 Wolf's *Russland und wir*, the first literary work about the Soviet Union by a German, was offered "to spread the truth" and help seal German-Soviet friendship.[44] Wolf traveled to Moscow in 1930, a year prior to writing *Metall*. He was also the author of many other scenarios and sketches for political films. His anti-fascist dramas belong to the outstanding "best and long sellers" of German exile literature.[45] He was later a communist ambassador in Warsaw.[46]

*Metall*[47] is a feature-documentary recounting the strike in Hennigsdorf (**fig. 6.6**). Weinberg claims that it is set against "the rising tide of Nazi and Stahlhelm hooliganism and developed into a semi-documentary political film. It exposed Nazi strike-breaking and murder methods. The production was abandoned before the last two reels were shot, shortly after Hitler came into power."[48] The Weinberg description does not indicate that the script was written by Wolf, nor that it primarily portrays Nazi strike-breaking or murder methods. Its main thrust is the need for Social Democratic and Communist workers' organizations in order to combat injustices of capitalist management.

After the *Metall* project was abandoned, Richter began a period of exile. Because of Hitler's policies, he could not return to Germany, and he was also afraid of the unstable situation in Russia. For several years he moved between European countries, hoping to gain residency or a visa to the United States. However, this situation did not prevent him from being productive. He managed, in fact, to begin another

von Hofacker

feature film, *Keine Zeit für Tränen* (No Time for Tears) (1933–34). Filmed in Paris, *Keine Zeit für Tränen* bears several alternate titles, including *Hier gibt keine Katharina* (There's No Katharina Here), *Der sogenannte Rendel* (The So-called Rendel), and *Das fremde Kleid* (Strange Attire).[49] It was written by Anna Seghers, Frederick Kohner, and Hans Richter.

The story is based on an actual reported event. In 1932 a newspaper in Mainz printed an account of Maria Einsmann's story. Following her husband's death, Einsmann had assumed his identity in order to work at his night-watchman job in a mining district. She took this drastic step in order to keep her two small children alive. She lived and worked as a man for twelve years until a mine accident disclosed her sex.

In the film script, Hermann Rendel finds work after

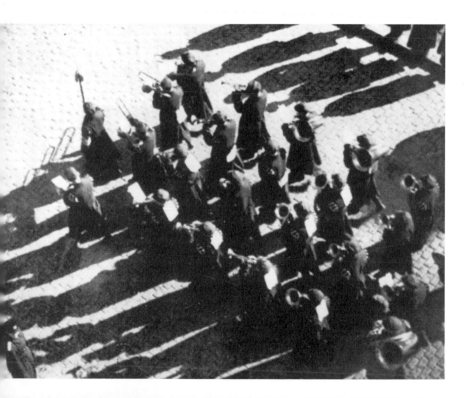

years of being unemployed, but he dies suddenly before reporting for his first day of work. Rendel's wife Katharina cannot bear to stand by and see her family's chances of survival dissolve. Determined to do what she can, she puts on her husband's clothes, crops her hair and reports for work. She does her job well and is respected by her colleagues. Marie, a young woman with no family or security, moves in with Katharina and assumes the identity of the children's mother. All goes well until the two women realize that they have traded economic security for a life of appearances. The accident brings an end to their exchanged identities.

It is known that Brecht was inspired by the story of Maria Einsmann even before Seghers and Richter. He based his story "Der Arbeitsplatz, oder Im Schweiße deines Angesichts sollst du kein Brot essen" on the same newspaper article.[50] According to Anna Seghers the idea to film this story was Richter's. He drove Seghers from Paris to his house in Lugano to work on the film script with her. Seghers claimed that the project was not realized because of political developments in Germany and France.[51]

*Keine Zeit für Tränen* demonstrates Richter's growing concern with political and economic issues, and his need to portray real life situations such as unemployment and discrimination against women in the work force. In need of money during her exile, Seghers contacted Richter requesting that he sell a short story version of the script to her. It appeared as a six-part serial in the *National Zeitung Basel* in 1940, under the pen name Eve Brand.

Prior to Richter's departure for the United States in 1941, he had begun some significant, but largely overlooked, political film projects. The first of these projects was *Candide* in 1934. Richter and his Zurich Dada associates had already paid homage to Voltaire in the name of their cabaret during World War I, and this modern version of Voltaire's satire was similarly biting. Richter's script reflects his concern about political events of the day. Candide remains nonchalant and detached, even in the face of the onrushing grip of National

Socialism. Through his stalwart optimism and belief in the status quo, Candide accepts fascism and its solutions to social and economic problems, even when that amounts to the "cannibalism" of the "inferior" races by their betters. Not surprisingly, *Candide* was unable to attract a studio or producer.[52]

The last two political films Richter attempted to make before his move to the United States were *Baron Münchhausen* in 1937 and *The Lies of Baron Münchhausen* in 1939. The Münchhausen story, about a man who tells incredible lies that actually reflect present-day events, was a perfect vehicle for Richter's brand of humorously veiled critique. The first *Münchhausen* was to be a collaboration between Richter and George Méliès, but the film was temporarily abandoned after Méliès's death in 1938. In 1939 Richter attempted another Münchhausen project. A contract had been signed with Jean Renoir's company, the casting begun, and the sets were in preparation when the war began and the film was abandoned for good.[53]

In 1940 Hilla Rebay invited Richter to come lecture in New York at the Museum of Non-Objective Art. Using this request, he was able to obtain a visa and come to the United States. When Richter arrived in America he immediately began writing new film documentaries in essay form. One script for the Woman's Centennial Congress was entitled *Women in Democracy* or *Women Fight for America* (1940–42). Intended for American women of the middle income group, it is a story about an average American girl living in a typical medium-sized American town. The theme was the "responsibility of women to participate in all of modern community life in order to maintain and extend the privileges which are theirs in a democratic society."[54] A propaganda film with the intention of boosting war morale, it was meant to stimulate citizens' motivation to defend "much loved and needed things," making each community a unit in defense against the "inner threat" of dissension and laissez-faire on which Hitler had so often said he counted.

From 1921 until 1942 Richter's purpose in film was to experiment, to discover new forms, to achieve a new way of seeing with the hope of changing the world. He wanted to reach his audience, relate to it, and at the same time educate it. As a citizen he believed in the responsibility of the artist, and as an artist Richter was convinced that the world would change for the better through the pursuit of new aesthetics. Although sobered by the failure of these aesthetic efforts, such as discovering the limits of animation, and his role in politics, Richter nevertheless worked his way back into a realism capable of addressing human beings in their social and political environment. He believed in the revolution of film through modern art and the revolution of society through film. When Weinberg quotes Richter from a 1926 edition of *G* as saying, "What the film needs is not an audience, but artists," he infers that Richter wants the artist to be responsible for his audience.[55] However, keeping in mind that he believed an audience to have valid concerns of its own, Richter's statement more likely calls on the artist to be responsible *to* his or her audience.

**Notes**   1.   *Das Echo,* 18 February 1935, theater and music section.

2.   Marcel Janco, "Creative Dada," in *Dada, Monograph of a Movement,* ed. Willy Verkauf (New York: George Wittenborn, 1957), 38.

3.   Werner Haftmann, *Malerei im 20. Jahrhundert* (Munich: Prestel Verlag, 1954), 267. In 1927 Kandinsky taught classes in mural painting at the Bauhaus. Kandinsky and Malevich had been acquainted since 1912 when Kandinsky invited Malevich to the Blaue Reiter exhibition in Munich. Kandinsky was profoundly influenced by Malevich's ideas, which came to the Bauhaus by way of El Lissitzky and Moholy-Nagy. Consequently, Malevich's *The World of Non-Objectivity* (published in Moscow in 1915) appeared in German in the Bauhaus book series in 1927.

4.   Kasimir Malevich, "Die Malerei und die Probleme der Architektur," in *Begegnungen von Dada bis Heute,* ed. Hans Richter (Cologne: DuMont Schauberg, 1973), 44–51.

5. Cleve Gray, ed., *Hans Richter by Hans Richter* (New York: Holt, Rinehart and Winston, 1971), 143. See also Charles W. Haxthausen, "Kontinuität und Diskontinuität in der Kunst von Hans Richter," in *Hans Richter 1888–1976: Dadaist, Filmpionier, Maler, Theoretiker* (exh. cat., Berlin: Akademie der Künste, 1982), 10.

6. Herman Weinberg, *An Index to the Creative Work of Two Pioneers,* vol. 6 of *Special Supplement to Sight and Sound Index Series* (London: British Film Institute, 1946), 11.

7. Hans Richter, "Filmessay as Filmform," 1941, Hans Richter Papers, Museum of Modern Art, New York.

8. László Moholy-Nagy, *Malerei, Fotographie, Film,* vol. 8 of the *Neue Bauhausbücher* series (Mainz/Berlin: Kupferberg, 1967), 26.

9. "Wissenschaft und Technik," *Film* 3 (1925).

10. Alexander Rodchenko, *LEF* 6 (1928), qtd. in John Willett, *Art and Politics in the Weimar Republic: The New Sobriety* (New York: Pantheon Books, 1978), 141.

11. Weinberg, *Index,* 11. Designed and directed by Richter. Photography: Reimar Kuntze. Music: Paul Hindemith (lost). March music played by a Bavarian brass band was later added by Richter. Original length 900 feet; released by Tobis in 450 feet. (Recorded by Tobis in 1929.) Actors: Darius and Madelaine Milhaud, Jean Oser, Walter Gronostay, Werner Gräff, Paul Hindemith, and Hans Richter.

12. Weinberg, *Index,* 11.

13. Hans Richter qtd. in Barbara Lass, "Hans Richter: Film Artist," master's thesis, New York University, 1982, 107–108. Text of video. Original source of Richter film clip unknown.

14. Reinhard Pabst, letter to Marion von Hofacker, January 1996.

15. Walter Benjamin, *Gesammelte Schriften,* vol. 6 (Frankfurt am Main: Suhrkamp, 1972), 104.

16. Richter, "My Experience with Movement in Painting and in Film," in *The Nature and Art of Motion,* ed. Gyorgy Kepes (New York: George Braziller, 1965), 152.

17. Ibid., 155.

18. Interview with Don Crafton in Lass, "Hans Richter: Film Artist," 109–110.

19. Interview with Standish Lawder, ibid., 110–111.

20. Scenario and direction: Richter. Photography: Max Tober. One reel, originally 18, later reduced to 7 minutes. Documentary produced for Maxim-Emelka, Berlin.

21. Weinberg, *Index,* 11.

22. Production: Tobis, Berlin. Scenario: Hans Richter and Werner Gräff. Direction: Richter; Photography: Reimar Kuntze. Music: Walter Gronostay. Sound production: Tonbild Syndikat AG. Length: 28 minutes (extract is extant). The production company Tobis is named after the credit title and as a company for sound production.

23. Weinberg, *Index,* 11.

24. Ibid., 11–12.

25. Hans Richter, *Filmgegner von heute—Filmfreunde von morgen* (Berlin: Hermann Reckendorf Verlag, 1929), 281.

26. Weinberg, *Index,* 12.

27. Hans Richter, "Neue Mittel der Filmgestaltung," *Die Form: Zeitschrift für gestaltende Arbeit* 4, no. 3 (1929): 53–56. Repr. in *Die zwanziger Jahre,* ed. Uwe M. Schneede (Cologne: DuMont Buchverlag, 1979), 262.

28. *Film und Foto,* catalogue to the exhibition "Internationale Ausstellung des Deutschen Werkbunds" (Stuttgart: Deutschen Werkbunds, 1929). Reprint: ed. Karl Steinort (Stuttgart: Deutsche Verlags Anstalt Gmbh., 1979).

29. Richter "Das Filmstudio," in *Film und Foto,* 16–17.

30. Werner Gräff, *Es kommt der neue Fotograf* (Berlin: Hermann Reckendorf, 1929).

31. Richter, *Filmgegner von heute—Filmfreunde von morgen.*

32. Ivor Montagu, *With Eisenstein in Hollywood* (New York: International Publishers, 1969), 15.

33. Willett, *Art and Politics in the Weimar Period,* 149.

34. Montagu, *With Eisenstein in Hollywood,* 16.

35. Richter, *Köpfe und Hinterköpfe* (Zurich: Arche, 1967), 123–124.

36. Montagu, *With Eisenstein in Hollywood,* 12.

37. Richter, *Köpfe und Hinterköpfe,* 146.

38. Ibid., 152.

39. *Report of the Swiss Werkbund* (1930), 2. See also "Woba: Schweizerische Wohnungsausstellung," *National Zeitung,* 27 August 1930.

40. Produced for the Swiss Werkbund. Sound and photography: Emil Berna. Scenario and direction: Richter. Also called *Die neue Wohnung,* in *Das Werk* (January 1931), 29.

41. Archive Filmmuseum Amsterdam.

42. Willett, *Art and Politics in the Weimar Period,* 145.

43. Friedrich Wolf, "Metall," in *Filmerzählungen,* ed. Else Wolf and Dr. Walther Pollatschek (Berlin: Aufbau-Verlag, 1959).

44. Dr. Walter Pollatschek in ibid., 428.

45. Alexander Stephan, *Die deutsche Exilliteratur, 1933–1945* (Munich: Verlag C. H. Beck, 1979), 186.

46. Gray, *Hans Richter by Hans Richter,* 47.

47. *Metall:* Berlin, Moscow, Odessa, 1931–1933 (uncompleted). Production: Prometheus and Mezhrabpom film. Scenario and direction: Richter. Photography: Katelnikoff. Assistant-director: Ogonesow. Sound. 8 reels.

48. Weinberg, *Index,* 12.

49. Hans Richter Papers, Museum of Modern Art, New York.

50. Alexander Stephan, *Anna Seghers im Exil* (Bonn: Bouvier Verlag, 1993), 48.

51. Anna Seghers, letter to Marion von Hofacker, 10 February 1981.

52. Weinberg, *Index,* 12–13.

53. Ibid., 13.

54. Hans Richter Papers, Museum of Modern Art, New York.

55. Weinberg, *Index,* 9.

ESTERA MILMAN

# Hans Richter in America: Traditional Avant-Garde Values/Shifting Sociopolitical Realities

A young generation that accepts—

especially today in the face of chaos—

that accepts the existing law and order,

is a loss for the future and hurts the

nation of tomorrow. I am against

violence, violence in a highly industrial

society unquestionably leads to

military dictatorship or fascism; but I

am for the student protests. . . . As a

matter of fact, I am listening to myself,

to the memories of youth; for it was

Hitler who said how easily he could

suppress rebellions with law and order.

Hans Richter, 1969–70

The inside cover of the Winter 1950–51 issue of *College Art Journal* carried a full-page reproduction of a rather nondescript 1949 Max Ernst image that had been made available for publication courtesy of Hans Richter. The issue also provided its readers with access to a short, aggressively utopian essay by Richter entitled "The Film as an Original Art Form." At the time, Richter was already being lauded by numerous members of the burgeoning contemporary North American artistic underground as an inspirational founding father who represented the early twentieth-century avant-garde and who thus provided a point of direct access to a set of powerful historical paradigms applicable to their own agendas.[1] Credited in the United States both as the cofounder of abstract cinema and as an innovative documentary filmmaker, he was the moving force behind the City College Film Institute, where he had been teaching and administrating for a decade. Earlier in the century, his friends and colleagues had included Hans Arp, Blaise Cendrars, Theo van Doesburg, Viking Eggeling, Sergei Eisenstein, Naum Gabo, Raoul Hausmann, Frederick Kiesler, El Lissitzky, Kasimir Malevich, Francis Pi-

cabia, Ludwig Mies van der Rohe, Kurt Schwitters, and Tristan Tzara, among a host of others. Having narrowly escaped the turmoil in Europe in 1941, Richter had found himself welcomed into the then American-based international avant-garde and counted such notable modernists and old friends as Marcel Duchamp, Ernst, Fernand Léger, and Man Ray among his community of collaborators (**fig. 7.1**). He had become an American citizen a few years prior to the appearance in print of "The Film as an Independent Art Form"; a few years later, Richter's directorship of the Film Institute would be jeopardized by McCarthyism.[2] Soon thereafter, his friends and students found themselves unwilling to address Richter's overtly politicized early twentieth-century production for fear that something might surface that "had to be hidden from the McCarthy people."[3] As would be the case for modernism per se, a historiographic process of decontextualization and depoliticization of the pivotal modernist's career was concurrently initiated. Richter the cultural critic and lucid spokesman for traditional avant-garde values entered the margins of an English-language art historical literature stripped of his utopian convictions and fundamental radicalism.

---

Richter opened his 1950–51 *College Art Journal* essay by insisting that the camera's liberation from *reproduction* was prerequisite to film's successful accrual of status as an independent art form, a paradox that, in the authentic tradition of the early twentieth-century avant-garde, he openly related to "psychological, social, economic [as well as] esthetic problems."[4] Similar attempts to liberate other media from representation would be voiced in contemporaneous writings; for example, in Harold Rosenberg's iconoclastic 1952 *Art News* essay, "The American Action Painters," wherein the critic insisted that "at a certain moment the canvas began to appear to one American painter after another as an arena in which to act—rather than as a space in which to reproduce, redesign, analyze or 'express' an object, actual or imagined."[5] Although the inherent radicalism of such shared perceptions remains

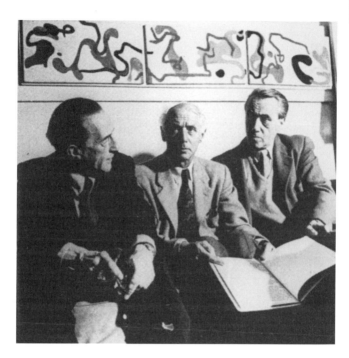

evident almost fifty years after their appearance in print, it is unlikely that such statements would have had political ramifications for either author, even within the context of the McCarthy era.

From our current perspective it is impossible not to note that Richter's opening statements inadvertently echo (although they do not entirely concur with) aspects of his compatriot Walter Benjamin's watershed 1934 essay "The Work of Art in the Age of Mechanical Reproduction." For example, both essays describe film as a potentially revolutionary art form capable of transforming its diverse audiences; they also address parallel concerns about the role of the film actor. In "The Film as an Original Art Form" Richter credits David Ward Griffith's innovative close-ups and cross cutting

of simultaneous events with the development of a revolutionary filmic style, but cautions that Griffith involuntarily created the movie star. Unfortunately, "as 'Star,'" Richter wrote, "the actor immortalized reproduction and dominated the film form once again."[6] Sixteen years earlier (and from an overtly Marxist perspective) Benjamin had also discussed the impact of the close-up and the transformed role of the actor, insisting that "the cult of the movie star, fostered by money of the film industry, preserves not the unique aura of the person but the 'spell of personality,' the phony smell of a commodity."[7] Nonetheless, I would again posit that Richter's critique of what he perceived to be the destructive dominance of the actor within midcentury mainstream film industry production was politically unproblematic at the time of its authorship.

Both men had experienced firsthand the ascendancy of the Nazi and Italian Fascist regimes and had, during the 1930s, participated in widespread debates among members of the international avant-garde (of both leftist and right-wing persuasions) concerning the relationship of aesthetic experience to the rise of totalitarianism. Convinced he could not escape the carnage in Europe, Benjamin had taken his own life in 1940, at the Franco-Spanish border; Richter had come close to a similar end in 1934 while traveling by sleeper from Paris to Zurich, soon after his German citizenship had been revoked for his blatantly anti-Nazi film production. In a late 1950s interview with Giddeon Bachmann, which will be discussed in some detail later in this essay, the expatriate would recount that, suddenly imagining that the Nazis were about to stop the train and send all German passengers to concentration camps, he rushed to the door in his pajamas and robe and prepared to jump, only to be saved by one of the French conductors who assured him they were not about to pass through German territory.[8]

In its attempted formulation of "revolutionary demands in the politics of art,"[9] Benjamin's 1934 essay repeatedly addresses the danger its author understood to be inherent in the aestheticization of violence and in the rise of fascism per

se. Although Richter's post–World War II recollections often included adamant discussions of the disruptive ascension of totalitarianism and its effect on the avant-garde, it is only in the penultimate paragraph of his 1950–51 *College Art Journal* article that such reference is made:

> In England, France, Denmark, Holland, Belgium, experimental film groups of individual artists, mostly painters, have taken up the work begun by the *avant-garde* of the twenties. They are following the only realistic line which an artist can follow: artistic integrity. In that way a tradition, temporarily interrupted by the stormy political events in Europe, has been taken up by a young generation, here and abroad. It is obvious today that this tradition will not be eradicated again but will grow.[10]

Despite the disparate contexts to which the two essays responded, both "The Work of Art in the Age of Mechanical Reproduction" and "The Film as an Independent Art Form" contain laudatory references to Soviet cinema. Alongside the writings of Karl Marx and the political theater of Bertolt Brecht, Benjamin had been deeply influenced by the Russian Revolution. In his essay he implies that it is postrevolutionary Russian cinema—and not the film production of Western Europe—that has proven capable of promoting "revolutionary criticism of social conditions, even of the distribution of property."[11] In "The Film as an Independent Art Form," Richter (who had been influenced by the mid-1920s Berlin premier of Sergei M. Eisenstein's *Potemkin* and who had counted the filmmaker among his community of friends and collaborators in the late twenties and thirties) juxtaposed a laudatory reference to Soviet "documentary" cinema and a dismissive critique of Hollywood "entertainment" films. Describing the latter as powerfully influential, yet ineffectual, offerings of "paradises, complete with gods and goddesses [and as] a grandiose perversion of the medium," the author continues:

Several times in the history of the movies a revolt has tem-
porarily broken the hold of the [theatrical and literary tradi-
tions] over the entertainment film. To state the two most
important revolts: the post-revolutionary silent Russian
film (*Potemkin*), and after the liberation of Italy from Fas-
cism the post-war Italian film (*Paisan*). In both cases the
fictional film has turned from fiction to history and from the-
ater style to documentary style in the use of natural set-
ting, people not actors, and real events.[12]

While this statement would most certainly have raised
a few eyebrows during the anti-Communist backlash of the
McCarthy years, I would argue that there is another set of
assumptions evident throughout the 1950–51 essay that
would also have caused its author problems with some of the
McCarthy people—Richter's unwavering defense of interna-
tional modernism and traditional avant-garde values. The au-
thor of "The Film as an Original Art Form" would assert that
"cubism, expressionism, dadaism, abstract art, surrealism
found not only their expression in films but *a new fulfillment
on a new level.*"[13] Alongside his championship of revolution-
ary documentary film, Richter also insisted that "experimental
film" was the only other authentically original film form. The
second half of the essay foregrounds the author's unshak-
able conviction of modernism's inherent responsibility to lib-
erate and transform, and his belief that the early twentieth-
century European avant-garde, of which he himself had been
a central participant, continued to provide serviceable mod-
els for the present (**fig. 7.2; plate 10**).

There is a short chapter in the history of the movies which
dealt especially with [experimental film]. . . . The story of
these individual artists, at the beginning of the twenties,
under the name of *avant-garde,* can properly be read as a
history of the conscious attempt to overcome reproduction

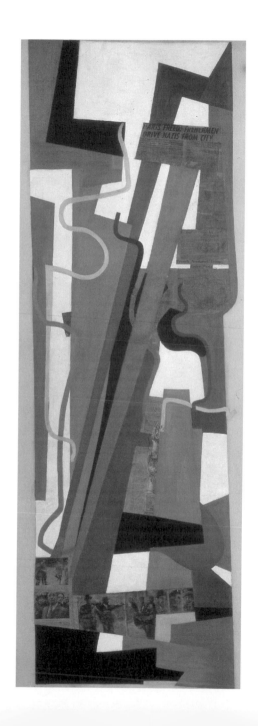

and to arrive at the free use of the means of photographic expression. This movement spread over Europe and was sustained for the greatest part by modern painters who, in their own field, had broken away from the conventional: Eggeling, Léger, Duchamp, Man Ray, Picabia, Ruttman, Brugiere, Len Lye, Cocteau, myself and others. The fact that it was nearly exclusively modern artists who represented this movement gives a hint of the direction in which the "liberation" of the film was sought.[14]

Within one brief essay, Richter had managed to juxtapose discussion of the film industry, the Russian revolution, and European modernist practice. While this particular publication may not have initiated Richter's firsthand experience with McCarthyism, it indicates its author's midcentury position as an influential spokesman for the early twentieth-century avant-garde. For the proper contextualization of the appearance in print of Richter's "The Film as an Original Art Form," a brief discussion of a then active (yet subsequently submerged) midcentury sociopolitical discourse is in order.

In 1952, Meyer Schapiro (who, in the mid-1930s, had opened the First Closed Session of the New York City–based American Artists' Congress Against War and Fascism) published the essay "The Introduction of Modern Art in America: The Armory Show" in Daniel Aaron's *America in Crisis*. Originally penned in 1950 as a Bennington College public lecture, the essay is far more than a history of the 1913 "International Exhibition of Modern Art"; it is a strategic defense of late nineteenth- through mid-twentieth-century modernism per se. At the close of the published article, Schapiro reiterates his historiographic agenda:

[Today] the hostile criticisms made in 1913 have been renewed with great virulence. We hear them now from the officials in culture, from Congress and the President. The director of the Metropolitan Museum of Art has recently condemned modern art as "meaningless" and "porno-

Milman

graphic," and as a sign of decay of civilization in our time. These criticisms are sometimes linked in an unscrupulous way with attacks on Communism, foreign culture, and religious doubt. They have a parallel in the attempts of totalitarian regimes in Europe to destroy modern art as an unpalatable model of personal freedom of expression and indifference to the state. The Nazis suppressed this art as "cultural Bolshevism," the Russian Government and its supporters in the West denounced it as an example of "cosmopolitanism" of "bourgeois decadence," Catholic spokesmen have rejected it as a manifestation of godless individualism.[15]

One year prior to Schapiro's initial presentation of his Bennington College lecture, Congressman George A. Dondero (who was heavily supported by the conservative, antimodernist Allied Artists Professional League) had presented his declaration, "Modern Art Shackled to Communism," to the United States House of Representatives, which included the following accusations:

As I have previously stated, art is considered a weapon of communism, and the Communist doctrinaire names the artist as a soldier of the revolution. . . .

What are these isms that are the very foundation of so-called modern art? . . . I call the roll of infamy without claim that my list is all-inclusive: dadaism, futurism, constructivism, suprematism, cubism, expressionism, surrealism, and abstractionism. All these isms are foreign in origin, and truly should have no place in American art. While not all are media of social protest, all are instruments and weapons of destruction. . . .

Léger and Duchamp are now in the United States to aid in the destruction of our standards and traditions. The former has been a contributor to the Communist cause in America; the latter is now fancied by the neurotics as a surrealist. . . .

The question is, what have we, the plain American people, done to deserve this sore affliction that has been visited upon us so direly; who has brought down this curse upon us; who has let into our homeland this horde of germ carrying art vermin?[16]

It was with two of the "germ carrying art vermin" of foreign origin singled out by Dondero in his 1949 congressional address that the newly naturalized Richter aligned his own modernist production in the 1950–51 *College Art Journal* essay. In addition, with the notable exceptions of futurism, constructivism, and suprematism, the author had openly positioned experimental filmmaking within an avant-garde tradition that encompassed the very "isms" that the Congressman had included in his "roll of infamy."

It could convincingly be argued that Richter's omission of futurism from his genealogy of avant-garde film production was dependent upon the Italian movement's then widely acknowledged relationship to Fascism and its resultant repression within pro-modernist, postwar, North American discourse.[17] Furthermore, based on Richter's own history as a founding member of international constructivism and his significant association with the father of suprematism, it also could be argued that his visible exclusion of these two movements from experimental film's notable lineage was a deliberate attempt to position the medium within a then-in-place English-language modernist canon, within which neither constructivism nor suprematism held pride of place. However, I would posit that such strategic distinctions would have had little impact in anti-modernist circles.

---

Taped two years after his early retirement from the directorship of the Film Institute (**fig. 7.3**), Richter's unpublished, late 1950s conversation with Giddeon Bachmann opens with his often repeated reminiscence that the experimental film movement was initiated at the end of 1918 by himself and Eg-

geling, both of whom were interested not so much in film as in the organization and orchestration of abstract forms. As was the case in "The Film as an Original Art Form," the artist positions his own historical accomplishments within a broadly described history of modernist practice that rejected superficial lines of demarcation among the media in favor of the

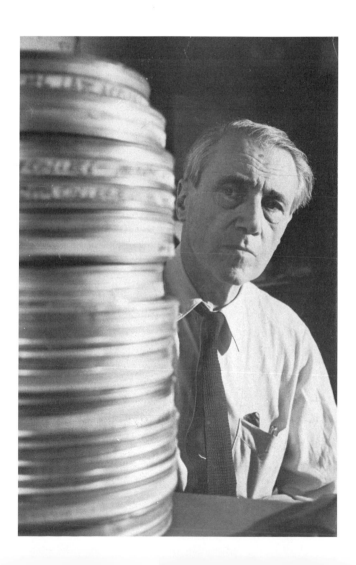

utopian realization of an intermedial "modern, universal language," a fundamental paradigm that informed much early twentieth-century avant-garde production. At the close of his lengthy recollection, Richter reiterates:

> These principles led me to film—I used the medium very reluctantly, only to express these principles. As you see here, on this now restored scroll, these principles are the principles of growth—of how a plant grows, animal growth. . . . In a direct way [these principles are about the development of] a universal language, which is what abstract art should be about.[18]

Forty years earlier, he had already made explicit that these universal principles were informed by then-current biomorphic and mechanomorphic world views and were perceived as capable of transforming culture. In the "Demonstration of the 'Universal Language'" (1920) (see appendix), he had noted: "The scrolls are 'machines,' complicated constructions like life with organic + alive and ever-changing expression. . . . They are machines not like a hammer that bangs on your head—more like an active living power—like a radioactive element, for example, that without your knowing it transforms you."[19] As he had insisted in his 1950–51 *College Art Journal* essay, in the Bachmann interview Richter persisted in voicing his conviction that "the values of the 1920s were still values [which continued to be applicable to a younger generation's vanguard production]."[20] He reminisced that, on his 1941 arrival in the United States, he was excited to discover that he, Léger, Ernst, Man Ray, and Duchamp "still believed in the same values [they] had believed in ten or twenty years ago [and that] the old spirit of the avantgarde was still alive in these people, especially in Léger—and of course Marcel Duchamp."[21] Recollecting that, during the war, New York City was home to "the only functioning international avant-garde culture," he also insists that he was

"received in the United States very well [and found] the tempo very invigorating."[22]

Asked by his interviewer whether or not he was treated like an enemy alien following the United States' declaration of war against Germany, Richter responded that "we were treated as human beings and felt at home here" and that, although he was required, at one point, to deliver his film equipment to a police station, the officers were very civil and accommodating, and that, all in all, he experienced "a feeling of security which [he] never felt in Europe during the [Hitler and Mussolini] period."[23]

Although all reference to Richter's early twentieth-century affiliations with radical anarchist and socialist causes is understandably absent from this late 1950s taped recollection, the artist repeatedly returns to discussion of his direct experience of the rise of totalitarianism in pre–World War II Europe. For example, although he does not address the Soviet component of the sponsorship of his never-completed *Metall,* he is willing to discuss the production itself, describing it as an anti-Nazi film that led to the rescission of his German citizenship in 1934. He speaks at great length of his travels during the 1930s between France, Switzerland, and Holland; of what he describes as his "precarious" 1940 experiences in Switzerland, where his vocal opposition to Nazi film production led to complaints from the "Nazi" consulate, subsequent detainment by the Swiss police, and the recommendation that he cancel an ongoing lecture series; and to the circuitous means by which he escaped Europe and migrated to the United States. He also openly discusses his participation, alongside Eisenstein, in the 1929 Swiss-based Congress of Independent Cinema (where the rise of fascism was of primary concern to many of the participants) and in the London-based lecture/workshop series that he and the revolutionary Russian filmmaker collaboratively realized later that year. Later he animatedly recalls the 1930 Congress of Independent Film in Brussels, during which he had chaired the Ger-

man delegation, and it is at this point in the interview that the artist unselfconsciously recollects the heatedly debated potential relationship of experimental cinema (and the avant-garde) to politics.

Describing the 1930 Congress as committed to the discussion of the future of experimental film within the context of the intensifying turmoil in Europe, he relates that the primary topic under debate was whether or not, in such times, experimental cinema was justified. Although he recollects that he felt very insecure about this issue, Richter remembers that he concurred with those of the participants who believed that "as part of civilization—on a humanistic level, [they] still had to do something to prevent the [recurrence] of the paleanthropic age—which finally came with Hitler and Mussolini in Europe."[24] He further recounts that, although "representatives from Spain and Italy resented [and] rejected progressive independence [and the] Congress broke up without any practical results," he and his colleagues continued to hold "interesting discussions about what could be done to vitalize [experimental cinema] in the political direction."[25]

A number of the incidents that Richter recounted in his conversation with Bachmann later appeared in print, sometimes almost verbatim, in the 1971 publication *Hans Richter by Hans Richter.* Edited by Cleve Gray, the book is composed, in part, of segments from a series of conversations with the artist taped by the editor from June 1969 to June 1970. For example, although in the 1971 publication Richter describes his arrival in New York City not as a comfortable experience but rather as a terrifying one, a confrontation with "Sodom and Gomorrah," he continued to insist that he was pleased to discover that "the old spirit of the avant-guard was still alive" in Léger, Max Ernst, Man Ray, and Marcel Duchamp, and "that during the war, the only functioning of an international art was in New York."[26] The ca. 1958 conversation and the 1971 publication contain almost identical descriptions of the means by which Richter's first American film, *Dreams That Money Can Buy* (1947) (**fig. 7.4**), was collabo-

ratively realized;[27] both also make reference to Richter and Eggeling's long-standing belief in the relationship of abstraction to the development of a universal language. However, in the decade that had transpired, both the North American sociopolitical climate and the art world's priorities had shifted, and as can be expected, Richter's 1971 insider's history responds strategically in kind.

Contemporary cultural historians convincingly argue that the romantic revolution of the 1960s represents the legacy of early twentieth-century utopian anarchic radicalism,

often described as a loosely composed association of varying kinds of World War I–era socialists, anarchists, and liberals. The most radical members of the artistic underground of the Vietnam era perceived themselves as successors to a subversive counterculture initiated in opposition to the so-called "neo-fascist McCarthyist 1950s."[28] They were also overtly influenced by elements of historical Dada, which captured the imagination of the period and served as a reinvented model for varying degrees of artistic activism. Although Richter had referred his affiliation with Dada during his late 1950s recollections, he spoke most often then about surrealism. The interview had been intended for publication in the never-realized *Cinemage 6,* and was thus concerned with the identification of historical paradigms applicable to the production of the contemporary North American underground film movement, some members of which had been identified with "neo-surrealism."[29] The 1969–70 tapes, by contrast, contain lengthy recollections of Richter's central role within historical Dada circles, as well as Dada's affiliations with anarchism:

> From the war into freedom and immediately into Dada! Everything seemed to fit into place now. . . . From that source, from that optimism, could also be understood a new kind of political belief—the tendency toward Anarchy. . . . Later we discovered that Anarchy was indeed a key word into which fitted all the other Dada movements: the New York Dada which contacted us through Picabia, the Berlin Dada of Huelsenbeck, Hausmann, Grosz . . . they were all fundamentally anarchistically inclined though in Berlin there was contact with the Communist Party, *Spartacus* and so forth.[30]

At this time Richter is also willing to reminisce more openly about his own radical political past, including his contributions to World War I–era anarchist and socialist collectives and publications,[31] and his subsequent politically charged experiences in Moscow while attempting to com-

plete his never-released anti-Nazi film *Metall.* What had not changed in the interim between the two sets of recollections was Richter's repeated remembrances of World War II–era carnage in Europe. As his late 1950s conversation with Bachmann drew to a close, Richter recounted that, following the completion of *Dreams,* he had continued to work with the problem of the labyrinth and had studied the "one hundred and twenty different versions of the Theseus story."

> It is my story. Theseus does not go into the labyrinth because of the Athenians but because of his own conscience. He never can get out of his ears the cries of the young prisoners who had been sacrificed to the minotaur. His conscience forces him down to face the minotaur and he finds three different versions of himself. . . . Finally, under the most atrocious circumstances, he finally faces the invisible minotaur—so big—he finds basically himself. I hate myself that instead of doing the *Minotaur,* I got involved with this chess film. . . . Now that I am 68 years old, I don't know if I can ever make a film like the *Minotaur.*[32]

Over a decade later, the venerated spokesman for avant-garde values again referred to this particular unrealized film project:

> In 1953–54 I wrote a scenario for *Minotaur,* a film I never made, but it is a major work as far as I am concerned. It is autobiographical. . . . The scenario started really from the same desire as the last episode of *Dreams:* the Labyrinth as an expression of the unforeseen ways in life you had to take, unforeseen obstacles you had to overcome. . . . It is the story of a man who is Everyman, but who becomes a hero when he does not suppress the voice of the innocents calling for help. That's the essence. And in telling the story, I remember as a boy protecting the weak ones in school, and it is, in retrospect, also concerned with the Hitler times. This incredible feeling of loneliness but still

being forced to do something for one's co-human beings and not being able to do anything. . . . You can't tell stories without telling stories you have lived through. I should have made this film. That I couldn't do it is just one of those paradoxical, inhuman things that happen.[33]

**Notes**

**Epigraph:** Cleve Gray, ed., *Hans Richter by Hans Richter* (New York: Holt, Rinehart and Winston, 1971), 49.

1. Conversation between Jonas Mekas, director of Anthology Film Archives, Inc., and the author, taped 7 November 1995. Mekas (who, in his own right, is probably our century's most respected diaristic filmmaker) has recently been quoted as follows: "[Richter] acted like a steadying rock; his standards were so high and uncompromising. He asked for the highest, for the most difficult. For this very reason, Hans wasn't very popular among the New York avant-gardists—he was too tough on them. But they knew he was there and that was an influence and inspiration in itself. He was one of our Founding Fathers, and we all respected him and were afraid of him." See Cecile Starr, "Notes on Hans Richter in the U.S.A.," *Film Culture* 79 (Winter 1996): 24. During our recent taped conversation, Mekas made similar observations. He further recounted that when he himself arrived in New York in 1949, having spent the intervening years since the close of World War II in a displaced persons' camp, he sent Richter a letter explaining that, although he had "no money," he wanted to study at the Film Institute. "Two days later, a note just came—'just come.'" According to Mekas, Richter "created the Institute." Although Richter was not teaching that semester, "he was always around," and the two became very good friends. "By the time I met Hans Richter I was ready to jump into the avant-garde cinema. I had just read *Art of Cinema,* which I found very inspiring. I found his film *Dreams That Money Can Buy* a very exciting moment. He was there like a father standing on the side. He represented the past, which was still inspiring—the avant-garde of the 1920s and 30s. He was an inspiration to all of us; the early avant-garde as a whole had an

Milman

impression on all of us." During our conversation, Mekas also recounted that Richter had attempted to turn the premiere of *8 × 8* into a benefit screening for *Film Culture* magazine (for which Mekas has long served as editor-in-chief). "He said, 'Leave blank checks on every seat, and I will pitch and you will pitch.' I don't think anyone wrote a check, but Duchamp and everyone else was there." Richter's influence within the burgeoning North American underground film community is widely acknowledged. Rarely discussed are the relationships among avant-garde cinema of this period and the more broadly described intermedial arts. For one animated recollection of this cross-disciplinary fertilization, see Jonas Mekas, "Notes on George Maciunas's Work in Cinema," in *Fluxus: A Conceptual Country,* ed. Estera Milman (Rhode Island: Visible Language, 1992), 125–132.

2. See Marion von Hofacker's chronology of Hans Richter in this volume.

3. Mekas interview. During our November 1995 conversation, Mekas insisted that he remembered Richter as being more concerned with aesthetic problems than "moral" issues and that, because his political films had little to do with the foundations of abstract cinema, he rarely discussed them. When I reminded him that some years earlier he and I had discussed his recollection of a political cloud that had surrounded Richter in the 1950s, Mekas responded by explaining that "we didn't want to pressure him [because we were concerned that] something might come out that had to be hidden from the McCarthy people." The filmmaker continued, "I was very apolitical in those days; I had just left the big political turmoil in Europe."

4. Hans Richter, "The Film as an Original Art Form," *College Art Journal* 10, no. 2 (Winter 1950–51): 157. The essay would subsequently be reprinted (to cite but two notable instances) in P. Adams Sitney's *Film Culture Reader* (New York: Praeger, 1970), and the January 1995 issue of *Film Culture.*

5. Harold Rosenberg, "The American Action Painters," *Art News* 51, no. 8 (December 1952): 25.

6.  Richter, "The Film as an Original Art Form," 157–158.

7.  Walter Benjamin, "The Work of Art in the Age of Mechanical Reproduction," in *Illuminations: Essays and Reflections,* ed. Hannah Arendt, trans. Harry Zohn (New York: Schocken Books, 1969), 231.

8.  Hans Richter, audio tape of a conversation with Giddeon Bachmann, circa 1958, originally intended for publication in the never-realized *Cinemage 6;* courtesy of Anthology Film Archives, Inc., New York. During this conversation Richter recounts: "[When the Nazis were in power] my brother-in-law had taken his co-lawyer, a Jewish war veteran, to his estate. My brother-in-law wasn't Jewish; I'm not Jewish. . . . When, in 1938 [the co-lawyer] was arrested on the farm of my brother-in-law, my brother-in-law left for Chile, taking his niece, a doctor, with him." The niece was to marry the Chilean Minister of Health, who later became the prime minister of Chile. It was through this affiliation that Richter was able to attain his never-used South American visa. Marion von Hofacker notes that Richter was, in fact, a Jew. See her chronology, in this volume, n. 1.

9.  Benjamin, "The Work of Art in the Age of Mechanical Reproduction," 218.

10. Richter, "The Film as an Original Art Form," 161.

11. Benjamin, "The Work of Art in the Age of Mechanical Reproduction," 231.

12. Richter, "The Film as an Original Art Form," 158.

13. Ibid., 160 (emphasis original).

14. Ibid.

15. Meyer Schapiro, "Introduction of Modern Art in America: The Armory Show," in his *Modern Art, Nineteenth and Twentieth Centuries* (New York: George Braziller, 1979), 176. In 1969–70, Richter would recount that, following the 1929 Baden-Baden opening of *Everything Revolves, Everything Moves,* he was beaten by two Nazi SA men who accused him of being a *Kulturbolschewist.* See Gray, *Hans Richter by Hans Richter,* 46.

16. Congressman George A. Dondero, "Modern Art Shackled to Communism," *Congressional Record,* First Session, 81st

Congress, Tuesday, 16 August 1949, Washington, D.C.: GPO. The congressman also singled out Picasso: "The artists of the 'isms' change their designations as often and readily as the Communist front organizations. Picasso, who is also a dada-ist, an abstractionist, or a surrealist, as unstable fancy dic-tates, is the hero of all the crackpots in so-called modern art." Although Picasso was never to visit the United States, the FBI persistently maintained a file on him just in case. Somewhat ironically, at one point during the ca. 1958 Richter/Bachmann taped conversation, the filmmaker makes less than laudatory note of the fact that members of the midcentury North American experimental film community had been referred to as "neo-Surrealists," playfully adding that he believed a more apt rubric would be "neuro-Surrealism." He then shared the tongue-in-cheek speculation that, although on the average only 10 percent of the population was mentally unstable, 25 percent of his students were being analyzed.

17. See Milman, "Futurism as a Submerged Paradigm for Artistic Activism and Practical Anarchism," *South Central Review* 13, nos. 2–3 (Summer/Fall 1996): 82–104. Richter himself was an avid defender of first-generation futurism. See, for example, his laudatory acknowledgment of the debts historical Dada owed the Italian movement, in Richter, *Dada: Art and Anti-Art* (London: Thames and Hudson, 1978), 216–217.

18. Richter/Bachmann taped conversation.

19. See Richter, "Demonstration of the 'Universal Language,'" 1920, trans. Dr. Harald Stadler, in the appendix to this volume.

20. Richter/Bachmann conversation. Richter was here voicing his opinion that contemporary vanguard film production was self-indulgent and made him uncomfortable, particularly that of Maya Deren, who had earlier worked with Richter at the Film Institute. Describing the "problem" of contemporary experi-mental film movement in the United States as being endemic to the anguished younger generation, Richter continues: "The values of the twenties are still values. They should work together with us to work something out that leads to another direction."

21. Ibid.

22. Ibid. This recounting differs from one that appeared in print in 1971. "[My heart was heavy] when I landed in New York, the city terrified me—Sodom and Gomorrah. . . . I was bewildered by the incredible and audacious arrogance of the buildings. The sky had become an accessory to the city, not the other way around; it was a small hole in the rooftops. It took some time for me to overcome the awesome inhumanity of the town." In Gray, *Hans Richter by Hans Richter,* 48.

23. Richter/Bachmann conversation. Interestingly enough, during this segment of the interview Richter describes the climate in the United States as one in which law and order prevailed, adding that "in Hitler's Germany and Mussolini's Italy, law did not exist." Such sentiments differ markedly from those presented in the ca. 1969–70 statement that appears as epigraph to this essay.

24. Richter/Bachmann conversation.

25. Ibid.

26. Gray, *Hans Richter by Hans Richter,* 48.

27. Ibid., 51–53. This volume also reproduces excerpts from the 1950–51 essay "The Film as an Original Art Form."

28. See, for example, Milman, "Futurism as a Submerged Paradigm," 169–170.

29. It is interesting to note that, although throughout his conversation with Bachmann he lauded aspects of surrealist practice, Richter also related the following: "The surrealists accused me of not following through—I never promised to follow their credo, but I was never a member of a group except the 1916, 17, 18 Dada group who had the credo they were not a group."

30. Gray, *Hans Richter by Hans Richter,* 32.

31. For example, Richter openly discusses his 1916 special issue of Pfemfert's *Die Aktion;* and his 1917 anti-war manifesto, "A Painter Speaks to Painters," which was originally published in the anarchist journal *Zeit-Echo,* is also reproduced in the 1971 publication. See Gray, *Hans Richter by Hans Richter,* 24, 31. Later in the published recollections, Richter posits that Dada's anarchistic tendencies were similar in kind to the student re-

bellions and, as such, were not as overtly political as was Ludwig Rubiner's aforementioned journal, for which he had served as art editor. He goes on to discuss briefly the anarchists' play *Those against Violence,* "in which [Rubiner] said that we have, for the sake of the further development of the masses, to accept the fact that art will become *Kitsch* and adore *Kitsch* and replace art with *Kitsch* because the undeveloped masses can't accept the esoteric, that is, what for them are esoteric expressions. That was his theory, though I could not agree with him. In our belly, in our heart, in our blood there was a kind of inquietude, a bad conscience, a continuous disquiet for which we had to find an expression." Ibid., 97. It is important to distinguish Richter's support of the anti–Vietnam War student rebellions from his response to contemporaneous art-based neo-Dada manifestations. For example, in *Hans Richter by Hans Richter* he recounts that Duchamp did not believe that his brand of "anarchism [was] valid for all people or for all generations. As a matter of fact, he wrote me a letter in which he said that the whole business about Pop-art, and so on, is nothing but a trick of the museums, art critics and galleries; because business has to go on, something new has to happen" (97).

32. Richter/Bachmann conversation.

33. Gray, *Hans Richter by Hans Richter,* 151.

HANS RICHTER

**Appendix**

**Demonstration of the "Universal Language"**

*translated from the German by Harald Stadler*

Note: [∗∗∗] indicates indecipherable words in the manuscript. *Italics* indicate French or English words in the original.

vertical                    position
diagonal                    situation
horizontal

                                                    and
                            number                  downward

horizontal line    curved line                    adapted from
vertical line      regular/irregular              V. E.
diagonal line

= dominant

D   / = D   proportion = D

_____ :

      intensity

    1   small

2 & 3  sufficiently bigger   different intensity

    3   big         "   numerical proportion

2 movement

First get a general idea of what you have *"in mind."* (hence "grope")

*Color-Play?*

The scrolls are meant to express knowledge *(knowledge)* knowledge that cannot be realized in theoretical ways— only through them.—Only if they exist does the theoretical knowledge of them obtain its content + form, = value.

The scrolls are "machines," complicated constructions like life with organic + alive and ever-changing expression—due to the relations which they themselves really possess within these repre- sentations + those which the inventory creates within them out of its own (everyone understand—as in music)
     They are machines not like a hammer that bangs on your head—more like an active living power—like a radioactive element, for example, that without your knowing it transforms you—

The "attitude" must not change the motives. that way they
change—in the eyes of the observer —Cover up the
importance /—. This is neutralized in diagonal systems: as they
assume a position that is principally suspended (space<u>less</u> so
to speak or demonstrating relativity in a vertical way). 2 fold
meaning of the diagonals!!!

everything multiplied

The manifestation of freed = identical will (identical with the
law) is form. Form does not want to appear as [∗∗∗] sign—
message—(basic form) but as invention = synthesis. (FORM
as a symbol———arises only through synthesis so to speak) a
<u>machine</u> that can perform all the functions (of the movement,—
the scroll), even <u>procreate</u>!

this is one theme
for the <u>1st</u> movement

analogy?
analogy                        that is

194

2nd dominant

*geometrical*
*repetitious*
*strong*
*round*

total <u>basic form</u> (order) <u>partial</u>
      geometric      nongeometric
      closed      open.

<u>partial basic form</u>
open

<u>total basic form</u>
<u>closed</u>

total basic form                  partial basic form
geometric                       nongeometric

total basic form                  partial form
filled                            empty

re. p. 7
Nowadays one has to leave the
"law" "standing" very sharp + rigid
(anti-[∗∗∗]) so that people will
really grasp
1) that there is a point
2) what the point is

All of this accepting
<u>these</u> patterns the analogy
to represent organic         Proceeding by way of
structures (<u>2</u>)              contrasts: <u>one</u> method!
+ respond to them        cf. p. 6/7

instruments from 1.

open

open

time — <u>form</u> ?

= back — again

+ new beginning

?

1 development from    to

2 development from    to

<u>forms of the process of development</u>

| simple | releasing | reversal | of emphasis |
| complicated | contrasting | " | of position |
| simple | analogizing | | |
| complicated | interluding—development | | |

= contrast rating The        instrument
here is problematic since it has no
aspect of <u>time</u>, it does not extend time.
Its growth is only an <u>alteration</u> and thus
descending. If that is meant—fine.
Otherwise it is or works wrong. If it
dissolves + takes on a new form—then
it says something right: it is newly
attracted to the constant?

how the form of time will be, that
depends not only on the "idea" but on
2) the dynamic of the theme,
1) the idea,
3) the total basic form,
4) the [***] that every instrument uses
6) the previous movement
5) the overall rhythm.

lacks motion (with, with diagonal

Everything geometric

The function of every single
instrument is first of all
determined . . . by leaving it out
(like III)

Everything organic

Time—Form

a) demonstrating the immobile ground figure

1)  Extension (Mass)  a) Main figure constant  b) Then: getting bigger.—Expansion on
    the spot out of itself Re-evaluation of the constant: each figure its maximum c)
    conclusion as break block

2)  Rotation (Diagonal Symphony)  1 Movement: increasing the ground figure.
    Rotating around the axis = space. Tension. Expansion + reduction of the
    orchestras. Maximum reversal for an ending.
    2/3 Movement alternating detailed playing + orchestra—top bottom change.
    right-left turn. Changing from big to small —from small to big (mostly as dance
    rhythm)
    4 Movement inversion of the big orchestra—interlude of the basic motif

3)  (Fugue.) Directing and Lifting the entire movement on the scroll.

4)  (Prelude) Fading of one instrument—Releasing—Increasing of another.

Crystallization.

At first the problem (the source) is not clear. According to which law are the changes "allowed" to occur? What kind of freedom is there? What does it consist of? where are the limits— since the possibilities are un-limited (answer p. 5)

dynamics
rhythm
metrics

### Time—Measure

1  Mass (cf. p. 7)
   striding rhythm—Every element is a synthesis of all the preceding ones and of the theme. <u>uniform measure</u>
   maestoso, grave. Relatively motionless
                                 —if very animated
   homogeneous (Accent)     then radical change!
                                 explosions

2  Symphony: dancing rhythm
   different from the basic measure of the beginning (in the interlude) changing from three-beat to two-beat measure./
   (Accent)—change

3  Prelude: prelude simple measure through (Accent) change.
   Slow increase follows . . . . . . flourish, fade, flourish,—end

Contrast [***] within time.

| increasing | : | decreasing | (spatial!) |
|---|---|---|---|
| filling | : | emptying | " |
| doubling | : | simplifying cf. space table (spatial) | |

Instrumente für die erste Satz

II Satz

Analyse

Instrumente für den zweiten Satz

Jedes Instrument entwickeln.
Es hat zwar eine Charakteristik der
Gebirte – aber es ist nicht vollendet
wenn es beginnt

VITA = ev. jede Bratschen
als Anwesend einer Entwicklung ?

grosse werden
wir verschwinden
sich vervielfältigen
unregelmässiger werden

} wer spielt mit wem ?

8

Instruments for the first movement                    II movement

                                                      analogy

Instruments for the second movement

                              Each instrument is to be developed.
                              Though it has its characteristics to the
                              ear—it is not completed when it begins

                    VITA = he: each letter
                    as an Accent of a development?!

            getting bigger
            getting smaller          who plays with whom?
            multiplying
            getting more irregular

2 movement

ending
cf. V. E.
upper
group

Each moment must be able to exist in itself, i.e. it must be
completed, a world of its own . . . and open for the next
imply the next

themes

cf. page
V. E.

intuition
the untamed, chaotic
theme,—idea: the strictly tamed, mental
intellect

secondary
it follows the law

nature + mind are
not opposites.
The one completes itself in
the other. The law lies above
them.

Through color (material) the groups are
interrelated—or contrasted.

1 movement chao-tic
2 movement severe—rigid color value 1,2—1,2
3 movement changing
  chaotic—severe =
  general outline—noticing—knowing.
  power of creation.
  + truth    —

Allowing the truth of the chaotic
to be expressed . . . but it is
controlled by will: the manifest
law.—as far as it really
expresses just that—is not just
improvised

large orchestra

truth  must  be  1) recognized
               2) wanted
color-dominants separate for each        3) created
movement—but related to each other.           three
1. movement color original state:             dominant
   everything + running into one another      will
   "without" contour                    organic is not un-defined
                                        but multiply defined
                            inorganic—writing uni-defined
                                            [***]

                                                    complicated

a) geometric / vertical
b) organic   / horizontal

                                                    complicated

vegetative theme
cf. V. E. tree

Larger things (studies) one must
acquire—undergo—in order to overcome
them—forget them.—
Without having gone through them,
sources of error will persist—, and the
will to liberation is—clouded.

2 4 movement: develop the "stone" the
constant of the inorganic (fully into an
vita organ    idea), in its ties to the flowing—organic
(pre-thought persists)

With Klee (Kandinsky) the problem of
analogy    movement is very often solved with an
arrow → There it goes. This is not a
symbol.

Theme of the first movement: determine
the relationship between the organic +
inorganic: by the law of
rhythm        stones
of form       constant
of motion

Nature of relationship + matter [***] —:
of relations [***]

movement 1
ANALOGY

Once this analogy has          in rhythm
been determined—it can,        position
in the 2nd movement, be        law
used—as established

angular analogy
hor. left  right
vert.

ending

At the end: note down the working
procedure in detail. In order to eliminate
once and for all problems which were arising
here: start from all sides.

Bach: fugue in f-minor work      that means: subdivide +
big simple powerful              fill
pace-rhythm of the beginning     the interspaces =
subdivided into one-half         inter-signs.
[∗∗∗]  with one eighth           Play decisively
ending double pace               with the space
                                 in between.

1 Diagonal Symph. contain motion + moment of time =
2 Mass has no                                    rotation
3 Prelude has                                    extension
                                                 crystallization

what has to be "explained"—introduced and what thus requires passages, for example

Create tables for which contrast-analogies?

heavy : light horizontal expression
filled   : empty vertical        ″

already a
first movement

what is that?

      a line

           Here the playing against each
           other of lines constitutes the theme

there

      already area limitation

                      Do not show the outer but the inner
                      sequence.—Not biologically: how
                      something emerges (materialistically) but
                      rather logically = the sequence
                      corresponding with the meaning, the law.

By all means start with the most simple things: [***] On the other hand it is not
supposed to be on a level of schoolwork but mature (preconditional) expression.

*Detail upward*
*tendency downward*

*detail downward*
*tendency upward*

1  movement                    space is being filled

2  movement                    space is being formed
                               and determined

Group
always in
contrasting pairs

analogy position
intersections

single—repeated
parallel big small                          connected—inorganic—regular
intersected                                 isolated—organic—irregular

intersected                                     intersected
regularly repeated                              not repeated
geometric                                       organic
   moments even                          geometric
    moments uneven                     organic
    a strong [***]
    b elapsing
irregular =
organic
proximity =
analogy

  meaning        theme             positive   negative   organic
                                              +          −        repeated
                     number                          contrast
                                                     connection
horiz—vertical                                       filling

joined together
dissolved

single component
ornamental

determined
undetermined

224

(envelope, Dec. 1957,
Aufbau Publ.)

Front:

*to most*
f.*i. From organic*          *which possibilities of*
   *to geometrical order*     1). Transformation
   *(or reverse)*     *2 problems*     2). *Conditions*
                                 *Instruments*
                        3. *Dramatization*
                          + *Aim*

Back:

*The amorph should have*
*+ geometrical under + side plays.*
*to prepare the transition*

*The Also—(or) the "back-ground" may*
*play their role + become forefront =*
*form = leading*

*to Chaos*

| Exposition | | Epilog |
1). Dominante mit Gegenspiel aus sich selbst – zusammenspiel
   erst in der mittleren Lage ausspielen
2) 2 Stimme mit Dominante als neues Zusammenspiel
3) 3 Stimme : Kontra Dominante – Newellenkurve Erhöhung – weniger flüchtig;
   als 1 + 2 : Wille – Bewusstsein – Stabilität – klarer Ordnung = hart.

Thema des Organisten

I Satz.
a   Dominante durchweg führend – im Gegenspiel mit 2ᵗ Stimme.
    Kontra Dominante als Accent.

b.  2 Stimme Zwischenspiel – relative maximale Entfaltung bis zum Gegenteil
    genau mit gleicher Figur wie Beginn

c.  Kontra Dominante Zwischenspiel – relativ maximale Entfaltung
    genau mit gleicher Figur wie Beginn ( viele Tonleitern-Fanfare) absolut

d. Climax:   Dominante in größter Vielfalt als mehrere
    Instrumentgruppen – stark bearbeitet durch in d. verbreitete
    Kontra - Dominante - 2 Stimme nur analysierend
    begleitend.
    Erst hier Thema „frei" Parallelverein + fixes Theaterwesen
    Neue Form bilden.
    minimalen zur maximalen Ausdruck.

*Exposition*                                    *Outline*

Theme—repeat [∗∗∗]                                          permanent
                                                            change of
    1) dominant with counter-playing out                        the
flowing
    of itself—play ensemble-playing                          + structured
    only in medium register                                  The cheerful
                                                             be on top
2) 2 voice with dominant as a new                            The dramatic
    ensemble-playing                                         be on bottom

3) 3 voice—counter dominant—characteristic introduction less fluid; then 1 + 2: will—
    consciousness—stability—clearer structure = rigid

I Movement.                                              Theme The Organic

a  dominant is leading throughout—in counter-playing with 2nd voice. Counter
   dominant as Accent.
b  2 voice interlude—relatively maximal development all the way to the symbol—with
   exactly the same figure as beginning
c  counter dominance interlude—relatively maximal development exactly with same
   figure as beginning (cf. prelude—guitar)
                                   flowing against continuous

d  climax: dominant in utmost diversity = as several groups of instruments—strongly
   answered by counter dominance as brought forth in c.—2 voice accompanies only
   in analogy
   Only here theme "free" parallelism + free improvisation
   Creating new form.
   Minimal expression before maximal expression.

light    dark

circle + rectangle                          Horiz. or vertical development?
                                            Closed or open?
                                            *Ramassé* or *allongé*?

limitations through lines
strictly limited
K cancelled
smaller K: top/bottom       empty
K
filled
diagonal:
radical

and
are incompatible.

radial   :   parallel   are 2 different motives
i.e. philosoph: emanating from one center
                and           are 2 diff.
      running parallel        calculations.

Objects

| I | II | III |
|---|----|-----|
| parallel | parallel in pairs | IV |
| | contrasting in groups | |
| | vertical : horizontal | |
| | open | |
| | *allongé* | |

III

counterposed in pairs
" in groups
closed : open
*allongé*
surface complicated

IV

counterposed crosswise
in pairs
counterposed in groups
horizontal
closed
*ramassé*
surface uncomplicated

possibilities
of the
basic form

| | | | |
|---|---|---|---|
| 1 | line | area | |
| 2 | geometric | | |
| 3 | regular | irregular | |
| 4 | diagonal | | emanating from point |
| 5 | long-short | short-long | emanating from line |
| 6 | empty | filled | emanating from area |
| 7 | single | multiple | limited on one side |
| 8 | internally linked | separated | limited on two sides unlimited |
| 9 | not intersecting | intersecting | |
| 10 | *allongé* | *ramassé* | |
| 11 | horizontal | vertical | |
| 12 | parallel | counterposed | |
| 13 | open | closed | |
| 14 | simple | complicated | |
| | dark on light | light on dark | |
| | straight ~~line~~ | ~~bent line~~ | |
| | solid | ~~shaky~~ | |

What are the analogies within this table?
"    "    " contrasts

Table of Differentiation

line without areal limitation                    Essence + Substance
area without line limitation

line with areal limitation
area with line limitation

(1⁰ moral 2⁰ material)
1⁰ similarity of will—analogy of border
   (moral 2⁰ material)
2⁰ difference of will—contrast of border
1 moral 2⁰ material
1⁰ contrast of manner—difference of material
   material moral
2⁰ similarity of manner, inner points of coordination

                    manner
1  With similar material, the difference of will is primary, the
   similarity of will is secondary.
2  With similar will, the difference of manner is primary, the
   similarity of manner is secondary.

1  Visible tangible contrasts of will +
   matter
2  Mysterious links between will and
   contrary matter.

Visible tangible similarities between       Sensory contrast
matter and will                             of will
                                            Similarity of
Mysterious contrasts between will           material
within the same matter. (large page)        Contrast of material
                                            Similarity of will

Mysterious similarity of will
Contrast within material

variations
of parallel

filled      empty K
area   =   line    A

point  emanating

Actually
[∗∗∗]    =
parallel

but one
theme conceivable as variation

Variations

eccentric concentric          variation with separate K +
K.                          A emanating from point.
intersected
Always at least
one contrast
variation                                    +
no contrast    filled   empty            one analogy

as a beginning

variation
with intersected

separate                                                          1 group single

linked                           transformations              2 group double

intersected                                                    3 group multiple

                                                                1 meaning main characteristic

## Chronology

Art is politics. Everything that

takes hold of the flow of life for

its own end is politics. **Hans Richter**

**1888** 6 April: Johannes Siegfried (Hans) Richter, the first of six children, born into the well-to-do Richter family living at Universitätstrasse 3b in Berlin.[1] Hans's father, Moritz Richter, practiced several different professions (real estate speculation, farming, furniture making) and during World War I was a legation councillor in Constantinople in the German Foreign Service.[2] Hans Richter's mother, Ida Gabriele Richter, née Rothschild, was born on 28 April 1864, in Cologne. Participation in the arts was viewed as an integral part of life for members of the Richter family.

**1902** Richter's parents sent him to a boarding school in Seesen in the Harz mountains, where he drew portraits of his schoolmates during class. They attracted the attention of his teachers, who praised the accuracy of his drawings.

**1904** At sixteen, Richter visited an exhibition of pastel drawings by Edouard Manet in Berlin. His impression was one of experiencing "absolutely heavenly music."[3]

von Hofacker

**1906** Richter graduated from the Falk-Real-Gymnasium in Berlin. His greatest ambition was to become a painter. His father, however, did not allow him to enroll at an art academy, choosing architecture for his son's vocation instead.

**1908** After Hans completed his apprenticeship in carpentry, Moritz Richter permitted him to enroll at the Academy of Art in Berlin. He studied there for one year and then transferred to the Academy of Art at Weimar. Richter copied paintings of the Old Masters at the Kaiser Friedrich Museum and the National Gallery in Berlin. A gallery in Bielefeld exhibited these paintings in 1913, paying Richter an amount he considered to be a small fortune.

**1910–1911** A publisher in Weimar commissioned Richter to complete six hundred pencil sketches illustrating the text of Boccaccio's *Decameron.* When he worked the drawings over in ink, he ruined them. Richter attended the Académie Julian in Paris.

**1911** In Paris, Richter collaborated with Emil Szittya on the publication of the journals *Les hommes nouveaux/ Neue Menschen,* for which he also wrote poems.[4]

**1912** When he returned to Berlin, Richter visited the Secession exhibition and saw Cézanne's painting *Les grandes baigneuses* for the first time: "I found it awful, ridiculous, badly drawn. An hour later I saw it again; I wasn't looking at it, it was looking at me! Suddenly something struck me, a kind of musical rhythm. . . . That was, so to say, the first finger that touched me from the hands of the gods of modern art. . . ."[5]

Richter relinquished portraying academic subjects and took up political and working-class themes. He observed rhythmical movement in musicians performing on their instruments, in the repetitive body movements of crews working in the streets, and in the movement of crowding masses at demonstrations, all of which he recorded in drawings and paintings. Richter's dynamic manner of painting and his colors indicated his leanings toward expressionism.

**1913** The year before the onset of World War I, Richter joined the mainstream of the avant-garde movement in Berlin that centered around Herwarth Walden, the publisher of the expressionistic art magazine *Der Sturm* (Storm). Richter became acquainted with members of the groups Die Brücke (Bridge) based in Dresden, and Der Blaue Reiter (Blue Rider) in Munich. He met Filippo Tommaso Marinetti, the Italian poet and leader of the futurists, who articulated the machine aesthetic. During Marinetti's visit to Berlin, Richter enthusiastically handed out flyers of the *Futurist Manifesto* to passersby and cab drivers at the Potsdamer Platz station. Richter was deeply affected by the gallery's autumn exhibition of 360 modernist paintings: "There I saw and realized, for the first time, what modern art was all about. . . . At the 'Herbstsalon' I saw modern art in all its glory; Picasso, Braque, the Futurists, and so forth."[6]

Richter began to push further and further toward abstraction: "What influenced me in Cubism was not only the new form of expression but the courage, the audacity to dare this step. . . . The structure of Cubism, Cubism as a constructive principle, seemed to me by far the most important step in painting made in our century."[7]

The possibilities of counterpoint that Richter introduced at this time are explored in all of his future works.

**1914** Richter joined the circle of expressionist artists gathered around Franz Pfemfert, publisher of the Berlin journal *Die Aktion* (Action). The group's socialist leanings and its antiwar course were compatible with Richter's "anarchistic tendencies."[8] Richter drew portraits of the writers and poets to accompany their published texts, which appeared bimonthly. Richter described Franz Pfemfert as

> the open-minded and sensitive no-nonsense publisher and editor of *Die Aktion,* the review of the new German literary generation between 1912 and

1920, [who] was actively anti-Kaiser and antiwar as well as protector and admirer of the young generation of poets and artists. He had an unerring sense of quality and an incorruptible intelligence. For those of us who searched for a new measure, a new image of man, he was a "patron saint." In his always crowded tiny office one met [Carl] Liebknecht and Rosa Luxemburg, as well as Carl Einstein and Däubler, Heym and Van Hoddis, Otten and Schickele, Kokoschka and Meidner, Schmidt Rottluff, Kafka and Franz Jung, Expressionists, Dadaists, Socialists, Tolstoyists, Cubists, poets and politicians.[9]

War was declared on 4 August, and on 15 September Richter was inducted into the army. The poets Ferdinand Hardekopf and Albert Ehrenstein gave Richter a farewell party. To give him some hope and consolation, they promised to meet in Zurich, in two years, at the Café de la Terrasse at three in the afternoon, provided, of course, that all three friends were still alive.[10] A few months later, serving in the light artillery, Richter was seriously wounded at Vilna, Lithuania. Partially paralyzed, he was sent to a hospital in Tilsit and was then transferred to Hoppegarten military hospital near Berlin (**fig. 9.1**).[11] His twenty-three-year-old brother Fritz was killed at the front, and his brother Richard, at twenty-one, was severely wounded.

**1915** On 13 February, two drawings by Richter appeared in *Die Aktion*. During the next three years, thirty-two graphics by Richter were published in *Die Aktion*.

**1916** In March, Richter was discharged from active duty and was placed in the reserves. On 25 March, Pfemfert honored him with a special issue of *Die Aktion,* called the "Hans Richter Heft" (Hans Richter Issue). Seven drawings appeared in this issue, as well as an essay about Richter by the art critic Theodor Däubler entitled "Notiz über den Maler Hans Richter" (Notes on the Painter Hans Richter). This essay was the first serious

review written about him, naming his aims and work as an artist. "The radical in him makes his talent thrive. The more he penetrates the problem of modern art, the more he gains in artistic stature. He has opted for all that is most modern, but he doesn't paint to a program, not even his own."[12] On 7 June, Richter had his first comprehensive exhibition at the Galerie Neue Kunst, located on the Briennerstrasse in Munich and owned by Hans Goltz. Richter designed a poster depicting a musical theme and was represented with seventy works (**fig. 9.2**). In the preface of the exhibition cata-

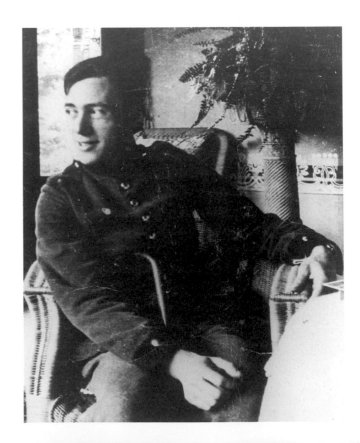

logue written by Richter, Dada ideas were anticipated: "Complexity at the price of standing still is a result of the bourgeois cowardice, which is so attached to the conventions it has come to take for granted that an attraction toward African sculpture and cubism appears as a precious artistic trick, on which they may elaborate the intellectual judgments of their never adventuresome thinking."[13]

Richter married Elisabeth (Lisa, Liesl, Lieska) Steinert on 28 August.[14] He traveled to Zurich with his wife to consult the specialist Professor Veraguth about his back injuries and used this as the opportunity he had

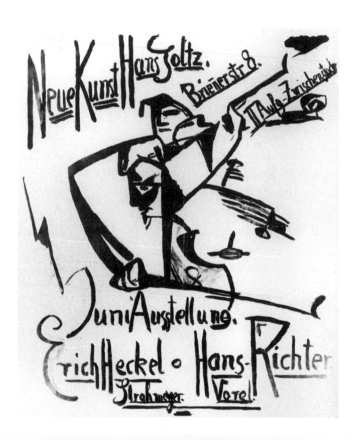

been waiting for "to get out of Germany."[15] On 15 September, Richter kept the appointment he had made two years prior to meet his Berlin friends in Zurich—and thereby met the initial core of the Dada group, which had formed in February:

> At three o'clock in the afternoon, I was in the Café de la Terrasse—and there, waiting for me, sat Ferdinand Hardekopf and Albert Ehrenstein. This unlikely encounter, like something in a dream, was followed by another. A few tables away sat three young men. When Ehrenstein, Hardekopf and I had exchanged our news, they introduced me to the three young men: Tristan Tzara, Marcel Janco, and his brother Georges. So it was that I landed on both feet, squarely inside what was already called the Dada group.[16]

**1917** In January, Richter designed a large poster announcing the first "Dada Exhibition" of abstract art at the Galerie Corray, located at Bahnhofstrasse 19. He exhibited paintings there with van Rees, Janco, Arp, Tscharner, Mme. van Rees, Lüthy, and Helbig, and works of art from Africa. On 23 March the grand opening of the Galerie Dada at the Galerie Corray took place. Richter raised funds for the event. The United States entered the war on 4 April, and on 9 April the second exhibition of German painters from Berlin's Sturm Galerie opened at the Galerie Dada.

Richter, however, still kept up ties with colleagues in Berlin. He contributed two drawings to the 17 April issue of *Die Aktion,* honoring the poet and editor Ludwig Rubiner.

From 2 May to 29 May the third exhibition at the Galerie Dada took place, in which children's drawings were included. At the end of May, Hugo Ball broke with Dada and left Zurich. He considered suing Tzara for misappropriating the funds of the Galerie Dada, but was dissuaded from doing so by Richter.[17] During May,

June, and July, Ludwig Rubiner published three of Richter's linoleum cuts in his magazine *Zeitecho* (Echo of the Times). In the essay printed in *Zeitecho* titled "Ein Maler spricht zu den Malern" (A Painter Speaks to Painters), Richter vented his feelings about the horrors of war and expressed his views on the political and social responsibility of the artist. This was Richter's first written statement on the artist and political awareness.

> If there is anything that is equally active in all of us, it is the grinding pain and disgust and bitter shame at living and making such an age with such good intentions and against our better knowledge.—How can one answer for its being so terrible and mindless, without spewing forth all one's wailing, hurting, and howling, as articulately as one is, as precisely as the terrifically sharpened awareness of guilt and injustice permits to the guilty and the good. . . . If painters would only take the view that painting should be an utterly human affair and an intellectual initiative, what could stop them from eliminating the vogue word ART for their graphical expressions?[18]

Richter oscillated between the idea of the political responsibility of the artist—an idea coming from the *Aktion* circle—and the humanist belief in the immanent good of man and his final transcendence of evil to create a better world. Richter's pacifist convictions began to waver. He felt he must be more politically active and use more direct approaches to resolve the conflict that war posed for him:[19] "Though Dada was not a political movement, we were all in one way or another connected and influenced politically by the war. Several of us were already loosely connected with the Anarchist group of Bertoni in Switzerland."[20]

Bertoni was a follower of Michael Bakunin. Richter attended meetings of the anarchist group; his interest in pacifist theory ended. He had a falling out with the radical socialist Rubiner, probably because Richter's

art did not fulfill Rubiner's criterion for a universally understood art. In June, Hugo Ball made note of the polarization of these two groups of exiled artists: "An interesting if not necessarily fruitful difference [arose] between us *the aestheticians* (Hans Arp, Ball, Janco, Richard Huelsenbeck, Hennings, and Tzara) and *the moralists* gathered around Rubiner (Ehrenstein, Leonhard Frank, Straßer, Schickele, etc.)" (emphasis added).[21] After Richter's falling out with Rubiner, he switched camps without further reservation and joined the Dadas: "That was the mysterious message which led me from Cubism to Dada and from Dada to abstract art and the promise of total freedom."[22]

Richter began painting the free-style *Visionary Portraits,* finding expression in a spontaneity governed by chance and the unconscious. He painted in an explosive manner that was relatively uncontrolled, in a "sort of self-induced trance," that took shape before the "inner rather than the outer eye."[23]

In July appeared the first issue of *Dada,* edited by Tristan Tzara (**fig. 9.3**). (The last number appeared in March 1920.) The Bolshevik Revolution in Russia began in October. The first issue of *De Stijl,* edited by Theo van Doesburg, appeared in Leiden, Holland.

**1918** January: Richter felt the need to apply more structure to his drawings. He met the Italian composer, Ferruccio Busoni, who advised Richter to study Bach's *The Notebook of Anna Magdalena Bach* of 1725 in order to learn more exactly the principles of counterpoint. India ink pen and brush drawings titled *Dada Heads* were the result of these formal studies: "What I tried to find was not chaos but its opposite, an order in which the human mind had its place but in which it could flow freely. . . . It allowed me also to discard objects (subject matter) altogether and articulate free abstract parts on a given plane against and with each other. It came to be a kind of musical as well as visual articulation."[24]

A drawing by Richter depicting a flagbearer for the new newspaper the *Freie Zeitung* (Free Newspaper),

started in 1916 and edited among others by Hugo Ball, was used for subsequent covers.

Early spring: Helmuth Viking Eggeling arrived in Zurich. Tristan Tzara introduced Richter to the Swedish painter.[25] This meeting marked the beginning of an artistic collaboration that had far-reaching effects. Eggeling had begun to create a vocabulary of abstract form, intending to explore its grammar and syntax by combining the forms into pairs of contrapuntal opposites within a system based on mutual attraction and repulsion of paired forms.

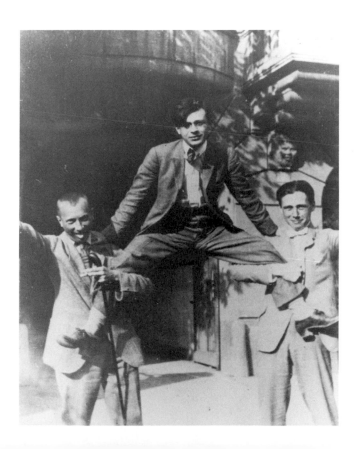

On 23 July Tristan Tzara directed the Dada soireé at the Saal zur Meise. He recited his *Manifeste Dada 1918.* Laban School members performed dances, wearing masks made by Janco. Richter designed the poster advertising the event.

Emmy Hennings looked for an artist to illustrate her book *Gefängnis* (Prison). (At the onset of World War I she had been arrested for forging passports for soldiers and conscientious objectors who wanted to flee Germany.) Richter began a large series of sketches and drawings on this subject. He later wrote, "outrage gave my pencil wings. I protested that this sensitive creature should ever have been thrown into a prison cell."[26]

From September to October the exhibition "Die Neue Kunst" (The New Art) was held at the Kunstsalon Wolfsberg in Zurich. Arp, Baumann, Hennings, Janco, Morach, and Richter participated. Richter showed eleven oil paintings on the theme of the visionary portrait and four drawings.[27] The exhibition signaled the end of the period of "balance" within Dada for Richter. It was marked by a parallel exhibition of works by the Spanish Dadaist Francis Picabia that took place simultaneously in another wing of the gallery.

On 7 November Kurt Eisner led a bloodless uprising in Munich and attempted to establish a socialistic democracy. A day later revolution broke out in Germany. Kaiser Wilhelm abdicated; Fritz Ebert became chancellor. World War I came to an end on 11 November.

The end of the war brought about the end of Dada in Zurich; the Zurich Dadas joined other progressive artists in Switzerland, forming the group Das Neue Leben (The New Life) in Basel. Janco described the Dada spirit within this group: "While it was tearing down, Dada also experimented and created the foundations for a new social aestheticism to serve the artist—at least in its last positive phase."[28] Richter did not participate in the group's first exhibition. The Dada art-

von Hofacker

ists worked under the name of Das Neue Leben until 1922.

December 3: The Novembergruppe met for the first time in Berlin. Richter was a member of the Novembergruppe from the outset.[29]

*Dada 3* appeared. Richter contributed two black and white linocuts on the *Dada Head* theme to the German issue, and three to the French edition of the magazine.

**1919** 15 January: Karl Liebknecht and Rosa Luxemburg were murdered by the Freikorps.

In the beginning of February, Hans Richter traveled from Lugano to Bern at the request of René Schickele, editor of the literary and political magazine *Die Weißen Blätter* (White Pages), to draw portraits of prominent political figures representing socialist parties and labor organizations of all countries, who were attending the first postwar meeting of the Second International. A small minority in attendance demanded revolution, nationalization of property, and immediate implementation of socialism, following the Russian example. Quickly overruled, the group repaired to Moscow and founded a new, Third International in conjunction with the Russian Communist Party.

Kurt Eisner was also present at the meeting in Bern. It is probable that Richter met with Eisner on this occasion.[30]

February 21: Kurt Eisner was assassinated by Count Anton Arco-Valley. In March Richter traveled first to Munich and then to Berlin to participate in the political events in the making,[31] then returned to Switzerland. On 7 April the Revolutionary Central Committee in Munich (including the literary leaders Ernst Toller, Erich Mühsam, and Gustav Landauer) proclaimed the Council Republic. It collapsed after a week because of internal discord and the communists' refusal to support it.

In April Richter founded the Bund Radikaler Künstler (Association of Radical Artists) in Zurich, calling for rad-

ical art reform, redefinition of the role of art in society, and the participation of artists in the formation and ideological evolution of the state. The manifesto proclaimed abstract art as the only acceptable form of art: "Besides, revolution in Germany, uprisings in France and Italy, world revolution in Russia had stirred men's minds, divided men's interests, and diverted energies in the direction of political change."[32]

9 April: The eighth Dada soirée, and the last Dada event in Zurich, took place in the Saal zur Kaufleuten. The program, under the direction of Walter Serner, was divided into three parts (**fig. 9.4**). Viking Eggeling held a discourse on abstract art and Hans Richter read a piece called "Gegen, ohne, für Dada" (Against, without, for Dada). Tzara called Richter's address "malicious, elegant, Dada, Dada, Dada."[33] Richter and Arp de-

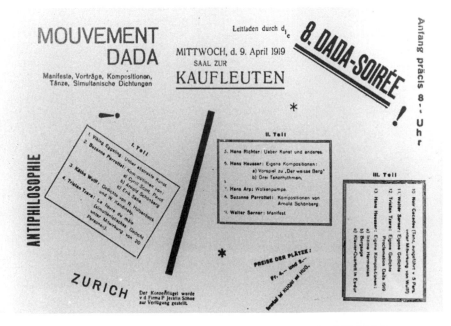

von Hofacker

signed sets for the dances choreographed by Sophie Taeuber, which the Laban School troupe performed. Richter may also have read his "Manifest radikaler Künstler" to the audience. This manifesto, which set up an all-encompassing program for radical art reform redefining the role of art in society, failed to go to press as planned because of Richter's sudden departure for Munich.[34]

Richter received a telelgram from his political friends in Munich, where revolution had broken out, telling him that he was needed and had to come at once. He went in a great hurry immediately after the eighth Dada soirée ended.[35] In Munich he joined his friends Alfred Wolfenstein, Nelly Sachs, Frida Rubiner, and H. Davringhausen, and his brother Richard Richter. Janco later emphasized: "[Hans Richter] had a revolutionary mind; he was a socialist, he had personally taken part in such activities in Germany and he was dreaming of a new social art."[36]

The Council (Soviet) Republic led by the literary anarchists Toller, Mühsam, and Landauer collapsed on 13 April after one week of existence. The Communists Eugene Leviné, Max Levien, and Towia Axelrod took power in Munich. On 19 April, during his stay in Munich, Richter was appointed chairman of the Action Committee of Revolutionary Artists, in charge of the seven units of the Kunstkommissariat (art commission) on matters concerning painting.

22 April: Richter attended the meeting of the Action Committee.[37] Points on the agenda were raising funds for social welfare, sale of the inventory of the palaces in Bavaria to foreign countries, and confiscation of important buildings in Munich, such as the royal palace.[38] On 23 April the Action Committee discussed the topic of general health insurance coverage for all artists.

24 April: At this meeting of the Action Committee, it was decided that Richter should read the Zurich Manifesto to the other Commissariat members. The Munich Council Republic met for the last time on 30 April. It

was riven by disagreement between the communists and the Independent (or Utopian) Socialists (USPD); Levien and Leviné resigned, ending the Munich Soviet. Twenty royalists and conservatives taken hostage at the Luitpold High School were murdered by retaliating revolutionary groups.

On 1 May The Bavarian Freikorps under Baron von Epp and troops of the rival state government sitting in Bamberg took Munich with much bloodshed, killing one thousand people in six days. Landauer was murdered on 2 May. Richter tried to leave Munich and return to Zurich via Austria.[39] He and his brother Richard were arrested, tried, and sentenced to life imprisonment. Ida Richter intervened on behalf of her sons. Through her influential connections at the Ministry of Justice, the brothers were released after two weeks' detainment.

4 May: A column about the "Manifest Radikaler Künstler Zürich 1919" was published in the *Neue Zürcher Zeitung.*

7 May: Treaty of Versailles.

The last publication of Dada appeared on 15 May. It contained two woodcuts by Richter, an illustration of his oil painting *Portrait Makabre,* and his manifesto "Gegen, ohne, für Dada."

The first issue of *Der Dada,* edited by Raoul Hausmann, George Grosz, and John Heartfield (Helmut Herzfelde) appeared in Berlin.

Richter returned to Zurich, resuming his studies of opposites with Viking Eggeling. Eggeling was in the process of creating an elementary syntax of form relationships for a "Universal Language" he called *Generalbaß der Malerei* (ground base of painting). In mid-September, Arp, Serner, and Tzara staged the ninth Dada soirée in Zurich. In November the first and only issue of *Der Zeltweg* was published.[40] The editors planned to publish "The Radical Artists' Manifesto" but later discarded the idea. A second issue of *Zeltweg* was planned but did not materialize. In December Tzara left

for Paris. This occasioned the end of Dada activities in Zurich.

Richter's parents invited Viking Eggeling and his wife Marion to live on their estate in Klein-Kölzig, Nieder Lausitz.[41] There Richter and Eggeling resumed the experiments with geometric compositions that they had begun in Zurich. Eggeling reduced form to lines arranged in patterns, whereas Richter's images included geometric forms. Richter completed *Präludium,* also known as *Composition Heavy/Light,* the first scroll drawing and the culmination of his study of single drawings. Not entirely satisfed, he decided the units must move convincingly from that point on and that film was the only means to achieve this goal.

**1920** Eggeling and Richter wrote the pamphlet "Universelle Sprache" in which they likened abstract form to a kind of universal language that everyone was capable of understanding. In June they sent this tract to prospective sponsors whom they asked to confirm their support to the Universum-Film A.G. (UFA) studios. Eggeling and Richter received a grant from the UFA studio. They rented an animation studio and hired a film technician.

The experiments at the UFA studio proved unsatisfactory. Discouraged with the difficulties, Eggeling and Richter no longer saw eye to eye on how to continue. Richter decided to animate simpler geometric forms. The drawing *Fuge* (1920) was finished. Richter and Eggeling took part in the exhibition "Gruppe Neues Leben" in Basel.

The Dada Fair was held in Berlin, where the politically leftist Berlin Dadas were avidly interested in the art of the Russian Revolution.[42] At the doors of the fair, a huge sign read, "Art is dead, long live Tatlin's new machine art."

November-December: Theo van Doesburg came from Holland to Klein-Kölzig because he had heard about Eggeling and Richter's work. He encouraged Richter to publish a journal on the same lines as his magazine *De Stijl* as a platform for Dada ideas.[43]

**1921** Van Doesburg returned to Germany. Richter, estranged from his first wife Elisabeth, married Maria von Vanselow, a member of the Zurich Laban dance group.

10 May: Van Doesburg wrote an article called "Abstract Filmbeelding" in *De Stijl* in which he described Eggeling and Richter's cooperative efforts to overcome "the static nature of easel painting."

Ludwig Hilberseimer, the Berlin architect and city planner, wrote the article "Bewegungskunst" (Kinetic Art) in the *Sozialistischen Monatshefte* (Socialistic Monthly), published 23 May.

Richter's and Eggeling's article "Prinzipielles zur Bewegungskunst" was published in *De Stijl* in July. Richter's drawings *Schwer/Leicht* and *Horizontal/Vertical* accompanied the article.[44]

Richter introduced Kurt Schwitters to Theo van Doesburg.

Late fall: Richter came to the conclusion that filmmaking was governed by laws that did not apply to painting. He decided to discard form altogether and articulate time in various rhythms and tempi instead. He adopted film and the oblong film format as the material he would work with. The single forms no longer had any meaning whereby the relation and interaction of the forms became relevant. Richter later described it as follows: "The simple [square] of the movie screen could easily be divided and orchestrated by using the rectangle of the cinema-canvas as my field of pictorial vision. Parts of the screen could then be moved against each other. Thus it became possible on this cinema-canvas to relate (by both contrast and analogy) the various movements to each other. So I made my paper rectangles and squares grow and disappear, jump and slide in well-articulated time-spaces and planned rhythms."[45]

Richter's first film, called *Film ist Rhythmus* (Film Is Rhythm), was completed around December. The film's running length was one and a half minutes. Theo van Doesburg showed this film fragment during a lecture tour in Paris. The atmosphere was hostile. Richter was

von Hofacker

introduced as a Dane because anti-German senti-
ments were still running high at the time.[46]

The art historian Adolf Behne wrote "Der Film als
Kunstwerk" (The Film as a Work of Art) for the *Sozialis-
tischen Monatsheften,* describing Eggeling and Rich-
ter's project: "This film, a logical development of
abstract forms of geometric precision, is a true motion
picture for the first time, an independent art work not
requiring any addition. The law of artistic movement se-
quences appears in complete clarity and tectonic disci-
pline, which an artistically sensitive person cannot
help perceiving."[47]

**1921–1922** December-January: To finance further film exper-
iments, Richter produced commercial films on a small
scale. Köschel, the florist shop located on the ground
floor of the building where he lived, hired him to adver-
tise its wares. He installed a film projector in an upper-
story window of his apartment and projected animated
figures onto the sidewalk below. Crowds gathered and
had to be dispersed by the police.[48]

**1922** In February Richter met Werner Gräff, a Bauhaus stu-
dent, who soon became his assistant. According to
Gräff, Richter was working on a new film score, in later
years named *Fugue in Red and Green,* mistakenly
dated 1923 but already completed in 1922 at the time
of Gräff's first visits to Richter's studio. Gräff ques-
tioned the shape of Richter's upright forms when the
shape of the cinema screen was horizontal. "From now
on [Richter] designed film moments in the horizontal
format 3:4."[49] Because Richter conceived *Fugue in
Red and Green* of 1922 as a predominantly white on
black animated film, the positive copy had to be colored
red and green—frame by frame—by hand, as color
film did not exist yet.

Richter and Gerd Caden founded the Constructivist
Group in Berlin. It was an extension of the Gruppe
Neues Leben from Basel and the Bund Radikaler
Künstler in Zurich.[50]

Spring: At the height of the German hyperinflation, the Richter family was forced to sell the estate in Klein-Kölzig. Hans Richter was estranged from his second wife Maria von Vanselow. Richter and Eggeling's friendship was strained, leading to the end of their collaboration.

March: The Soviet government commissioned El Lissitzky to prepare the "First Russian [Art] Exhibition in Berlin." The Russians exhibited six hundred works of art at the Galerie van Diemen. Lissitzky asked Eggeling and Hans Richter to collaborate on the magazine *Veshch-Objet-Gegenstand.*[51] Eggeling was not interested; rather than collaborate on *Veshch,* Richter decided to set up his own magazine.

May: Theo and Nelly van Doesburg moved to Weimar. A meeting of the International Congress of Progressive Artists took place in Düsseldorf from 29 to 31 May. Richter attended, representing his magazine *G* (for *Gestaltung*), the first issue of which was still in planning. Schwitters represented his periodical *Merz* (Germany), van Doesburg *De Stijl* (Holland), Lissitzky *Veshch* (Russia), and Moholy-Nagy *MA* (Hungary). In a cooperative declaration that van Doesburg published in *De Stijl,* the representatives of the journals expressed their hope that they "will no longer be tossed about between the two societies, one of which has no need of them, and the other which does not yet exist, and that they will be in a position to transform the present world."[52]

In September, at the Bauhaus in Weimar, members of the Congress of the Constructivists held a meeting at which they celebrated an official farewell to Dada. Tristan Tzara traveled from Paris to deliver the funeral oration for Dada.

**1923** Richter published the first issue of *G* in July (**fig. 9.5**) and the second in September. These two issues appeared in newspaper format and carried the subtitle *Material zur elementaren Gestaltung.* (The next three issues, appearing in June 1924, March 1926, and April

1926, bore the subtitle *Zeitschrift für elementare Gestaltung.*) The editorial staff was composed of Richter, Werner Gräff, and Ludwig Mies van der Rohe. Articles were contributed by artists and architects such as Mies, Tzara, Gabo, Pevsner, Malevich, Kiesler, van Doesburg, Arp, Schwitters, Lissitzky, Hausmann, Grosz, Man Ray, and Richter.

Richter completed two horizontal scrolls in oil, *Rhythmus 23* and *Fuge 23.* The third scroll Richter completed is called *Orchestration der Farbe* and has a vertical format.

6 July: The final Dada soirée, "Soirée du coeur à barbe" (Soirée of the Bearded Heart), took place in Paris at the Théatre Michel. Richter's *Film ist Rhythmus,* or *Rhythmus 23,* was shown, along with films by Man Ray (*Retour à la raison*) and Charles Sheeler (*La fumée de New York*). The performance ended in a riot.[53]

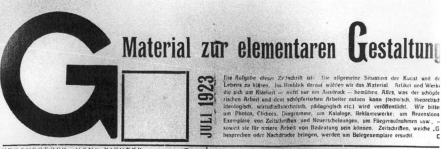

**1924** Hannover: A collective exhibition of work by artists and writers contributing to *G* was arranged at the Kestner Gesellschaft.

Richter completed *Rhythmus 25,* his last abstract film. He hand-colored the film frame by frame in primary and secondary colors. Because of the high cost of production only one copy was made, and it was later lost.

**1925** 3 May: The November Group sponsored a film matinee entitled *Der Absolute Film* at the UFA *Filmpalast* (theater) on the Kurfürstendamm in Berlin, featuring *Reflektorische Farbenspiele* (Reflecting Color Play) by Hirschfeld-Mack from the Bauhaus, *Film ist Rhythmus* by Hans Richter, *Symphonie Diagonal* by Eggeling, *Opus 2, 3, and 4* by Walther Ruttmann, *Ballet mécanique* by Fernand Léger and Dudley Murphy, and *Entr'acte* by René Clair and Francis Picabia.

19 May: Viking Eggeling died at the age of 45 in a Berlin hospital.

Richter stopped painting and turned his full attention to film.

Sergei M. Eisenstein completed his revolutionary montage film *Panzerkreuzer Potemkin* (Battleship Potemkin). Richter described the experience of seeing the film:

> I was at the opening of *Potemkin* in the Alhambra on Kurfürstendamm, one of the most elegant Berlin theaters. I never experienced anything like that either before or after. . . . After only the first twenty minutes, a lost revolution, a successful inflation, marches and uprisings, the emotions of the Berliners had reached a boiling point. They were seeing their own—unsuccessful—revolution. The infested meat . . . their wartime rations . . . the Cossacks, their own armed forces, their Noske and the different Storm troops.[54]

von Hofacker

In the mid-twenties Richter took several trips to Paris. He celebrated New Year's Eve 1924 with Man Ray, who introduced him to surrealism.[55]

**1926** Richter completed *Filmstudie* (Film Study), a poetical film that portrayed inner visions in a surrealistic manner. Richter met Piet Mondrian in Paris.[56] In Berlin, Richter moved in Russian constructivist circles that included artists such as Naum Gabo, Antoine Pevsner, Nathan Altman, Ivan Puni, and Ilya Ehrenburg.

Kasimir Malevich came from Russia to visit the Bauhaus. On this occasion he saw a screening of Richter's film *Rhythmus 25*. He was impressed and suggested collaborating with Richter on a colored film to demonstrate his suprematist theories. Malevich provided an outline titled "Die Malerei und die Probleme der Architektur" and returned to Russia, leaving Richter in charge to carry out the film project for him. A sound track for Malevich's film project was completed, but the project was soon abandoned.

**1926–1927** Wanting to create a platform in Germany for experimental film, Richter founded the Gesellschaft für Neuen Film (Society for New Film) with Karl Freund and Guido Bagier.[57] The Gesellschaft ran films at the small UFA theater on Kurfürstendamm for a short time before it folded.

**1927** Hans Richter married Erna Niemeyer.[58]

**1927–1928** The Gesellschaft für Neue Musik (Society for New Music) asked Richter to make a film for the Baden-Baden Musikfestival Deutsche Kammermusik (Festival of German Chamber Music). The musical score for this film was composed by Paul Hindemith. For the film, which Richter entitled *Vormittagsspuk* (Ghosts Before Breakfast), he drew on Dada for inspiration—the only movement he claimed ever to have known completely. It was a film created for objects—hats, revolvers, coffee cups, hoses—that rebel against their everyday routine, moving independently at their own speeds until at the end order is restored. The mu-

sic was played by the orchestra from a score that was synchronized with the film. Although the film was set against a seemingly harmless domestic background, the film's political overtones appeared obvious to censors and caused difficulties for Richter.

**1928–1929** Production of the films *Rennsymphonie* (Race Symphony) and *Zweigroschenzauber* (Twopenny Magic) followed. These were shorts screened before feature films. To finance further film experiments Richter earned money making commercials for industry and writing for the media.

**1929** While Germany suffered from the Great Depression, Richter shot *Alles dreht sich, Alles bewegt sich!* (Everything Revolves, Everything Moves). The film had its premiere in Baden-Baden. SA officers who were present disliked the film's message and declared Richter to be a cultural Bolshevik (*Kulturbolschewist*).[59]

March: Richter insisted that the avant-garde film form was the only acceptable form in western Europe. On the other hand, the documentary film form was appropriate coming from Russia: "The development of a young art—a film form separate from the film industry is being realized in Europe—in Russia however, the most ingenious experiments in epic cinema take on a form that is understood by everyone right away. It has to do with the difference in the structure of society there. There is no such thing as an avant-garde."[60]

Richter was appointed the head of the film exhibition for the International Film and Photo Exhibition of the German Werkbund in Stuttgart (18 May–7 July). He invited avant-garde filmmakers from eastern and western Europe to take part. The Russian avant-garde was especially well represented. As a handbook to the film section of the exhibition, Richter wrote his first book, *Filmgegner von heute—Filmfreunde von morgen* (Film Enemies Today, Film Friends Tomorrow). Werner Gräff was Richter's coauthor, and Richter in turn coauthored Gräff's book *Es kommt der neue Fotograph* (The New

von Hofacker

Photographer is on His Way), which appeared at the same time.

September: Avant-garde filmmakers joined ranks at the Congress of Independent Cinematography at La Sarraz, Switzerland, trying to establish an international filmmaking cooperative that would enable artists both to remain independent of commercial film and to take a political stand against fascism. For a practice session in filmmaking, the cast, under the direction of Eisenstein and Richter, acted out the satire *Der Kampf des unabhängigen gegen den kommerziellen Film* (The Battle of Independent against Commercial Film, no longer extant). Ivor Montagu, head of the London Film Society, invited Richter to conduct a workshop in London with Eisenstein, who lectured on film. Richter's film *Everyday* was shot.

**1930** Richter was in Paris, where he attended the premiere of Buñuel and Dalí's film *L'Age d'Or* (**fig. 9.6**).

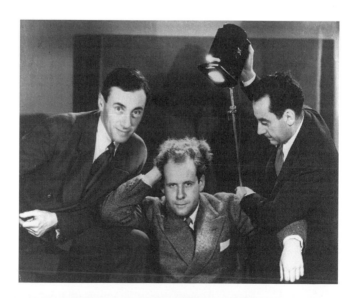

After his short interlude of producing surrealistic films, Richter resumed working with constructivist principles. He published the article "L'objet et mouvement" on 15 March in the constructivist magazine *Le Cercle et Carré*. Richter held various jobs in order to finance his film projects, among them the position of art, film, and music editor of the Berlin *Täglicher Rundschau* newspaper. He was invited to give lectures on film at the Bauhaus in Dessau.[61] He completed two documentary films: *Neues Leben* (New Life), which he produced for the Swiss Werkbund, and *Radio Europa,* commissioned by Philips, the Dutch electrical equipment firm.

September: The members of the Congress of Independent Film met again, this time in Brussels. Richter headed the German delegation.

Richter organized another film club, called the Deutsche Film-Liga, whose purpose was to sponsor films that were controversial and censored.

16 October: 140,000 metalworkers went on strike at the steel plants located in the town of Hennigsdorf, north of Berlin. "Steel Helmets" (*Stahlhelm* troops) attacked them, killing large numbers of strikers.[62]

**1931–1932** Richter signed a contract for a German/Russian coproduction of the film *Metall* (Metal) for Prometheus and Meshrabpom film studios, based on the events of the metalworkers' strike in Hennigsdorf. The script was written by the film author Friedrich Wolf, based on an idea and draft by Richter.[63]

May: The filming for *Metall* took place in Hennigsdorf, Moscow, and Odessa. Richter left for Moscow sometime after May.

**1933** 30 January: Hitler came to power.

During the course of shooting *Metall,* the script was altered seven times by the Russians as the political situation between Germany and Russia changed from day to day. While the last third of the film was being shot, the project was terminated and then entirely abandoned because the Soviet government did not want to risk provoking Nazi Germany.

27–28 February: The Reichstag building in Berlin burned. A week after the fire Richter's apartment was looted. Some of his art was confiscated by the Nazis, and some was destroyed. Thirteen works were officially entered into the journal recording the confiscation.[64]

1 April: In Germany, a new wave of anti-Jewish measures began. Jews were deprived of their constitutional rights. Those who held jobs at universities, theaters, publishing houses, and the press lost them. The modern art movement went underground.[65]

Caught between two totalitarian systems and their changing policies, Richter recognized the hopelessness of the situation—not only for the completion of his film but for his personal safety as well. Fearing reprisals from the Russians, he fled the country, leaving his possessions in Russia. Not able to return to Germany as a Jew, as an artist whose work was stamped *degenerate,* and as a citizen whose political affiliations had become illegal, Richter sought refuge in Holland. The electrical firm Philips gave Richter a contract for several film projects.

1934 April: Richter was registered as a resident of the Dutch town of Eindhoven. He traveled to Switzerland to work on film scripts. A project for a new film was concerned with the subject of discrimination against women in the workplace, for which the authors Anna Seghers and Friedrich Kohner wrote a script based on Richter's idea. Because of political developments in Germany and France, the project was not completed.[66]

1935 Richter lectured in Holland on film and published the pamphlet *Film: Gisteren, heden, morgen* (Film, Yesterday, Today, Tomorrow) for the Dutch Film Liga in Amsterdam. In September Hitler's "Nuremberg Laws" were passed, robbing Jews of their German citizenship.

1936 Richter continued his desperate efforts to establish residency in France or Switzerland. He was without possessions, documents, or a passport. On various

occasions he traveled to Meudon, France, where he stayed with Nelly van Doesburg, Hans Arp, and Sophie Taeuber.[67]

**1937** Richter moved from Holland to Switzerland. He found work at the Central Film studios in Zurich. He also exhibited again, participating in the famous constructivist exhibition in Basel. The article "Von der statischen zur dynamischen Form" (From Static to Dynamic Form) appeared in the second issue of the periodical *Plastique,* which was published by Sophie Taeuber in Meudon.

**1938** April: The article by Richter called "Kulturfilm als Kunst" (Cultural Film as Art) appeared in the magazine *Der Geistesarbeiter/Le Travailleur Intellectual* and was published separately by the Schriftstellerverein (Association of Authors) and the Gesellschaft Schweizer Dramatiker (Society of Swiss Dramatists).

**1939** Richter became the head of film production at the Frobenius Film Studios in Basel, a position he accepted when the company promised to produce Richter's film about Baron Münchhausen.

Richter completed the draft of his second book, *Der Kampf um den Film* (The Struggle for Film). It was not published until 1976.

23 August: The Nazi-Soviet non-aggression pact was signed.

1–3 September: Germany invaded Poland, and France and Great Britain declared war on Germany.

**1940** April: Richter lectured at the Film Conference in Basel.[68]

10 May: Germany invaded Holland, France, and Belgium.

The Swiss police pressured Richter to leave the country. His attempt to obtain immigration papers for Chile, where his sister lived, failed. At the urging of his brother Albert he applied for immigration papers to the United States but was not successful. Georg Schmidt, director of the Kunstmuseum Basel, invited Richter to

stay at his house in Binningen. They organized the first retrospective of Viking Eggeling's works.[69]

Hilla von Rebay, a friend from Richter's student days at the art academy in Berlin and a curator at the Museum for Non-Objective Art in New York City (later the Guggenheim Museum), invited Richter to give a series of lectures on "Absolute Film." She used her influence at the American Consulate in Basel to have immigration papers for Richter's departure issued before the Swiss authorities carried out their threats of deporting him across the border to Germany.

Since it proved impossible to receive immigration papers for aliens at this time, Richter applied for a visitor's visa stating his purpose there as delivering lectures on film. In a last great effort to save lives in Europe, various U.S. based groups such as Varian Fry's ERC (Emergency Rescue Committee) for endangered refugees and HIAS (Hebrew Immigrant Aid and Sheltering Society) helped artists and writers to come to the United States. Netty Berg, a schoolteacher from the Bronx who was affiliated with HIAS, volunteered to be Hans Richter's sponsor during his stay in America.[70]

**1941** 3 April: Richter traveled to Portugal via France and was interviewed by Serge Lang, who wrote the article "Quelques instants avec Hans Richter avant son départ pour l'Amerique" for *La Revue de l'Ecan*. On 2 June Richter was booked on the A. Export Line sailing from Portugal bound for Canada. He landed at Rouses Point and entered the United States by train:

> When I left Lisbon, on the eve of my fifty-third birthday, I felt sure that I would never see Europe again. My heart was heavy, looking at the vanishing lines of Portugal; it was no lighter when I landed in New York, the city terrified me—Sodom and Gomorrah. Not for any moral reasons, though; and certainly there were more than the proverbial five good people that would have changed the fortune of

Sodom and Gomorrah in the Bible. I was bewildered by the incredible and audacious arrogance of the buildings. The sky had become an accessory to the city, not the other way around; it was a small hole in the rooftops. It took some time for me to overcome the awesome inhumanity of the town. But later, when I met the people, this changed, and I changed too.[71]

June/July: Richter gave a lecture on film at the Documentary Film Producer's Association. Irving Jacoby, head of the newly founded Institute of Film Technique at New York City College, offered him a teaching position at the college. Its function was to help fill the government's need for trained filmmakers for production of documentary films. Richter accepted.

Aside from teaching, Richter held the administrative jobs of substitute supervisor and later director of the steadily growing Institute of Film Technique. Teaching suited him; he liked the spirited, independent-minded students he met in his classes.

My real contact with the new country was established by my work with the young people of America. ... I began to love this contact. It showed me a tough, skeptical but enthusiastic youth—as youth is more or less everywhere. The life with these people made me see America in its potential. I spent fourteen years with them. What I have learned since has deepened, but has not changed the outlook I gained then; it made an American of me in spite of the fact that I have never stopped being a European.[72]

8 December: The United States and Britain declared war on Japan; 11 December: Germany and Italy declared war on the United States.

**1942** In New York Richter met Frida Ruppel, who later became his wife. After an interruption of 15 years, he began to paint again. Together with European colleagues living in New York, he participated in the exhibition "Masters of Abstract Art." He wrote a two-part article, "Die Entwicklung des politischen Film" (The Development of the Political Film), pointing out the differences between political films from Russia and propaganda films from Germany.[73]

**1943** Vera Richter, Hans's younger sister, crippled at an early age in a riding accident, died as a victim of the Nazi euthanasia program.

**1943–1946** It took Richter a year to complete the scroll painting *Stalingrad* (1943–44). Of this work he said, "This is no longer abstract painting; it is a portrayal of the terrifying contemporary events by means of artistic forms born during our time." *Invasion* (1944–45) portrayed the events of the Allied landing in Normandy. *Liberation of Paris* (1945–46), was a vertical scroll expressing his feelings when he learned that the Nazis had been driven from this city.

**1944–1947** Richter interested Fernand Léger, Max Ernst, Marcel Duchamp, and Man Ray in collaborating on a full-length feature film in color. Financed by Art of This Century Film, Inc., *Dreams That Money Can Buy* was backed by Peggy Guggenheim, owner of the Art of This Century Gallery in New York, and Kenneth McPherson (**fig. 9.7**).

**1945** 8 May: War in Europe was over.

**1946** 26 October: Peggy Guggenheim gave Richter his first one-man exhibition in the United States.

**1947** One year after *Dreams That Money Can Buy* was released, Richter received the Special Award at the Venice Biennale for "the best original contribution to the progress of cinematography."[74] Richter became an American citizen. He was promoted to the position of professor at New York City College (**fig. 9.8**).

**1950** 10 February: The Galerie des Deux Îles in Paris showed Richter's first one-man exhibition in Europe in thirty years.

Viking Eggeling's works, stored in the depot of the Kunstmuseum in Basel since 1941, were sent to the National Art Museum in Sweden for an exhibition that Richter organized.

**1951** Hans Richter married Frida Ruppel.

The book *Dada Painters and Poets: An Anthology,* edited by Robert Motherwell, was published. Richter contributed a chapter called "Dada XYZ."

*Forty Years of Experiment,* a film anthology in two parts, included experimental films and film fragments that Richter and Eggeling had made in the twenties and excerpts from Richter's films produced in the U.S.

**1952** Richter traveled to Europe on a lecture tour. On 10 June an exhibition of his recently discovered works and some later works opened at the Galerie Mai in Paris in an exhibition titled "Hans Richter, oeuvres de 1912 à 1952."

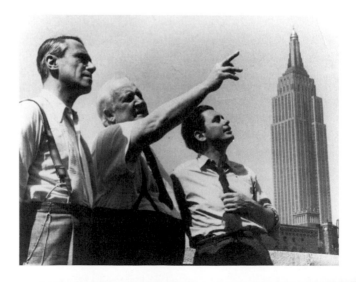

von Hofacker

**1953** Richter took part in a De Stijl exhibition at the Stedelijk Museum in Amsterdam. In December he participated in a collective Dada exhibition at the Sidney Janis Gallery in New York.

**1953** The anti-communist wave of the McCarthy era endangered Hans Richter's position as director of the Film Institute at City College.

**1953–1954** In Richter's 1948 script to the *Myth of the Minotaur,* the Narcissus episode from his film *Dreams That Money Can Buy,* was developed and expanded to a monograph.

**1956–1957** Richter produced his last film, *Dadascope,* a film collage composed of Dada poems by Arp, Hausmann, Duchamp, Man Ray, van Doesburg, Tzara, Huelsenbeck, and Schwitters that were written between 1916 and 1924. Against the background of the abstract poems that Richter called anti-poems, Richter's Dada friends acted out episodes for this "anti-film."

Inspired by work on *Chesscetera* (also called *Passionate Pastime*)—the film about the game of chess

starring Marcel Duchamp and the chess champion Larry Evans—the idea for a further film called *8 × 8* was born. The cast was made up of his Dada friends Arp, Huelsenbeck, Ernst, and Duchamp, as well as Julian Levy, Frederick Kiesler, Yves Tanguy, and others.

1 November: Richter retired from his teaching position and duties as director of the Institute for Film Technique at New York City College.

**1958** The Richters decided to live in Europe "part-time," spending the winters in the mild climate of the canton of Ticino in Switzerland. Richter shared a studio complex with other artists that was dubbed the Künstler Kibbutz (Artists' Kibbutz). They spent the summers living and working at their house in Southbury, Connecticut.

6 April: On his seventieth birthday, Richter was honored by a retrospective exhibition at the Corcoran Gallery of Art in Washington, D.C. In the fall he was honored by the Academy of Arts in Berlin with membership and a traveling exhibition called "Ein Leben in Bild und Film" (A Life in Image and Film).

**1960–1961** August: Richter gave three lectures on "Dream-Surrealism and Film: The Relationship between Modern Art and Modern Psychology" in Zurich.[75]

Richter's third book, *Dada Profile,* portrayed the personalities connected with Dada with whom he was associated between the years 1914 and 1930.

**1961–1963** Richter completed part two of the film *Dadascope.* Following his retirement from his teaching position and his move to Switzerland, he went through a period of immense activity and artistic creativity that peaked toward the end of the sixties (**fig. 9.9**).

**1964** Richter's book, *Dada, Kunst und Anti-Kunst,* written in 1962 and 1963, was published. It soon became a standard work on Dada.

**1965** Richter wrote an autobiographical text for a monograph in the series *Plastic Arts of the Twentieth Century,* with an introduction by Sir Herbert Read. The Richters moved from Ascona to an apartment in Locarno.

**1966** The Goethe Institute in Munich asked Richter to write the text for the catalogue and curate the exhibition "Dada 1916–1966: Documents of the International Dada Movement." *Köpfe und Hinterköpfe* (Heads and Numbskulls), Richter's fourth book, described the international film avant-garde against the background of Berlin in the 1920s.

**1967** 18 March: Berlin honored Richter with its Major Prize.

**1968** January: A large retrospective exhibition was launched at the Byron and the Finch College galleries in New York.

**1969** Richter's book *Filmgegner von heute—Filmfreunde von morgen* (Film Enemies Today, Film Friends Tomorrow), written for the "Film und Foto" exhibition in Stuttgart in 1929, was published as a reprint edition in Berlin "despite great inner resistance to the work of writing and theorizing."[76]

The Federal Republic of Germany awarded Richter the German Order of Merit.

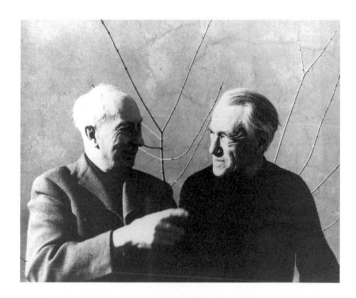

**1971** May: The Academy of Arts in Berlin named Richter a full member.

27 June: Richter was awarded the Golden Film Ribbon at the International Film Festival in Berlin for his outstanding contribution to film as an art form.

**1972** Richter contracted pneumonia and was hospitalized for four weeks, recuperating at the exclusive Schloß Elmau hotel in Bavaria.

**1973** Richter's book *Begegnungen von Dada bis Heute* (Encounters from Dada to the Present) was published in Germany.

**1970–1976** In this period twenty-eight one-man shows of Richter's works were organized. He also participated in about thirty-two group exhibitions.

**1976** Richter revised and edited his book *Der Kampf um den Film,* which he had written in 1939. It was published in Munich. Richter wrote the texts and selected photographs for a book of his graphic work, *Hans Richter: Opera grafica dal 1902 al 1969,* published in Italy.

1 February: Hans Richter died in Minusio in Ticino at the age of eighty-seven.

**Notes**

Epigraph: Cleve Gray, ed., *Hans Richter by Hans Richter* (New York: Holt, Rinehart, and Winston, 1971), 170.

1.  The names of the Richter children in chronological order are: Hans, Dora, Fritz, Vera, Albrecht, Richard. Birth certificates were issued by the registry office, Berlin Mitte, Judenstraße 34–42, number 304, on 9 April 1888. This record, accessible since Germany's reunification in 1989, discloses that Hans Richter was born at home, that both parents are Jewish (German: "mosaische Religion"), and that Moritz Richter was a businessman. The copy of Hans Richter's birth certificate from the Richter Papers, dated 19 October 1933, which was used as a source for the exhibition catalogue *Hans Richter 1888–1976* (Berlin: Akademie der Künste, 1982) and which gives Richter's religion as Protestant, his mother's name as Bötscheld, and his father's profession as proprietor of estates, is false. Documents issued during the Third Reich recording Hans's christening

von Hofacker

ceremony and church wedding ceremonies are not authentic either.

2.  Gray, *Hans Richter by Hans Richter,* 28–29.

3.  Ibid., 21.

4.  Hans Richter, letter to Ervin Szabo. The letterhead gives the *Neue Menschen* office address as Paris, Bouvlevard Voltaire 185. "Nebel" (Fog) by Richter appears in the first issue, "Die Moral" in the second issue. Christian Weinek, "Emil Szittya. Leben und Werk im deutschen Sprachraum 1886–1927," Ph.D. diss. University of Salzburg, 1987.
    Hans Richter was co-editor with Karl Lohs and Emil Szittya for the *Horizont Flugblätter* in 1919. Letter from Hubert van den Berg to Marion von Hofacker, 25 May 1995.

5.  Gray, *Hans Richter by Hans Richter,* 22.

6.  Ibid., 24.

7.  Ibid.

8.  Richard Richter, interview, Jerusalem, December, 1980.

9.  *Hans Richter: Opera grafica dal 1902 al 1969* (Pollenza: La Nuova Foglio, 1976), 14.

10. Hans Richter, *The World Between the Ox and the Swine* (exh. cat., Providence: Rhode Island School of Design, Museum of Art, 1971), 10–11.

11. Hilla von Rebay, letter to her father, 1915: "We do not expect the poor fellow to recover." Given to Marion von Hofacker by Dr. Gabriele von Rebay, Munich.

12. Theodor Däubler, "Notiz über den Maler Hans Richter," *Die Aktion* 6, no. 13 (25 March 1916): 181.

13. Hans Richter, preface to the exhibition catalogue *XXIX Collective Exhibition* (Munich: Hans Goltz, Galerie Neue Kunst, 1916), 3f.

14. Civil ceremony marriage certificate. Registry office for marriage records, Dahlwitzerstrasse 7, Berlin.

15. Gray, *Hans Richter by Hans Richter,* 30.

16. Hans Richter, *Dada: Art and Anti-Art* (London: Thames and Hudson, 1965), 28.

17. Richard Sheppard, ed., *New Studies in Dada, Essays and Documents* (Driffield, UK: Hutton, 1981), 170.

18. Hans Richter, "Ein Maler spricht zu den Malern," *Zeit-Echo* 3 (June 1917): 19–23.

19. Hans Richter, "Dada XYZ," in *Dada Painters and Poets,* ed. Robert Motherwell (New York: Wittenborn, Schultz, 1951), 288. See also Marcel Janco, "Schöpferischer DADA," in *Dada, Monograph of a Movement,* ed. Willy Verkauf (New York: Wittenborn, 1957), 30, 44.

20. Gray, *Hans Richter by Hans Richter,* 30.

21. Hugo Ball, letter to August Hoffmann in Hugo Ball, *Briefe, 1911–1927* (Einsiedeln: Benziger, 1957), 82.

22. *Hans Richter: Opera grafica,* 106.

23. Richter, *Dada: Art and Anti-Art,* 55.

24. Gray, *Hans Richter by Hans Richter,* 68.

25. Eggeling was born in Lund, Sweden, in 1880.

26. Hans Richter, *Begegnungen von Dada bis heute* (Cologne: DuMont Schauberg, 1973), 81.

27. *Die Neue Kunst* (exh. cat., Kunstsalon Wolfsberg, Zurich, September–October, 1918).

28. Janco, "Schöpferischer DADA," 48.

29. Hans Richter, letter to Helga Kliemann in Helga Kliemann, *Die Novembergruppe* (Berlin: Mann, 1969), 77.

30. Richard Richter, interview, December 1980.

31. Hans Richter, letter to Tristan Tzara (Berlin, 13 March 1919), Fonds Doucet, Paris. Richter informs Tzara that he stayed in Munich for a short time.

32. Richter, *Dada: Art and Anti-Art,* 80.

33. Ibid., 78.

34. Richter, *Begegnungen von Dada bis heute,* 12. For the manifesto, see "Manifest Radikaler Künstler Zürich 1919," unpublished manuscript, Hans Richter Papers, Museum of Modern Art Library, New York.

35. Ferdinand Hardekopf, letter to Olly Jacques, 19 April 1919, repr. in Richard W. Sheppard, "Ferdinand Hardekopf und Dada," *Jahrbuch der Schiller-Gesellschaft* 20 (1976): 144.

36. Marcel Janco, "Creative Dada," in *Dada, Monograph of a Movement,* 38.

37. Copy of the original protocol of the meeting from Justin Hoffmann.

38.  According to the protocol, additional state-owned buildings considered for confiscation were: Nymphenburg Porcelain Manufactory, Schack Galerie, Villa Stuck, and the Maximilianeum (the Bavarian Parliament building).

39.  Ferdinand Hardekopf, letter to Olly Jacques, 6 May 1919.

40.  The editors of *Der Zeltweg* were Otto Flake, Walter Serner, and Tristan Tzara.

41.  Klein-Kölzig is located in eastern Germany and belongs to the county of Nieder Lausitz near the border with Poland.

42.  Willy Rotzler, *Konstruktive Konzepte* (Zurich: ABC Verlag, 1977), 82.

43.  Hans Richter, *Köpfe und Hinterköpfe* (Zurich: Arche, 1967), 24.

44.  Hans Richter, "Prinzipielles zur Bewegungskunst," *De Stijl* 4, no. 7 (1921): 20.

45.  Hans Richter, in *Hans Richter, Monographie,* ed. Marcel Joray for the series *Kunst des 20. Jahrhunderts* (Neuchâtel: Editions du Griffon, 1965), 29.

46.  Hans Richter, interview, *Film Culture* 31 (Winter 1963–1964): 26–35.

47.  Adolf Behne, "Der Film als Kunstwerk," *Sozialistische Monatshefte* 27, no. 56 (15 December 1921): 457.

48.  Richard Richter, interview, December 1980.

49.  Werner Gräff, "Formal Experiment in Film," in *Film als Film: 1910–1975,* ed. Birgit Hein and Wulf Herzogenrath (exh. cat., Cologne: Kölnischer Kunstverein, 1977), 80.

50.  Hans Richter, *Filmgegner von heute—Filmfreunde von morgen* (repr. Zurich: Hans Rohr, 1968), appendix.

51.  El Lissitzky, *Proun und Wolkenbügel, Schriften, Briefe, Dokumente,* ed. Sophie Lissitzky-Küppers and Jen Lissitzky (Dresden: Verlag der Kunst, 1977), 205.

52.  Theo van Doesburg, El Lissitsky, and Hans Richter, "Statement of the International Faction of the Constructivists at the First International Congress of Progressive Artists," in *De Stijl* 5, no. 4 (1922): 59–64.

53.  Michel Sanouillet, *Dada à Paris* (Paris: J. J. Pauvert, 1965), 383.

54.  Richter, *Köpfe und Hinterköpfe,* 111.

55.  Ibid., 133.

56. Richter, *Begegnungen von Dada bis heute,* 37.

57. Richter, *Köpfe und Hinterköpfe,* 146.

58. Gray, *Hans Richter by Hans Richter,* 43. Erna Niemeyer's pseudonyms are: Renate Green, Mensch, Ré. Niemeyer and Richter were divorced in 1929. She married Philippe Soupault, the French surrealist poet, in 1936.

59. Richter, *Köpfe und Hinterköpfe,* 144.

60. Hans Richter, "Neue Mittel der Filmgestaltung," *Die Form, Zeitschrift für gestaltende Arbeit* 4, no. 3 (1929): 53–56.

61. Georg Schmidt, letter to Hans Richter in *Ein Leben für Bild und Film* (exh. cat., Berlin, Zurich, Munich: PUB, 1958–1960).

62. Also known as the Soldiers' Forces of World War I. These veterans formed in 1918, later merged with the SA, and were disbanded in 1935.

63. Friedrich Wolf, "Metall" (1931), in *Filmerzählungen,* vol. 1 (Berlin: Aufbau Verlag, 1959), 15–37.

64. Gray, *Hans Richter by Hans Richter,* 47. See also Paul Ortwin Rave, *Kunstdiktatur im Dritten Reich* (Hamburg: Gebr. Mann, 1949), 89. The number of confiscated paintings is based on lists drawn up by the National Socialists.

65. Rotzler, *Konstruktive Konzepte,* 127.

66. Anna Seghers, letter to Marion von Hofacker, Berlin, 10 February 1981.

67. Certificat de bonnes Vie et Moeurs, Meudon, 22 July 1936.

68. Hans Richter, unpublished manuscript, Hans Richter Papers, Schiller-Gesellschaft Archiv, Marbach.

69. *Viking Eggeling* (exh. cat., Kunstmuseum Basel, 1941).

70. U.S. Department of Justice application forms, Hans Richter Papers.

71. Gray, *Hans Richter by Hans Richter,* 48.

72. Ibid.

73. Hans Richter, "Die Entwicklung des politischen Film," in *Deutsche Blätter* (Santiago: 1942), vol. 1, pp. 21–24, and vol. 2, pp. 17–20.

74. Ibid.

75. Hans Richter, "Dreams, Surrealism, Film." Three typewritten manuscripts, Hans Richter Papers, Museum of Modern Art Library, New York.

76. Richter, *Filmgegner von heute—Filmfreunde von morgen.*

# Bibliography

**Writings by Hans Richter** (arranged chronologically)

## Books, Pamphlets

*Universelle Sprache.* Pamphlet written in collaboration with Viking Eggeling. Forst in der Lausitz, 1920. 8 pp. Probably no longer extant.

*Filmgegner von heute—Filmfreunde von morgen.* Written in collaboration with Werner Gräff. Programmatic text for the film section of the Stuttgart Werkbund exhibition of 18 May–17 July 1929. Berlin: Hermann Reckendorf Verlag, 1929. Reprint: H. P. Manz ed., Filmwissenschaftliche Studientexte II, Zurich: Hans Rohr Verlag, 1968. Reedition: introduction by Walter Schobert, Frankfurt: Fischer Taschenbuch Verlag, 1981.

*Film: Gisteren, heden, morgen.* Pamphlet written for the Dutch Filmliga. Special edition of the review *Filmliga Amsterdam* 8 (1935), no. 7/8.

*Der Kampf um den Film.* Written in Carabietta, Switzerland, 1934–39. Ed. Jürgen Römhild. Munich: Carl Hanser, 1976. Reedition: Frankfurt: Fischer Taschenbuch Verlag, 1979. Foreign language editions: Moscow, 1981, and *The*

*Struggle for the Film: Toward a Socially Responsible Cinema,* New York: Scolar Press, 1986.

*Film and Progress.* Not published in full; published in part in the *Neue Zürcher Zeitung.* American version of *Der Kampf um den Film,* prepared in collaboration with Herman Weinberg, New York, 1939–42.

*Dreams That Money Can Buy.* Program pamphlet. Texts by Man Ray, Louis Applebaum, John Cage, Richard Huelsenbeck, Siegfried Kracauer, J. Sweeny. New York: Films International of America, 1947.

*The Minotaur: A Film Project.* Pamphlet. New York: H. R. Productions, 1951.

*Dada-Profile,* in the series *Sammlung Horizont.* Zurich: Die Arche Verlag, 1961.

*Dada, Kunst und Antikunst.* Cologne: DuMont Verlag, 1964. Third, revised, and expanded edition, 1973. Foreign editions: London: Thames & Hudson, 1966; New York: McGraw-Hill, 1965; Brussels: Editions de la Connaissance, 1965; Tokyo: Bijutsu shuppan-sha, 1966; Milan: Mazzotta, 1966; Buenos Aires, 1973.

*Hans Richter, Monographie.* Ed. Marcel Joray for the series *Kunst des 20. Jahrhunderts.* Illustrated volume of a selection of Richter's work and an autobiographical text. Neuchâtel, Switzerland: Editions du Griffon, 1965.

*Dada 1916–1966. Dokumente der internationalen Dada-Bewegung.* Munich: Goethe Institute, 1966. Catalogue to the Goethe Institute "DADA" exhibition. Compiled with commentary by Hans Richter.

*Köpfe und Hinterköpfe.* Zurich: Die Arche Verlag, 1967.

*Hans Richter by Hans Richter.* Ed. Cleve Gray. New York: Holt, Rinehart and Winston, 1971. Illustrated volume of memoirs and a selection of magazine articles, essays, and poems by Richter.

*Begegnungen von Dada bis heute. Briefe, Dokumente, Erinnerungen.* Cologne: DuMont Schauberg, 1973. The English translation has not been published.

*Hans Richter: Opera grafica dal 1902 al 1969.* Ed. Olivio Galassi. Pollenza: La Nuova Foglio, 1976. Illustrated volume

of graphic works and annotations on Richter's life and work.

*Le Teste di Hans Richter, 1960–1965.* Designs, thoughts, and poetry, compiled by Sergio Grandini. Lugano: Stampatore G. Topi, 1977.

**Articles, Essays, Poems, Interviews**

"Nebel." *Les Hommes Nouveaux—Neue Menschen,* no. 1 (1911). Richter uses pseudonym.

"Die Moral." *Les Hommes Nouveaux—Neue Menschen,* no. 2 (1912). With pseudonym.

"Vorwort." In *XXIX Collective Exhibition. H. Richter, O. Strohmeyer, L. Vorel* (7 June–8 July 1916). Exhibition catalogue. Munich: Galerie Hans Goltz, 1916.

"Ein Maler spricht zu den Malern." In *Zeit-Echo* 3, no. 1 and 2 (May/June 1917): 3–5, 19–23, illus. p. 15. Also in *Sankt Ziegenzack springt aus dem Ei,* from the series *Texte, Bilder und Dokumente zum Dadaismus in Zürich, Berlin, Hannover und Köln,* ed. K. Schuhmann. Leipzig/Weimar: Kiepenheuer Verlag, 1991: 105–109. Also in *Hans Richter by Hans Richter,* ed. Cleve Gray (excerpt in English), p. 31.

"Gegen ohne für Dada." In *Dada 4/5: Anthologie Dada,* ed. T. Tzara (February 1919): 26. Reprint: Rome/Milan: Mazzotta, Arturo Schwarz, 1970; Nice: Centre du XX$^e$ siècle, 1976, ed. Michel Sanouillet, p. 83.

"Manifest Radikaler Künstler. Zürich." *Neue Zürcher Zeitung,* 4 May 1919. Reprint: *Neue Zürcher Zeitung,* 28 July 1979.

*Horizont-Flugschriften.* Ed. Emil Szittya, Karl Lohs, and Hans Richter. Vienna/Berlin, 1919.

"Prinzipielles zur Bewegungskunst." *De Stijl* 4, no. 7 (1921): 109–112. Reprint: *De Stijl 2 1921–1932,* ed. Ad Petersen, Amsterdam/The Hague: Athenaeum, Bert Bakker, 1968: 81–89; and Hans L. C. Jaffé, *Mondrian und De Stijl,* Cologne: DuMont Verlag, 1967: 135–137.

"Erklärung der internationalen Fraktion der Konstruktivisten des ersten internationalen Kongresses der fortschrittlichen Künstler. Düsseldorf." 30 May 1922. Signed: Hans Richter, El Lissitzky, T. van Doesburg. *De Stijl* 5, no. 4

(1922): 59–65. Reprint: *De Stijl 2 1921–1932,* ed. Ad Petersen, Amsterdam/The Hague: Athenaeum, Bert Bakker, 1968: 203–204. Also as "Nyilatkozat, felolvastatott a haladó müvészek internacionáléjanak düsseldorfi kongresszusàn" *MA* 7, no. 8 (1922): 63.

"Film." *De Stijl* 5, no. 6 (1922): 91–92. Reprint: *De Stijl 2 1921–1932,* ed. Ad Petersen, Amsterdam/The Hague: Athenaeum, Bert Bakker, 1968: 228; and Hans L. C. Jaffé, *Mondrian und De Stijl,* Cologne: DuMont Verlag, 1967: 171–173.

"K. I. Konstruktivistische Internationale schöpferische Arbeitsgemeinschaft." (Weimar) September 1922. Signed: Theo van Doesburg, Hans Richter, El Lissitsky, Karel Maes, Max Burchartz. *De Stijl* 5 (1922), 113–119. Reprint: *De Stijl 2 1921–1932,* ed. Ad Petersen, Amsterdam/The Hague: Athenaeum, Bert Bakker, 1968: 247–250.

Letter to Tristan Tzara, dated 2 December 1922. Bibliothèque Nationale, Paris, Bibliothèque Littéraire Jacques Doucet, Paris. Also in *Film als Film—1910 bis heute,* ed. Birgit Hein and Wulf Herzogenrath, Cologne: Kölnischer Kunstverein, 1977: 23.

"Film." *De Stijl* 6, no. 5 (1923): 65–66. Reprint: *De Stijl 2 1921–1932,* ed. Ad Petersen, Amsterdam/The Hague: Athenaeum, Bert Bakker, 1968: 377; and Hans L. C. Jaffé, *Mondrian und De Stijl,* Cologne: DuMont Verlag, 1967: 188–189.

"Konstruktivizmus." *MA* 8, no. 9–10 (1923): 4–5.

*G. Zeitschrift für elementare Gestaltung.* Ed. Hans Richter. Nos. 1–5/6 (1923–26). Reprint: ed. Marion von Hofacker, Munich: Kern Verlag, 1986. An author index to the five issues appears as "Great Little Magazines, G," *Form,* no. 3 (15 December 1966): 26–31.

"Material zur elementaren Gestaltung." *G,* no. 1 (July 1923): 1–2; no. 3 (June 1924): 1–3.

"Die Eroberung der Maschinen." *G,* no. 3 (June 1924): 24.

"Prag." *G,* no. 3 (June 1924): 28.

"Die schlecht trainierte Seele." *G,* no. 3 (June 1924): 34–37. Reprint also in Richard Huelsenbeck, ed., *Dada—Eine literarische Dokumentation,* Reinbek bei Hamburg: Ro-

wohlt, 1964: 96–100. English version: "The Badly Trained
Sensibility," *Image* 2, no. 6 (October 1965): 18–19.

"Kurt Schwitters." *G*, no. 3 (June 1924): 47.

"Arp." *G*, no. 3 (June 1924): 9.

"De Stijl." *G*, no. 3 (June 1924): 58.

"L'Esprit Nouveau." *G*, no. 3 (June 1924): 60.

"Der Querschnitt." *G*, no. 3 (June 1924): 61.

"An den Konstruktivismus." *G*, no. 3 (June 1924): 62.

"Der neue Baumeister." *Qualität, Internationale Propaganda.
Zeitschrift für Qualitätserzeugnisse* 4, no. 1/2 (January/
February 1925).

"Rhythm." *Little Review* (Winter 1926): 21.

"Vorwort." *G*, no. 4 (March 1926): 1.

"Arp und die elementare Gestaltung." *G*, no. 4 (March
1926): 9.

"Die Kunst von heute: Ausstellung abstrakter Kunst. Paris.
December 1925." *G*, no. 4 (March 1926): 11–14.

"Viking Eggeling." *G*, no. 4 (March 1926): 14–16.

"Filmmanifesto." [Signed "G."] *G*, no. 5/6 (April 1926): 1–2.

"Notes." *G*, no. 5/6 (April 1926): 6.

"Dimension." *G*, no. 5/6 (April 1926): 8.

"Teil einer Partitur zu dem Film Rhythmus 25." *G*, no. 5/6
(April 1926): 11.

"Fuge aus einem absoluten Film (I)." *G*, no. 5/6 (April 1926):
17.

"Die eigentliche Sphäre des Films." *G*, no. 5/6 (April 1926):
18.

"Kitsch ist nahrhaft." *G*, no. 5/6 (April 1926): 20.

"Bisher." *G*, no. 5/6 (April 1926): 23.

"Geschichte ist das, was heute geschieht." *G*, no. 5/6 (April
1926): 24.

"Die reine Form ist die Natürliche." *G*, no. 5/6 (April 1926):
27–28.

"Die Nutte siegt." *G*, no. 5/6 (April 1926): 31.

"Kino und Kultur." Weekly page, ed. Johannes M. Richter, in
*Tägliche Rundschau* (Berlin), 28 December 1926–1 April
1928. [Almost all of the articles for this page are signed
"R", "H. R." or "R . . . r." The name Johannes M. Richter is
identical with the name appearing on official documents

belonging to Hans Richter. According to Richter (in *Köpfe und Hinterköpfe,* p. 173), he was art, music, and film editor of the *Tägliche Rundschau.*]

"Neue Mittel der Filmgestaltung." *Die Form.* 4, no. 3 (1929): 53–56. Reprint: *Die Form,* ed. Felix F. Schwartz, Frank Gloor, Gütersloh: Bertelsmann, 1969: 230–232; and *Die Zwanziger Jahre. Manifeste und Dokumente Deutscher Künstler,* ed. Uwe M. Schneede, Cologne: DuMont Verlag, 1979: 259–262.

"Aufgaben eines Filmstudios." *Die Form* 4, no. 3 (1929): 72.

"Der absolute Film braucht die Industrie." An interview with Hans Richter. *Film-Kurier* 10, no. 6 (5 January 1929).

"Avantgarde im Bereich des Möglichen." *Film-Kurier,* special issue entitled *Zehn Jahre Film-Kurier* (1 June 1929).

"Film von Morgen" *Das Werk* 16, no. 9 (1929): 278–284. Polish translation as "Film Jutra," *Praesens,* no. 2 (May 1930): 160–165.

"Der Moderne Film." *Filmliga Amsterdam* 3, no. 6 (March 1930).

"Richtigstellung." *Lichtbildbühne* (April 1930). Reply to a review of one of Richter's lectures in *Film-Kurier* (8 March 1930).

"L'objet en mouvement." *Cercle et Carré* (Paris), no. 3 (June 1930). Reprint: *Cercle et Carré,* ed. Michel Seuphor, Paris, 1971: 133–135.

"Letter" by Hans Richter to the editor on the filming of "Romance Sentimentale." *Film-Kurier* 12, no. 212 (8 September 1930).

"Der Film—eine Ware." *Arbeiterbühne und Film,* no. 4 (1931): 24–26. Reprint: Cologne: DuMont Verlag, 1974.

"Von der statischen zur dynamischen Form." *Plastique* (Paris), no. 2 (1937): 12–18. Reprint: Richard Huelsenbeck, ed., *Dada, eine literarische Dokumentation,* Reinbeck: Rowholt Verlag, 1964: 250–252.

"Kulturfilm als Kunst." *Der Geistesarbeiter. Organ des Schweiz. Schriftsteller-vereins und gesellschaft Schweiz. Dramatiker* 17 (April 1938): 49–56.

"La vie courte mais feconde du film d'avantgarde." Unpublished manuscript, dated July 1939. 6 pp.

"Wahrheit im Film." *Neue Zürcher Zeitung,* 14 January 1940. Advance excerpt from *Der Kampf um den Film.*

"Urkino." *Neue Zürcher Zeitung,* 25 February 1940. Advance excerpt from *Der Kampf um den Film.*

"Urkino II." *Neue Zürcher Zeitung,* 21 April 1940. Advance excerpt from *Der Kampf um den Film.*

"Der Film Essay: Eine neue Form des Dokumentarfilms." *Nationalzeitung,* supplement, 25 May 1940. Reprint: *Schreiben Bilder Sprechen,* ed. Christa Blümlinger and Constantin Wulff, Vienna: Sonderzahl, 1992: 195.

"Quelques instants avec Hans Richter avant son départ pour l'Amérique." Interview with Serge Lang. *La Revue de l'Ecran* (Paris) 4 (3 April 1941): 387-B, col. 5.

"Post-War Planning and Documentary Film." Unpublished manuscript, 1941. 11 pp.

"Die Entwicklung des politische Film." *Deutsche Blätter* 2, no. 1 (1944): 21–24, and 2, no. 2 (1944): 17–20. In collaboration with Jat Leuda. Reprint: Karsten Witte, ed., *Theorie des Kinos Traum fabrik,* Frankfurt: Suhrkamp Verlag, 1972: 61–78.

"Cinéma américain d'avant-garde." *Style en France.* Special issue of *Cinéma,* no. 4 (July–September 1946): 96–97.

"Voir du merveilleux." *La Revue du Cinéma* 2, no. 7 (1947): 15–18. Reprint: Pierre Lherminier, *L'Art du cinéma,* Paris, 1960: 468.

"A History of the Avantgarde." In *Art in Cinema,* ed. Frank Stauffacher. San Francisco: Art in Cinema Society, San Francisco Museum of Art, 1947: 6–21.

"Avantgarde Film in Germany." In *Experiment in the Film,* ed. Roger Manvell. London: Grey Walls Press, 1949. Reprint: New York: Arno Press, 1970: 218–233. German version: "Der avantgardistische Film in Deutschland (von 1921–1951)," *Cineaste* special issue of *Deutsche Filmtage Göttingen* (1953): 13–23. Also in Italian as "Il cinema d'avanguardia in Germania." *L'occhio tagliato, documenti del cinema dadaista e surrealista.* Edition Martano. No. 10 (1972): 92.

"The Avantgarde Film Seen from Within." *Hollywood Quarterly* 4, no. 1 (Fall 1949): 34–41.

"Hans Richter: Painter—Film Producer." *Collection of the Société Anonyme. Museum of Modern Art 1920.* New Haven: Yale University Art Gallery, 1950: 171–172.

"Minnesord." In the exhibition catalogue *Viking Eggeling 1880–1925. Technare och filmkonstuar.* Stockholm, 27 October–19 November 1950: 9–10.

"Dada X Y Z." In *The Dada Painters and Poets,* ed. Robert Motherwell. New York: Wittenborn, Schultz, 1951: 283–290. Originally written in 1948.

"The Film as an Original Art Form." *College Art Journal* 10, no. 2 (1951): 157–161. German version: "Der Film als selbständige Kunstform," in the exhibition catalogue *Hans Richter Maler und Filmschöpfer,* Berlin: Akademie der Künste, 1967: 3–9. Also in *Avantgardistischer Film 1951–1971,* ed. Gottfried Schlemmer, Munich: Hanser Verlag, 1973: 16–18. French version: "Un art original. Le film." *Cahiers du Cinéma* 2, no. 10 (March 1952): 11–15. Italian version: "Il film arte originale." *Sette Arte* (Ivrea) 1, no. 1 (1952): 73–74.

"Il film come forma d'arte originale." *La Biennale di Venezia,* no. 4 (April 1951): 29–30.

"Anatomie de l'avant-garde." *L'Age du Cinéma* (Paris), no. 3 (June/July 1951): 3–6.

"Histoire de l'avant-garde allemande 1918–1930." *L'Age du Cinéma* (Paris), no. 6 (1951): 20–24. A revised version of "Avantgarde Film in Germany."

"Vita privata del movimento 'dada' 1916–1918." *La Biennale di Venezia,* no. 7 (January 1952): 16–21.

"Easel-Scroll-Film." *Magazine of Art 45* (February 1952): 78–86.

"Film and Painting." *College Art Journal* 11 (1952): 10–14.

"Funzione del cinema sperimentale." *Cinema,* no. 97 (November 1952): 222–226.

"Il film di avanguardia il film astratto e il futurismo." *Cinema Italiano,* no. 12 (December 1953): 39–44. Original manuscript, "The Avantgardefilm and Futurism," July 1953, 5 pp. This is a reply to Antonio Giulio Bragaglia, "Richter e i futuristi," *Cinema Italiano,* no. 3 (1953).

"Max Ernst: sincerità-serietà-immaginazione-gioia." *La Biennale di Venezia*, no. 19/20 (April 1954): 32–36.

"Otto storie sugli scacchi." *La Biennale di Venezia*, no. 22 (September/October 1954): 15–20.

"Film as an Original Art Form." *Film Culture* 1, no. 1 (January 1955): 19–23. Reprint: *Film: A Montage of Theories*, ed. Richard Dyer MacCann, New York, 1966: 180–186; *Film Culture Reader*, ed. P. Adams Sitney, New York, 1970: 15–20.

"Eight Free Improvisations on the Game of Chess." *Film Culture* 1, no. 1 (January 1955): 36–38.

"Frank Stauffacher." *Film Culture* 1, no. 5/6 (Winter 1955): 4–5.

"8 × 8. Hans Richter's Latest Experimental Film." *Film Culture* 1, no. 5/6 (Winter 1955): 17–19.

"Theory and Experiment in the Modern Film." In *Erkenntnis und Aktion. Vorträge und Gespräche des Europäischen Forums Alpbach 1955.* Berlin: Otto Molden, 1955: 190–204.

"In Memory of Two Friends: Fernand Léger 1881–1955." *College Art Journal* 15, no. 4 (1956): 340–343.

"In Memory of Two Friends: Yves Tanguy." *College Art Journal* 15, no. 4 (1956): 343–346.

"Fernand Léger." *La Biennale di Venezia*, no. 27 (March 1956): 5–6. Identical to "In Memory of Two Friends."

"Yves Tanguy." *La Biennale di Venezia*, no. 27 (March 1956): 27–28. Identical to "In Memory of Two Friends."

"8 × 8—An Interview with Hans Richter by Gideon Bachmann." *Film and TV Music* 16, no. 2 (Winter 1956): 19–20.

"Dada and the Film." In *Dada. Monograph of a Movement— Monographie einer Bewegnung—Monographie d'un mouvement*, ed. Willy Verkauf. New York: George Wittenborn, 1957: 64–73. Teufen, Switzerland: Arthur Niggli, 1958, 1961, and 1965: 57–66.

"Beginnings of German Abstraction." In *The World of Abstract Art*. New York: The American Abstract Artists, 1957: 37–40.

"30 Years of Film Poetry. Self-Expression and Communication." Unpublished manuscript, c. 1957. 8 pp.

"Hans Richter on the Nature of Film Poetry. An Interview by Jonas Mekas." *Film Culture* 3, no. 11 (1957): 5–8.

"8 × 8." *Cinema Nuovo* 4, no. 113 (September 1957): 118–119.

"Al posto del cannone la macchina da scrivere." *Cinema Nuovo* 4, no. 114–115 (September 1957): 164–165.

"Film as a Part of Modern Art." Unpublished essay by Hans Richter submitted for Graham Foundation Grant. New York, 1958. 2 pp.

"Filmen son konstform." In *Apropå Eggeling,* ed. K. G. Hultén. Stockholm, 1958: 8–14.

"Om Viking Eggeling." In *Apropå Eggeling,* ed. K. G. Hultén. Stockholm, 1958: 15–17.

"8 × 8." Brochure to the film *Fifth Avenue Theatre.* New York, 1958.

"A Clowning out of the Void." Review of the U.S. edition of Willy Verkauf's *Dada. Monograph of a Movement. Saturday Review,* 1 February 1958: 20.

"Glorified Juke Box and Activated Sound." *Herald Tribune.* March 1958. Manuscript: 4 ff.

"On the Function of Film History Writing." *Film Culture* 4, no. 3 (April 1958). Entire sequel, no. 18: 25–26.

"Der Zufall." In *Dada. Dokumentation einer Bewegung,* ed. K. H. Hering and E. Rathke. Exhibition catalogue. Düsseldorf: Kunstverein für die Rheinland und Westfalen, Kunsthalle, 1958: 104–105.

"Dada ist tot, es lebe Dada." *Magnum* 22 (February 1959): 11–12.

"Experiment als Lebenselexier. Ein Gespräch mit Hans Richter von Willy Rotzler." *Die Weltwoche* 27, no. 1321 (1959): 5.

"Peinture et film." *XXe Siècle* 21, no. 12 (May/June 1959): 25–28.

"Gespräch mit Hans Richter von Friedrich Bayl." *Art International* 3, no. 1–2 (1959): 54–55.

"Von der Malerei zum Film." *Frankfurter Allgemeine Zeitung,* 20 June 1959.

Letter to Piero Dorazio, dated 27 July 1959. In *Piero Dorazio.* Exhibition catalogue. St. Gallen: Galerie Im Erker, 28 May–16 July 1966.

Letter to Walter Mehring, dated March 1959. In Walter Mehring, *Berlin Dada*. Zurich: Arche Verlag, 1959: 89–90.

"Vorwort." In Adrien de Menasce exhibition catalogue (10 February–12 March 1960). Zurich: Galerie Charles Lienhard, 1960: 3–4.

"Dada Profiles." In *Arts Yearbook,* vol. 5: *Perspectives on the Arts,* ed. Hilton Kramer. New York: Art Digest, 1961: 11–36. Excerpts on Duchamp, Lehmbruck, Ball, Hennings, Grosz, Tzara, Huelsenbeck, Baader, van Doesburg, Man Ray, Schwitters.

"Dichter, Denker, Dadaisten." *DU* 21, no. 242 (April 1961): 55–57. Advance publication of *Dada-Profile.*

"Intervju med Hans Richter with L. Sjöberg." *Konstrevy* 37, no. 3 (1961): 88–93.

"Be Be (= Bewegte Bewegung)." *Blätter und Bilder. Zeitschrift für Dichtung, Musik und Malerei,* no. 13 (March/May 1961): 48–53.

"Je ne suis pas un cinéaste. . . ." *Positif. Revue de Cinéma,* no. 40 (July 1961): 1–3.

"From Interviews with Hans Richter during the Last Ten Years." (By Jonas Mekas, Gideon Bachmann, and with the Danish Film Museum.) *Film Culture,* no. 31 (Winter 1963/64): 26–35. Excerpt in *Film als Film—1910 bis heute,* ed. Birgit Hein and Wulf Herzogenrath, Cologne: Kölnischer Kunstverein, 1977: 21.

"Introduzione a 'Dadascope'." *La Città* 3 (June 1964): 53–54.

"Dadaismo-surrealismo-cinema sperimentale." *La Città* 3 (June 1964): 59–68.

"Dalla pittura moderna al cinema moderno." *La Biennale di Venezia,* no. 54 (September 1964): 3–13.

"My Experience with Movement in Painting and Film." In *The Nature and Art of Motion,* ed. György Kepes. Vision and Value Series. New York: George Braziller, 1965. German version: "Meine Erfahrungen mit Bewegung in Malerei und Film," in *Wesen und Kunst der Bewegung,* ed. György Kepes, Brussels: La Connaissance, 1969: 142–156.

"Témoignages: Hans Richter." *Études Cinématographiques,* no. 38–39 (1965): 55–56.

"Arp se levant derrière un nuage." In *Jean Arp—Hans Richter.* Exhibition catalogue. Paris: Galerie Denise René, 1965.

"The Badly Trained Sensibility." *Image* 2, no. 6 (October 1965): 18–19. Originally published in German as "Die schlecht trainierte Seele," *G,* no. 3 (June 1924): 34–37.

"Stolpern." *Neue Zürcher Zeitung,* 5 February 1966, morning issue, pp. 5/6.

Introduction to "Great Little Magazines, *G.*" *Form,* no. 3 (15 December 1966): 27.

"Le origini del film astratto." *L'Arte Moderna* 6, no. 54 (1966): 367–371.

"Bemerkungen zu meinen Arbeiten." *Hamburger Filmgespräche III.* Hamburg: Hamburger Gesellschaft für Filmkunde, 1967: 19–24.

"Begegnungen in Berlin." In *Avantgarde Osteuropa 1910–1930.* Exhibition catalogue. Berlin: Deutsche Gesellschaft für Bildende Kunst/Akademie der Künste, October/November 1967: 13–21.

Letter to Helga Kliemann, dated 25 November 1967. In Helga Kliemann, "Die Novembergruppe." *Bildenkunst in Berlin* 3 (1969): 78. Reprint: *Kunst-metropole Berlin 1918–1933,* ed. B. Schrader and J. Schebera. Berlin and Weimar: Aufbau-Verlag, 1987: 45–46.

"Step by Step." *Studies in the Twentieth Century,* no. 2 (Fall 1968): 7–20. Also in *Form,* no. 9 (April 1969): 21–25.

"L'avant-garde allemande des années vingt." *Carl Mayer e l'Espressionismo.* Rome: Edizioni di Bianco e Nero, 1968: 169–174.

"In Memory of Marcel Duchamp." *Form,* no. 9 (April 1969): 4–5.

"Ich über mich." *Civiltà delle macchine. Rivista bimestrale di cultura contemporanea* 17, no. 3 (May–June 1969): 37–48.

"In Memory of a Friend (Marcel Duchamp)." *Art in America* 57, no. 4 (July–August 1969): 40–41.

"Foreword" and two color lithographs [based on Giuseppe Ungaretti's text "Ultimi cori per la Terra Promessa"]. In *Im-*

von Hofacker

*ages and Words.* Translated by Paul Celan. Milan: M'Arte edizioni, 1970.

"Reflections on Dymos." Poem in exhibition catalogue. Milan: Galleria del Naviglio, 24 October–8 November 1970.

"The World between the Ox and the Swine. Dada Drawings by Hans Richter." *Bulletin of Rhode Island School of Design* 57, no. 3–4 (August 1971): 56 pp. Exhibition catalogue with interview between Daniel Robbins and Hans Richter.

"Pittura moderna: cinema moderno 1910–1970/Modern Painting: Modern Film 1910–1970. Dynamism and Kinetism." *Quintaparete. Documenti del surrealismo,* no. 3 (January 1972): 8–10, 12–13.

"Viking Eggeling." *Studio International Journal of Modern Art* 183, no. 942 (March 1972): 97–99.

"Marcello Pirro." Poem in exhibition catalogue *Hans Richter/ Pirro.* Venice: Edizione Cooperativa Libreria Università, 1972.

"Massimo de Stefani." In exhibition catalogue. Turin: Galleria L'Approdo, 9–23 January 1973: 8.

"Hans Richter et le futurisme." *Espaces. Documents XXe Siècle* 2 (Fall 1973/74): 7–8.

"Der Film als selbständige Kunstform." In *Avantgardistischer Film 1951–1971: Theorie,* ed. G. Schlemmer. Munich: Carl Hanser Verlag, 1973: 16.

"Si." Poem in exhibition catalogue *Walter Valentini l'assessorato alla cultura.* Urbino: in collaborazione con la stamperia Posterula, 1975.

*Jay E. Kent.* Exhibition catalogue. Turin: L'Approdo Arte Moderno, 1975.

"The First Day," "Fullfilment," "Counter, counter." Poems in *L'Europa letteraria e artistica* 1, no. 2 (February/March 1975): 96–98.

"The Private Life of an Arrow." Poem in *Early Form Sequences 1927–1932 Kurt Kranz.* Hamburg: Verlag Hans Christians/Cambridge, Mass.: MIT Press, 1975: 7.

"I miei primi incontri con l'amico Federico Fellini." *Cinema Nuovo* 15, no. 240 (March/April 1976): 101–103.

"Chaos." *Stereo Headphones,* no. 7 (1976): 38–39.

"Mostra personale di Massimo de Stefani." In Massimo de Stefani exhibition pamphlet, no. 154. Turin, Galleria L'Approdo, 16 April–8 May 1977.

**Writings on Hans Richter**

**Discussions of Richter in Books and Articles**

Anonymous. "American Avantgarde Film." *Penguin Film Review* 8 (1949).

Anonymous. "Cubism and Abstract Art." New York: Museum of Modern Art, 1936.

Anonymous. "Dada Zurigo, a cura di Luisa Valeriani." *Martano.* Turin, 1970.

Anonymous. "Experiment with Celluloid Hans Richter." *Penguin Film Review* 9 (1949).

Anonymous. "Filmographie de Hans Richter." *L'Age du Cinéma* 1 (1951).

Anonymous. "Hans Richter—Filmt Rechter Hand—Malt Linker Hand." In *Vernissage, Kunst, Kritik, Kontakte.* Baden-Baden: Aegis Verlag, 1960.

Anonymous. "Pourquoi le Minotaure." *L'Age du Cinéma* 4/5 (1951).

Anonymous. "Surrealist Movie." *Life* 21, no. 23 (2 December 1946): 86–88.

Albéra, François. "Eisenstein en Suisse." *Documents Cinémathèque Suisse 9: Travelling 48* (Winter 1976): 89–95.

Alemanno, Roberto. "La scompara di un grande amico." *Cinema Nuovo* 25, no. 239 (January/February 1976): 47.

Amsel, Mathias. "Hans Richter zwischen Malerei und Film." *Filmstudie,* no. 30.

Apollonio, Umbro. "Hans Richter." *D'Ars* 13, no. 58–59 (February–March 1972): 90–105.

Aristarco, Guido. "La caccia del Minotauro." *Cinema Nuovo,* 31 (1953).

Aristarco, Guido. "Document 2." *La Revue du Cinéma* 18 (1948).

Arnheim, Rudolf. *Storia delle teoriche del Film.* Turin: Einaudi, 1960.

Arnheim, Rudolf. "Über Bewegungskunst." *Sozialistische Monatshefte* 2, no. 63 (1926): 312–315.

Arp, Hans. "Hans Richter." *Blatter und Bilder* 13 (1961): 54.

Arp, Hans. "Hans Richter." In *Unser täglicher Traum.* Zurich: Arche Verlag, 1956: 69–70.

Arp, Hans. "Hans Richter, Painter, Film Producer." In *Collection of the Société Anonyme Museum of Modern Arts 1920.* New Haven: Yale University Art Gallery, 1950: 71.

Bagier, Guido. *Der kommende Film.* Stuttgart: Deutsche-verlags-anstalt, 1928.

Bassan, R., and M. Roudevitch. "Se souvenir de Hans Richter." *Ecran* 58 (May 1977): 6–10.

Bayl, Friedrich. "Gespräch mit Hans Richter." *Art International* 3, no. 1–2 (1959): 54–55.

Bayl, Friedrich. "On Hans Richter." *Art International* 4, no. 10 (1960): 34–38. Translated from the German "Gespräch mit Hans Richter." Also in exhibition catalogue *Hans Richter—Painting and Film.* Munich: Goethe Institute, 1970: 4.

Behne, Adolf. "Der Film als Kunstwerk." *Sozialistische Monatshefte* 27, no. 57 (December 1921): 1, 118. Reprint: *Film als Film—1910 bis heute,* ed. Birgit Hein and Wulf Herzogenrath, Cologne: Kölnischer Kunstverein, 1977: 21.

Bragaglia, A. G. "Cinema astratto." *Cinema* (December 1952).

Bragaglia, A. G. "Richter e i futuristi." *Cinema Italiano* 3 (1953).

Brederoo, Nico. "Der Avantgarde-, Dokumentar- und Reklamefilm: Die Niederlande und die deutsche Emigration." In *Die Niederlande und das deutsche Exil 1933–1940,* ed. Kathinka Dittrich and Hans Würzner. Königstein: Athenäum, 1982: 215–217.

Brissoni, Armando. "Indagine strutturale sul linguaggio cinematografico dei Ritmi 21, 23, 25 e Filmstudie 1926 di Hans Richter." In brochure. Padua: Liviana Editrice, 1968: 3–17.

Calvesi, Maurizio. "Futurismo e arte meccanica: Il comica, l'automatico, il casuale." *L'Arte Moderna* 5, no. 42 (1965), pp. 201–232.

Codroico, Roberto, and Lietta Pezzolato. "Richter e l'uomo visible." *Cinema Nuova* 21, no. 218 (July/August 1972): 254–255.

Däubler, Theodor. "Notiz über den Maler Hans Richter." *Die Aktion. Wochenzeitschrift für Politik, Literatur, Kunst* 6, no. 13 (25 March 1916): cols. 181–182.

Debrix, Jean R. *7ème Art*. Paris: Edition du Cerf, 1960.

Dencker, Klaus Peter. "Hinweis auf einen fast vergessenen Künstler. *Mitteilungen des Instituts für moderne Kunst* 13/ 14 (1976): 7 pp.

Diebold, Bernhard, "Film und Kunst. Ein Momento an die Film Kulturträger." *Frankfurter Zeitung*, no. 660 (1920): 1–2.

Doesburg, Theo van. "Abstracte Filmbeelding." *De Stijl* 4, no. 5 (1921): 71–75. Reprint: *Film als Film—1910 bis heute*, ed. Birgit Hein and Wulf Herzogenrath. Cologne: Kölnischer Kunstverein, 1977: 18.

Dorfles, Gillo. "Una mostra di Hans Richter a Milano." *Domus* 376 (March 1961): 40–44.

Francalanci, Ernesto L. "Hans Richter e le vie dell 'antidada.'" *Art Internations. The Lugano Review* 15, no. 8 (October 1971): 36–37, 79.

Frenkel, Heinrich. *Unsterblicher Film. Die grosse Chronik. Von der Laterna Magica bis zum Tonfilm*. Munich: Kindler Verlag, 1956.

Friedländer-Mynona, Salomo. "Goethes Farbenhaler und die moderne Malerei." In *Berlin. Sammlung Gabrielson Göteborg. Erwerbungen 1922/23*. Berlin, 1923: 7–10.

Gauthier, Paule. "Hans Richter: art-et-anti-art dada: un artiste-anartiste pionnier de l'art moderne." *Cunause, no.* 123–124 (May–October 1975): 10–21.

Goll, Claire. "Ich verzeihe keinem." Munich: Scherze, 1976.

Goodman, Ezra. "Dreams That Money Can Buy." *Dance* 21, no. 2 (February 1947): 22–27, 50.

Gräff, Werner. "Concerning the So-Called G Group." *Art Journal* 23, no. 4 (Summer 1964): 280–282.

Gray, Cleve. "Foreword." In Richter, *Hans Richter by Hans Richter*, ed. Cleve Gray. New York: Holt, Reinhart, and Winston, 1971: 8, 14–16.

Gray, Cleve. "Portrait: Hans Richter." *Art in America* 56, no. 1 (January/February 1968): 48–55.

Gregor, Joseph. "Das Zeitalter des Films." *Film Artystyevy.* 2 (1937): 113.

Grohmann, Will. Untitled. *La Città* 3 (June 1964): 51–52.

Grohmann, Will. "Hans Richter: peinture et cinéma." *Apeiros, no.* 6 (1974): 62–64.

Habasque, Guy. "Hans Richter." *Aujourd'hui,* no. 28 (September 1960): 42.

Habasque, Guy. "Hans Richter." *Quadrum. Revue internationale d'art moderne,* no. 13 (1962): 61–74.

Haftmann, Werner. "Postscript." In Hans Richter, *Dada, Kunst und Anti-Kunst.* Cologne: DuMont Verlag, 1964: 220–228.

Hasenfratz, Doris. "Begegnung mit Hans Richter." *Sie und Er* 35, no. 10 (March 1959): 24–25.

Hausmann, Raoul. "More on Group G." Letter to the Editor. *Art Journal* 24, no. 4 (Summer 1965): 350–352.

Hilberseimer, Ludwig. "Bewegungskunst." *Sozialistische Monatshefte* 56 (1921): 467–468. Also in *Veshch* (1922), ed. El Lissitzky. Reprint: *Film als Film—1910 bis heute,* ed. Birgit Hein and Wulf Herzogenrath. Cologne: Kölnischer Kunstverein, 1977: 19–20.

Hofacker, Marion von. "Foreword." In *G 1923–1926,* ed. Marion von Hofacker. Munich: Kern Verlag, 1986: 4.

Hoffmann, Justin. "Der Aktionsausschuß revolutionärer Künstler Münchens." In *Revolution und Rätezeit in München,* ed. Wolfgang Kehr. Munich: Institut für Zeitgeschichte, 1979. Also in *München 1919: Bildende Kunst/ Fotografie der Revolutions- und Rätezeit,* ed. Dirk Halfbrodt and Wolfgang Kehr. Munich: Institut für Zeitgeschichte, 1979: 21–75.

Hoffmann, Justin. "G—The First Modern Art Periodical in Germany." In *G 1923–1926,* ed. Marion von Hofacker. Munich: Kern Verlag, 1986: 144 ff.

Hofmann, Werner. "Hans Richter." Obituaries of academy members. *Nachrufe, 1970–1979 Akademie der Künste* 4, vol. 4 (1970–1979): 103–104.

Hofmann, Werner. *Zeichen und Gestalt.* Frankfurt am Main, 1957.

Huelsenbeck, Richard. "Encuento con Hans Richter." *Humbolt.* 1960.

Hugnet, Georges. *L'Aventure Dada, 1916–1922.* Paris: Galerie de l'institut, 1956.

Hugnet, Georges. *Dictionnaire Dada.* Paris, 1961.

Jaffé, Hans L. C. *Mondrian und De Stijl.* Cologne: DuMont Verlag, 1967.

von Hofacker

Janco, Marcel. "Gehopferischer Dada." In George Witten-
born, *Dada, Monographie einer Bewegegong,* ed. Willy
Verkauf, 1957: 26–49.

Jean, Marcel. "Hans Richter." *XXème Siècle,* no. 16 (1959).

Jordan, L. J. "Onze Vijfde Matinee." *Filmliga Amsterdam* 3,
no. 6 (March 1930): 73–75.

Kállai, Erno. "Konstruktivismus." *Jahrbuch der jungen Kunst*
5 (1924).

Kerber, Bernhard. "Brief aus Berlin." *Art International* 25
(1982): 55–63.

Kerényi, Magda. "Der Maler und Filmschöpfer Hans Richter."
*Journal für Kultur und Kritik* (1976).

Kliemann, Helga. "Die Novembergruppe." *Bildende Kunst in
Berlin* 3 (1969): 291.

Kracauer, Siegfried. "Filming the Subconscious." *Theatre
Arts* 32, no. 2 (February 1948): 36. Also in exhibition cata-
logue *Hans-Richter—Painting and Film.* Munich: Goethe
Institute, 1970: 12.

Kurtz, Rudolf. "Expressionismus und Film." In *Die Lichtbild-
bühne,* vol. 1 (Berlin: Hans Rohr Verlag, 1926). Reprint,
ed. H. P. Manz, Berlin: Verlag der Lichtbildbühne, 1965:
98–100.

Kyrou, Ado. *Le surrealisme au cinéma.* Paris: Le Terrain
Vague, 1963.

Langlois, Henri. "L'avantgarde hier et aujourd'hui." *La Revue
du Cinéma* 2, no. 11 (1948): 43–49.

Langlois, Henri. "Notes sur l'histoire du cinéma." *La Revue
du Cinéma* 2, no. 15 (1948).

Langsfeld, Wolfgang. "Hans Richter—ein Pioner der moder-
nen Künst." *Film-Bild-Ton* 18, no. 2: 41–42.

Lawder, Standish D. "A Chronology of Abstract Film 1892–
1930." *Image* (Cambridge, October 1965): 13–15.

Lawder, Standish D. *The Cubist Cinema.* Anthology Film Ar-
chives, series 1. New York: New York University Press,
1975.

Leiser, Erwin. "Hans-Richter-Endlich Entdeckt." *Du, die Kunst-
zeitschrift* 4 (1982): 76–77.

Leiser, Erwin. "Ich lebe in der Gegenwart—Versuch über
Hans Richter." *Du, die Kunstzeitschrift* 5 (1980): 20–27.

Leiser, Erwin. "Malare och filmskapare. Om Hans Richter." In *Stockholms Tidningen* (28 December 1965): 18–19.

Leiser, Erwin. Review of *Viking Eggeling 1880–1925.* by L. O'Konor. *Neue Zürcher Zeitung* (6 April 1972).

Lissitzky, El, and Hans Arp. *Kunstismen.* Erlenbach, Switzerland: Rentsche Verlag, 1925.

Lissitzky-Küppers, Sophie, and Jens Lissitsky, eds. *El Lissitsky—Proun und Wolkenbügel.* Dresden, 1977.

Luft, Friedrich. "Rectangles Start Dancing." *Die Welt* (22 March 1966). Also in *Hans Richter Painting and Film.* Exhibition Catalogue. Munich: Goethe Institute, 1970: 4.

Lukach, Joan. *Hilla Rebay: In Search of the Spirit in Art.* New York: George Braziller, 1983.

Mascioni, Grytzko. "Il cinema." *L'Arte Moderna* 14, no. 120 (1967): 81–120.

Mascioni, Grytzko. "Everyday: il film inedito di Hans Richter." *Il Dramma* 4 (April 1970): 68–74.

Mehring, Walter. *Berlin Dada.* Zurich: Arche Verlag, 1959: 89.

Mekas, Jonas. "Hans Richter on the Nature of Film Poetry." Interview. *Film Culture* (1958): 5–8.

Mekas, Jonas. "A Visit with Hans Richter." *The Village News* (New York, 1951): 91–93.

Miro, Ester de. "Hans Richter." In *Cine qua non.* Florence: Vullecchi, 1979: 59–60.

Moholy-Nagy, László. "Problèmes du nouveau film." *Cahiers d'art* 7, no. 6/7 (1932): 277–280.

Motherwell, Robert, ed. *The Dada Painters and Poets. An Anthology.* New York: Wittenborn and Schulz, 1951. Reprint: Boston: G. K. Hall, 1981.

Moussinac, Léon. *Panoramique du cinéma.* Paris: Au Sans Pareil, 1929.

Mussman, Toby. "Early Surrealist Expression in Film." *Film Culture* (1966): 7–17.

Noble, G. W. "Historical Development of the Animated Film." *International Photographer* (March 1949).

O'Konor, Louise. "Viking Eggeling and Hans Richter." In *Viking Eggeling 1880–1925, Artist and Filmmaker. Life and Work.* Stockholm: Acta Universitatis Stockholmiensis, Almquist and Wiskell, 1971: 57–71.

Passoni, Franco. "Le esperienze di Hans Richter." *Siprauno,* no. 5 (September/October 1965): 107–114.

Pezzolato, Lietta, and Roberto Codroico. "Ribellione antinazi-fascita nell'avanguardia di Richter." *Cinema Nuovo* 20, no. 214 (November/December 1971): 432–439.

Pezzolato, Lietta, and Roberto Codroico. "Richter e l'uomo visibile." *Cinema Nuovo* 21, no. 218 (July/August 1972): 254.

Rapisarda, Giusi. "Dada al cinema." In *Il dadaismo,* ed. Silvia Danesi. Milan: Fratelli Fabbri Editori, 1977: 88–89.

Read, Herbert. "Introduction." In *Hans Richter by Hans Richter,* ed. Marcel Joray. Neuchâtel, Switzerland: Editions du Griffon, 1965: 5–7.

Read, Herbert. Untitled. *La Città* 3 (June 1964): 52–53. Also in Herbert Read, *Hans Richter Painting and Film.* Exhibition catalogue. Munich: Goethe Institute, 1970.

Reef, Betty. "Movies Go to College." *Popular Photography* 18, no. 1 (January 1946): 73–78, 88–94.

Reef, Betty. "The New Avant-Garde Movie." *Vogue* (15 April 1946): 156–7.

Reef, Betty, and Arthur Reef. "Artists Make a Movie." *Popular Photography* (1947).

Ribemont Dessaignes, Georges. *Déjà jadis.* Paris: Julliard, 1958.

Rohe, Franz. Review of *Dada, Monographie einer Bewegung,* ed. Willy Verkauf. *Das Kunstwerk* 7, no. 13 (January 1960): 40.

Rondolino, Gianni. "Oggi dipingo un film: il catalogo mondiale dei film dei pittori." *Bolaffi Arte* 5, no. 37 (February 1974): 64.

Rotzler, Willy. "Experiment als Lebenselexier. Ein Gespräch mit Hans Richter." *Die Weltwoche* (6 March 1959).

Rotzler, Willy. "Köpfe und Hinterköpfe." Review in *DU* 28 (March 1966): 216.

Rotzler, Willy. "Kunst und Künstler in Zürich 1914–1918." *DU Atlantis* 26 (September 1966): 689–706.

Roudevitch, Michel. "A Dada with Hans Richter." *International Animated Film Festival: Annecy Festival,* no. 2 (May 1971).

Roudevitch, Michel, and Raphaël Bassan. "Se souvenir de Hans Richter." *Ecran,* no. 58 (May 1977): 5–10.

Rukser, Udo. "Hans Richter." *Humboldt* 11, no. 41 (1970): 28–32.

Sadoul, George. *Les Pionniers du Cinèma.* Paris, 1955.

Samson, Jean Paul. "Pages de journal (April 26, 1940)." *Temoins* 9, no. 27 (June 1961): 11–13.

Sanesi, Roberto. "Annotazioni sul linguaggio di Hans Richter." In *Hans Richter: Opera grafica dal 1902 al 1969.* Pollenza: La Nuova Foglio, 1976: 1–181.

Sanesi, Roberto. "Del ritmo." *L'Europa letteraria e artistica* 2 (February/March 1975).

Sanesi, Roberto. "Hans Richter: viaggio nella libertà." *Gala International* 69 (December 1974): 95–102.

Sanesi, Roberto. Introduction to *Hans Richter: Opera grafica dal 1902 al 1969.* Pollenza: La Nuova Foglio, 1976: xii–xv.

Sanesi, Roberto. "Prima V Annotazioni sul linguaggio di Hans Richter nella sua fase iniziale." *Le Arti* 26, no. 3 (March 1976): 19–28.

Sanesi, Roberto. "Richter ultimo tempo." *Studio Marconi* 5 (1976).

Sanouillet, Michel. *Il movimento dada.* Milan: Fratelli Fabbri Editori, 1969.

Schifferli, Peter, ed. *Dada: Die Geburt des Dada. Dichtung und Chronik der Gründer.* Zurich: Verlag der Arche, 1957.

Schmidt, Georg. *Der Film.* Basel: Holbein Verlag, 1947.

Seaton, Mary. *Sergej M. Eisenstein.* New York, 1952.

Seuphor, Michel. "Au temps de l'avant-garde." *L'Oeil,* no. 11 (November 1955): 24–39.

Seuphor, Michel. "Hans Richter." *L'art abstrait.* Paris: Maeght, 1950: 311.

Seuphor, Michel. "Paris—New York 1951." *Art d'Aujourd'hui* 2, no. 6 (June 1951): 13–14.

Seuphor, Michel. "Richter's Orchestrations." *Art Digest* 28, no. 14 (15 April 1954): 26.

Sheppard, Richard. "Dada and Politics." In *Studies of a Movement,* ed. Richard Sheppard. Buckinghamshire, England: Alpha Academic, 1980: 39–74.

Sheppard, Richard. "Ferdinand Hardekopf und Dada." *Jahrbuch der deutschen Schiller-Gesellschaft* 20 (1976): 132–161.

Sheppard, Richard. "Thirty-three Letters, Telegrams and Cards from Hans Richter to Tristan Tzara and Otto Flake (1917–1926)." In *New Studies on Dada: Essays and Documents,* ed. Richard Sheppard. Driffield, England: Hutton Press, 1981: 122–143.

Sherlock, M., and J. Goldworthy. "Cinema's Free Spirit: Hans Richter, 1888–1976." *Film Criticism* 11 (1976): 39–42.

Starr, Cecile. "From the Abstract to the Concrete." *Film Library Quarterly* 71, no. 1 (1974): 13–16.

Starr, Cecile. "Hans Richter." In *Experimental Animation,* ed. Robert Russett and Cecile Starr. New York: Van Nostrand Reinhold, 1976: 49–56.

Stevo, Jean. "Cinéma surréaliste." *Film-Presse* 4, no. 7/8 (December 1952): 7–8.

Stevo, Jean. "Hans Richter, poète, cinéaste et peintre." *Espaces, Documents XXe Siècle* 2 (Winter 1973/74): 1–6.

Teige, Karl. "Zur Ästhetik des Filmes." *Das Kunstblatt Berlin* 9 (1925): 332–339.

Verdone, Mario. "Cinema surrealista." *Quintaparete, documenti del surrealismo,* no. 1 (April 1971): 54–56.

Verkauf, Willy, ed. *Dada Monograph of a Movement—Monographie einer Bewegnung—Monographie d'un mouvement.* New York: George Wittenborn, 1957; Teufen, Switzerland: Arthur Niggli, 1958, 1961, 1965). Reedition: London, 1975.

Veronisi, Giulia. "La Bauhaus e l'arte astratta in Germania." *L'Arte Moderna* 6, no. 50 (1966): 161–200.

Weaver, Mike. "Great Little Magazines: G," in *Form,* no. 3 (15 December 1966): 26–31. English translations of articles by Schwitters, Doesburg, and Mies van der Rohe that appeared in *G,* no. 3 (1924).

Weaver, Mike. "Hans Richter: Constructivist and Dadaist." *Image* 2, no. 6 (October 1965): 16.

Weinberg, Herman G. "Le culte de la platitude dans la critique cinématographique." *La Revue de Cinéma* 3, no. 17 (September 1948): 54–58.

Weinberg, Herman G. "Dreams That Money Can Buy. American Letter." *Sight and Sound* 15, no. 60 (Winter 1946/47): 140.

Weinberg, Herman G. "Hans Richter." In *An Index to the Creative Work of Two Pioneers: I. Robert J. Flaherty II. Hans Richter.* Special supplement to *Sight and Sound,* Index Series no. 6 (1946): 10–15.

Weinberg, Herman G. "An Index to the Creative Work of Hans Richter." *Film Culture Magazine* (1957): 8 pp. Revised to date from the preceding article.

Weinberg, Herman G. "30 Years of Experimental Film." *Films in Review* 2, no. 1 (December 1951): 22–27.

Weinstein, Joan. *The End of Expressionism: Art and the November Revolution in Germany, 1918–19.* Chicago: University of Chicago Press, 1990.

Werner, Theodor. Letter to Hans Richter. "Werner-Grohmann-Read." *La Città* 3 (June 1964): 51.

Werner, Theodor. Untitled. *La Città* 3 (June 1964): 51–53.

Wolf, Friedrich. "Metall (Hennigsdorf), 1931." *Filmerzählungen,* vol. 11, ed. Else Wolf and Walther Pollatscek. Berlin: Aufbau-Verlag, 1963: 15–37.

Wolfradt, Willi. "Grosse Berliner Kunstausstellung. November Gruppe." *Der Cicerone* 5 (1923): 522–523.

Young, Vernon. "Films: The Fantasies of Hans Richter." *Arts Digest* 29, no. 1 (October 1954): 19.

Young, Vernon. "Painter and Cinematographer." *Arts International* 33, no. 9 (September 1959): 48–55.

**Exhibition Catalogues on Richter** (arranged chronologically)

*Hans Richter, Strohmeyer, Lascar Vorel. XXIX. Kollektiv-Ausstellung Neue Kunst.* Folder; introduction by Hans Richter. Munich: Galerie Hans Goltz, June–July 1916: 1–4.

*Ausstellung die Neue Kunst.* Pamphlet; text by W. Jollos. Zurich: Kunstsalon Wolfsberg, September 1918.

*I. Internationale Kunstausstellung.* Düsseldorf: Kaufhaus Tietz, May 1922.

*"Film und Foto,"* Internationale Ausstellung des Deutschen Werkbunds. 18 May–7 July 1929. Catalogue to the exhibition. Reprint: ed. Karl Steinroth, Deutsche Verlagsanstalt, 1979.

*Réalités Nouvelles.* Galerie Charpentier, 30 June–15 July 1939.

*6th Annual Exhibition of American Abstract Artists.* The Fine Arts Galleries, 9–23 March 1942.

"From Orchestration of the Form to Scroll Painting." Text by Hans Richter. *Masters of Abstract Art. Helena Rubenstein Benefit for the Red Cross.* Exhibition catalogue. New York: New Art Center, 1 April–15 May 1942.

*Dreams That Money Can Buy.* Brochure. Texts by Man Ray, James Sweeney, Marcel Duchamp, Max Ernst, Siegfried Kracauer, Richard Huelsenbeck, and John Cage. New York: Films International of America, 1943: 22 pp.

*Hans Richter: 1919–1946.* Folder to the exhibition. Introduction by Frederick Kiesler. New York: Art of This Century Gallery, 22 October–9 November 1946.

*Hans Richter.* Folder. Texts by Jean Arp, Marcel Duchamp, and Michel Seuphor. Paris: Galerie des Deux Îles, February 1950.

*Hans Richter.* Folder. Texts by Jean Arp, Marcel Duchamp, and Michel Seuphor. Paris: Galerie d'Art Moderne, March 1950.

*Hans Richter.* Paris: Galerie d'Art Moderne, 11 March 1950.

*Hans Richter—Oeuvres de 1912 à 1952. Peintures, dessins, rouleaux.* Folder. Poem by Richard Huelsenbeck. Paris: Galerie Mai, 10–24 June 1952.

"De Stijl, 1917–1928." Review of the exhibition in *Bulletin of the Museum of Modern Art* 20, no. 2 (Winter 1952–53).

*Modern Masters.* Catalogue to the exhibition. New York: Rose Fried Gallery, January–15 February 1954.

*Hans Richter. Paintings, Scrolls, Drawings.* Folder. Texts by Robert Goldwater and Jean Arp. Paris: Rose Fried Gallery, 30 March–24 April 1954.

*Hans Richter. An Exhibition of Paintings, Scrolls and Drawings. From 1915 to 1958. Presented on the Occasion of*

*Hans Richter's Seventieth Birthday.* Folder. Texts by Sir Herbert Read, Hans Arp, Rudolf Arnheim, Marcel Duchamp, Naum Gabo, Will Grohmann, Franz Roh, Ludwig Mies van der Rohe, and Herman G. Weinberg. Washington, D.C.: The Institute of Contemporary Arts in Gallery 41 of the Corcoran Gallery of Art, 6 April–11 May 1958.

*Dada. Dokumente einer Bewegung.* Catalogue to the exhibition. Düsseldorf: Düsseldorf Kunsthalle, Kunstverein Rheinlande und Westfalen, September–October 1958.

*Hans Richter. Ein Leben für Bild und Film.* Catalogue to the exhibition. Texts by Theodor Werner, Will Grohmann, Sir Herbert Read, Marcel Duchamp, Ludwig Mies van der Rohe, and Jean Arp. Berlin: Akademie der Künste, 17 October–16 November 1958.

*Hans Richter.* Catalogue to the exhibition. Rome: Galleria Nazionale d'Arte Moderna, December 1958–January 1959.

*Hans Richter. Ein Leben für Bild und Film.* Catalogue to the exhibition. Zurich: Kunstgewerbe Museum, 1 March–19 April 1959.

*23rd Annual Exhibition of American Abstract Artists.* New York: Betty Parsons Gallery, 1–13 June 1959.

*Meditazioni sul tempo.* Catalogue to the exhibition. Text by Giorgio Kaisserlian. Milan: Galleria Pagani del Grattacielo, 1960.

*Hans Richter—40 Jahre Rollenbild.* Catalogue to the exhibition. Munich: Städtische Galerie, Lenbachhaus, May–June 1960.

*Konkrete Kunst.* Zurich: Helmhaus, 8 June–14 August 1960.

*Hans Richter—40 ans de peintures-rouleaux.* Catalogue to the exhibition. Texts by Herta Wescher, Jean Arp, Will Grohmann, and Sir Herbert Read. Paris: Galerie Denise René, September 1960.

*Hans Richter—40 Jahre Rollenbild und Film.* Exhibition catalogue. Hannover and Kassel: Werkkunstschule Hannover, Staatliche Werkkunstschule Kassel with the Kasseler Kunstverein, December 1960.

*Hans Richter—40 Jahre Rollenbild.* Catalogue to the exhibition. Essen: Museum Folkwang, January–February 1961.

*Hans Richter Schild, Film, er malt.* Catalogue number 262. Amsterdam: Stedelijk Museum, March–April 1961.

*Bewogen, Beweging.* Group exhibition. Catalogue number 264. Amsterdam: Stedelijk Museum, March–April 1961.

*Richter.* Catalogue to the exhibition. Legnano: Galleria Pagani del Grattacielo, 11–28 June 1961.

*AACI: Art Abstrait, Constructif International.* Catalogue text by Michel Seuphor. Paris: Galerie Denise René, December 1961–February 1962.

*Hans Richter.* Catalogue to the exhibition. Texts by Franco Russoli and Jean Arp. Turin: Galleria Civica d'Arte Moderna, May–July 1962.

*Mostra Personale di Hans Richter.* Catalogue to the exhibition. Text by Giorgio Kaisserlian. Milan: Galleria Pagani del Grattacielo, 1962.

*Omaggio a Richter.* Flier. Locarno: Casa del Negromante, April 1962.

*Hans Richter.* Catalogue to the exhibition. Milan: Galleria Schwarz, March 1963.

*Schrift en beeld, Art and Writing.* Richter's "Liberation of Paris" scroll. Group exhibition. Catalogue no. 333. Amsterdam: Stedelijk Museum, May–June 1963: 84.

*Rilievi e dipinti di Hans Richter.* Catalogue to the exhibition. Text by Giorgio Kaisserlian. Milan: Galleria Pagani del Grattacielo, 1963.

*28th Annual Exhibition of American Abstract Artists.* New York: Loeb Student Center, New York University, 8–23 January 1964.

*1908–1928.* Group exhibition. Milan: Galleria Schwarz, October 1964.

*Hans Richter. Dadaismo e astrazione (1909–1923).* Exhibition catalogue. Text by Guido Ballo. Milan: Galleria Schwarz, March–April 1965.

*Arp/Richter.* Catalogue to the exhibition. Texts by Arp and Richter. Paris: Galerie Denise René, April 1965.

*Hans Richter.* Catalogue to the exhibition. Texts by Jean Arp, Sir Herbert Read, Naum Gabo, Marcel Duchamp, Hermann Weinberg, Friedrich Bayl, and Ludwig Mies van der Rohe. Venice: Galleria del Cavallino, September 1965.

*Settimana Richter.* Catalogue to the exhibition. Venice: Galleria del Cavallino, September 1965.

*Hans Richter.* Catalogue to the exhibition. Galleria del Cavllino, September 1965.

*Dada/Suites 10.* Catalogue to the group exhibition. Geneva: Galerie Krugier & Cie, February 1966.

*Hans Richter Exhibition.* Catalogue to the exhibition. Tokyo: Tokyo Gallery, April–May 1966.

*Hommage à Franz Roh.* Catalogue to the group exhibition. Munich: Kunstverein München, July–August 1966.

*Dada 1916–1966. Cinquant'anni a Dada. Dada in Italia 1916–1966.* Catalogue to the group exhibition. Milan: Galleria Schwarz, August–September 1966.

*Yesterday and Today: 1936–1966, 30th Annual Exhibition of American Art.* Riverside Museum, 25 September–27 November 1966.

*Dada, Key Documents: 1916–1966.* Catalogue to the group exhibition. New Delhi: National Gallery of Modern Art, 1966.

*Dada 1916–1966, Documents of the International Dada Movement.* Catalogue to a collective traveling exhibition compiled, commentated, and introduced by Hans Richter. Munich, Rome, Barcelona, Tel Aviv, Haifa, Athens, Istanbul, Ankara, Nuremburg, Tokyo: Goethe Haus, 1966–1968.

*Hans Richter, opere recenti.* Catalogue to exhibition no. 464. Milan: Galleria del Naviglio, January–February 1967.

*Hans Richter—Maler und Filmschöpfer.* Exhibition catalogue. Berlin: Akademie der Künste/DFFB, 20–21 March 1967.

*Vom Konstruktivismus zur Kinetik. 1917 bis 1967.* Catalogue of names of participating artists. Krefeld, Germany: Galerie Denise René, Hans Mayer, June–September 1967.

*Dada—Ausstellung zum 50 jährigen Jubiläum.* Catalogue to the group exhibition. Zurich: Kunsthaus Zürich, October–November 1967. Paris: Musée National d'Art Moderne, November 1967–January 1968.

*Collage 67.* Catalogue to the group exhibition. Text by Friedrich Bayl. Munich: Städtische Galerie im Lenbachhaus, November–December 1967.

*Dada 1916–1966. Eine Dokumentation.* Catalogue of press releases to the exhibition "DADA Documents of an International Movement." Munich: Goethe Haus, 1968.

*Art: 1905–1967 Hans Richter.* Catalogue to the exhibition with text by Brian O'Doherty and introduction by Elayne Varian. New York: Byron Gallery and Finch College Museum of Art/Contemporary Wing, January–February 1968.

*Hans Richter.* Catalogue to the exhibition. Text by Palma Bucarelli. Padua: Galleria d'Arte La Chiocciola, March 1968.

*Dada, Surrealism and Their Heritage.* Exhibition catalogue. Text by William S. Rubin. New York: Museum of Modern Art, March–June 1968.

*Hans Richter—Dada 1918.* Brochure. Munich: Galerie Klihm, November–December 1968.

*Berlin XXe Siecle. Expressionismus-Berlin.* Catalogue to the group exhibition. Texts by Eberhard Roters and Lyss Decker. Lausanne: Kunstverein Berlin and Museé Cantonal des Beaux-Arts, November 1968–January 1969.

*Hans Richter—Dada Zeichnungen 1918.* Brochure. Text by Achille Perilli. Rome: Galleria Il Segno in collaboration with the Deutsche Bibliothek Rome, Goethe Institute, March 1969.

*Industrie und Technik in der deutschen Malerei—von der Romantik bis zur Gegenwart.* Catalogue. Introduction by Siegfried Salzmann. Duisburg: Wilhelm-Lehmbruck-Museum, May–July 1969.

*Hans Richter Painting and Film.* Ed. Eva Maria Ledig. Catalogue to the exhibition. Texts by Hans Arp, Friedrich Luft, Friedrich Bayl, Gideon Bachmann, Siegfried Kracauer, Rudolf Arnheim, Hans Richter, and Sir Herbert Read. Munich: Goethe Institute, 1970.

*German Experimental Films. From the Beginnings to 1970.* Catalogue. Text by Ingo Petzke. Munich: Goethe Institute, 1970.

*Hans Richter.* Brochure. Text by Achille Perilli. Rome: Galleria Il Segno in collaboration with the Deutsche Bibliothek Rome, Goethe Institute, April 1970.

*Hans Richter.* Catalogue no. 556 with the poem "Reflections on Dymos" by Hans Richter. Text by Brian O'Doherty.

Milan: Galleria del Naviglio, 21 October–8 November 1970.

*Hans Richter. Rilievi 1970 e il Film "Dal dada al surrealismo quarant'anni di esperienze."* No. 20. Milan: Galleria del Naviglio, 21 October–11 November 1970.

*Hans Richter.* Catalogue to the exhibition. Text by Man Ray. Turin: Il Fauno Galleria d'Arte, January–February 1971.

*Hans Richter. Dada Drawings and Recent Work.* Catalogue with text by Man Ray. Geneva: Galerie Georges Moos, February–March 1971.

*Hans Richter.* Catalogue to the exhibition. Venice: Galleria d'Arte Moderna Il Capricorno, April–May 1971.

*Aspetti della grafica europea 1971.* Collective exhibition catalogue. Venice: Museo d'Art Moderna Ca' Pesaro La Biennale di Venezia, September–October 1971: 74–75. Richter biography and illustrations of paper relief.

*The World between the Ox and the Swine. Dada Drawings by Hans Richter.* Exhibition catalogue with introduction and interview of Hans Richter by Daniel Robbins. Providence: Museum of Art, Rhode Island School of Design, October 1971.

*Hans Richter / Marcello Pirro.* Catalogue with texts by Sir Herbert Read, V. Guidi, G. Carboni, Ennio Pouchard, and R. De Grada. Poem by Hans Richter. Ravenna: Galleria dell'Accademia Loggetta Lombardesca, August 1972.

"Marcello Pirro." Poem by Hans Richter in Italian and English. Ravenna: Galleria dell'Accademia Loggetta Lombardesca, 1972: 2 pp.

"Hans Richter." Text by Marcello Pirro. Ravenna: Galleria dell'Accademia Loggetta Lombardesca, August 10–30, 1972: 5 pp.

*Mappe mit fünf farbigen seidensiebdrucken. Baumgartner, Glattfelder, Keller, Leppien, Richter.* Exhibition catalogue. Texts by Rudolph Jockel and Aldo Passoni. Darmstadt/ Turin: Musei Civici di Torino, 1972.

*Hans Richter.* Catalogue no. 617. Text by Guido Ballo. Milan: Galleria del Naviglio, March–April 1973.

*Omaggio a Hans Richter.* Exhibition catalogue. Texts by Marziano Bernardi, Giorgio Brizio, Paride Chiapatti, Angelo Dragone, Janus. Turin: Goethe Institute, Musei Civici di Torino, April 1973.

*Fritz Kempe 5 Jahrzehnte Photographie.* Catalogue to the exhibition. Portrait of Hans Richter by Fritz Kempe and drawing by Hans Richter, "Gruß an Fritz Kempe." Hamburg: Museum für Kunst und Gewerbe, April–May 1973: 24–25.

*Hans Richter. Arbeiten 1913 bis 1973.* Invitation to exhibition opening. Text by Werner Haftmann. Düsseldorf: Galerie Denise René, Hans Mayer, May 1973.

*Hans Richter. Recent Work.* New York: Betty Parsons Gallery, November 1973.

*Grafica dei linuaggi non-verbali.* Brochure of group exhibition. Text by Gianfranco Arlandi. Milan: Arte Contemporanea, February–March 1974.

*Hans Richter. Graphiken.* Brochure of exhibition of graphics from 1964 to 1974. With text "Notizen zu Hans Richters Graphiken." St. Gallen: Galerie am Ring, 1974.

*1954–1974.* Collective exhibition celebrating 20th anniversary of the Goethe Institute of Turin. Illustrations of paintings by Hans Richter. Turin: Goethe Institute, July 1974: 31–34.

*Hans Richter.* Brochure to the exhibition. St. Gallen: Galerie am Ring, November 1974.

*L'immagine razionale. Ben Nicholson, Victor Pasmore, Hans Richter.* Catalogue no. 12 to the exhibition. Text by Gianfranco Bruno. Milan: Galleria d'Arte Cocorocchia, November–December 1974.

*Hans Richter. Oeuvres dada.* Exhibition catalogue. Texts by Man Ray (1972), Jean Arp, Marcel Duchamp (1958), and Ludwig Mies van der Rohe. Paris: Galerie Denise René, May 1975.

*Hans Richter—opere dal 1960 al 1975.* Exhibition catalogue. Texts by M. Fagiolo dell'Arco, "Hans Richter e il dinamismo del caso," and Man Ray, "Lettera a voce a Hans Richter." Rome: Galleria d'Arte La Borgognona, November 1975.

von Hofacker

*HR—Hans Richter/Image et cinéma.* Exhibition catalogue. Text by Sir Herbert Read. Paris: Goethe Institut München, 1976.

*Freunde Danken Werner Haftmann.* Exhibition catalogue. Berlin: Nationalgalerie Berlin, 1976.

*Hans Richter 1888–1976.* Exhibition catalogue. Text by Frank Ponzi. Reykjavík, Iceland: The American Cultural Center, 1976.

*The Golden Door: Artist-Immigrants of America, 1876–1976.* Catalogue to the exhibition. Introduction by Daniel J. Boorstin and text by Cynthia Jaffee McCabe. Washington, D.C.: Hirshhorn Museum and Sculpture Garden, Smithsonian Institution, May 1976: 341–343.

*Cinéma, dadaiste et surréaliste.* Catalogue to the group exhibition. Texts by Marc Debard, P. Adams Sitney, and Alain Virmaux. Paris: Musée National d'Art Moderne, Centre National d'Art et de Culture Georges Pompidou, Fall 1976.

*Berlin/Hannover. The 1920s.* Catalogue to the exhibition. Introduction by John Bowlt and texts by R. M. Murdock. Dallas: Dallas Museum of Fine Arts, January–March 1977.

*Hans Richter (1888–1976) Bild und Film, Grafik der letzten Jahre.* Brochure to the exhibition. Luxembourg: Stadttheater Esch-Alzette Thomas-Mann Library, January–February 1977.

*Tendenzen der zwanziger Jahre. 15. Europäische Kunstausstellung Berlin.* Exhibition catalogue. Texts by (among others) Eberhard Roters, Karl Riha, and Hanne Bergius. Berlin: Akademie der Künste, August–October 1977.

*Art of the Dadaists.* Catalogue to the exhibition. Text by Timothy Baum. New York: Helen Serger, la boétie, inc., September–November 1977.

*Zürcher Kunstgesellschaft Jahresbericht.* Annual Report to the Zurich Art Association. With the text "Zu den zeichnungen und Bildern von Hans Richter" by Ursula Perucchi-Petri. Zurich: Zürcher Kunstgesellschaft, 1977: 77–81.

*Film als Film—1910 bis heute,* ed. Birgit Hein and Wulf Herzogenrath. Catalogue to exhibition. Texts by (among other) Herzogenrath and Werner Gräff. Cologne: Kölner

Kunstverein, November 1977–January 1978; Berlin: Akademie der Künste, February–March 1978; Essen: Museum Folkwang, April–May 1978; Stuttgart: Württembergischer Kunstverein, June–July 1978: 48 ff. English translation as *Film as Film—Formal Experiment in Film 1910–1975.* London: Hayward Gallery, May–June 1979.

*Dada and Surrealism Reviewed.* Ed. Dawn Ades. London: Arts Council of Great Britain, Hayward Gallery, January–March 1978.

*Film Retrospective: Hans Richter on His 90th Birthday.* Brochure to the exhibition. Brussels: Thomas Mann Library, Kulturinstitut Deutschland, March 1978.

*Omaggio a Hans Richter.* Brochure to the exhibition. Milan: Vismara Arte Contemporanea, April 1978.

*Hans Richter 1888–1976. Dessins et portraits dada 1888–1976.* Exhibition catalogue. Texts by Marguerite Arp, Gabrielle Buffet-Picabia, and Henry-Claude Cousseau. Les Sables-d'Olonne: Musée de l'Abbaye Sainte-Croix, April–June 1978.

*Monte Verità—Berg der Wahrheit.* Ed. Harald Szeemann. Exhibition catalogue with 16 essays. Ascona: Electa Editrice, July–August 1978.

*Paris-Berlin 1900–1933.* Ed. Werner Spies. Catalogue to the exhibition. Paris: Centre National d'Art et de Culture Georges Pompidou, 1978. German translation: Munich: Prestel Verlag, 1979.

*Hans Richter's Stalingrad (Victory in the East).* Catalogue to the exhibition. Text by Cynthia Jaffee McCabe. Washington, D.C.: Hirshhorn Museum and Sculpture Garden, Smithsonian Institution, 1980.

*Dada in Zürich.* Werkverzeichnis. Items no. 60–94. Catalogue to the exhibition. Zurich: Kunsthaus Zürich, April–June 1980.

*Abstraction. Towards a New Art, Painting 1910–20.* Exhibition catalogue. Texts include Dawn Ades, "Dada and Abstract Art in Zurich 1915–1920" (pp. 58–62). London: Tate Gallery, April 1980.

*Dada, Berlin, Cologne, Hannover.* Exhibition catalogue. Text by Hellmut Wohl. Boston: Institute of Contemporary Art,

November 1980–January 1981; Fort Worth: Fort Worth Art Museum, March–April 1981.

*Hans Richter 1888–1976: Dadaist, Filmpionier, Maler, Theoretiker.* Exhibition catalogue. Texts by Charles Haxthausen, Ursula Perucchi-Petri, Justin Hoffmann, Standish D. Lawder, Erwin Leiser, Willy Rotzler, Marion von Hofacker, and Cynthia Jaffee McCabe. Berlin: Akademie der Künste, January–March 1982; Zurich: Kunsthaus Zürich, April–May 1982; Munich: Städtische Galerie im Lenbachhaus, June–July 1982.

*Hans Richter Retrospective Information Sheets.* Zurich: Zurich Art Association, February 1982: 14–19.

*Berlin-Amsterdam, 1920–1940, Wechselwirkungen.* Exhibition catalogue. Text and introduction by Katrinka Dittrich. Amsterdam: Goethe Institute, February 1982.

*Aus Berlin emigriert.* Catalogue to works by Berlin artists who emigrated from Germany after 1933. Introduction by Eberhard Roters. Berlin: Berlinische Galerie, April–September 1983.

*Hans Richter, pitture e collages.* Exhibition catalogue. Texts by Guglielmo Volonterio and Marion von Hofacker. Lugano: Galleria Pro Arte, October–December 1983.

*Vom Klang der Bilder. Die Musik in der Kunst des 20. Jahrhunderts.* Ed. Karin von Maur. Exhibition catalogue. Texts include Sara Selwood, "Farblichtmusik und abstrakte Film" (pp. 414–421). Stuttgart: Staatsgalerie Stuttgart, July–September 1985.

*Dada in Zürich.* Sammlungsheft 11. Catalogue to the exhibition. Texts by Hans Bolliger, Guido Magnaguagno, and Raimund Meyer. Zurich: Kunsthaus Zürich and Arche Verlag, 1985.

*Jean Arp, Ben Nicholson, Hans Richter, Italo Valenti.* Folder announcing exhibition of lithographs and aquatints. Locarno: Galleria L., August–September 1987.

*The Art of Counterpoint: Nineteen Works by Hans Richter.* Exhibition catalogue. Text by M. Schnell. Purchase, N.Y.: Neuberger Museum, SUNY at Purchase, February–April 1988.

*Dada and Constructivism.* Exhibition catalogue. International Museums Agency, The Museum of Modern Art, Kamakura, The Seibu Museum of Art, The Tokyo Shimbun, Japan, October 1988–February 1989.

*Hans Richter: Malerei und Film.* Kinematograph 5. Catalogue to the exhibition. Introduction by Walter Schobert and texts by Justin Hoffmann, Eva Wolf, Bradford Smith, Cecile Starr, Gisela Hoßmann, Viola Kiefner, Stephanie Casal/ Pia Lanzinger, Rudolf Kuenzli, Ludger Derenthal, and Marion von Hofacker. Frankfurt am Main: Deutsches Filmmuseum, February–April 1989.

*Hans Richter.* Exhibition catalogue. Texts by Marion von Hofacker and Harald Szeemann. Locarno, Switzerland: Palazzo Morettini, August 1989.

*Peinture, cinéma, peinture.* Catalogue to the exhibition. Texts include Sarah Wilson, "Hans Richter: Dreams That Money Can Buy." Marseilles: Vieille Charité, October 1989.

*Konstruktivistische internationale schöpferische Arbeitsgemeinschaft 1922–1927. Utopien für eine Europäische Kultur.* Exhibition catalogue with texts by (among others) Hartmut W. Redottée and Marion von Hofacker. Düsseldorf: Kunstsammulung Nordrhein-Westfalen, May–August 1992; Halle: Staatliche Galerie Moritzburg, September–November 1992.

*Dada. Eine Internationale Bewegung 1916 bis 1925.* Exhibition catalogue. Texts by Raimund Meyer, Dietmar Elger, and Guido Magnaguagno. Munich: Kunsthalle der Hypo-Kulturstiftung, September–November 1993; Hannover: Sprengel Museum, November 1993–February 1994; Zurich: Kunsthaus Zürich, March–May 1994.

*XIX e XX secolo: da Turner a Beuys, evoluzione e sviluppi della collezione.* Exhibition catalogue. Texts by Marco Franciolli and Manuela Rossi. Lugano: Museo Cantonale d'Arte, November 1993–March 1994.

*Süddeutsche Freiheit. Kunst der Revolution in München 1919.* Exhibition catalogue. Texts by (among others) Justin Hoffmann and Helmut Friedel. Munich: Städtische Galerie im Lenbachhaus, November 1993.

*Dada. Arte e antiarte.* Exhibition catalogue. Texts by (among others) Giovanni Lista, Arturo Schwarz, and R. Siligato. Rome: Palazzo delle Esposizioni, April 1994.

*Hans Arp/Hans Richter.* Exhibition catalogue. Texts by Hans Richter, Max Bill, and Hans Arp. Zurich: Galerie Pro Arte, 10 March–7 May 1995.

**Masters Theses and Ph.D. Dissertations on Hans Richter**

Hoffmann, Justin. "Veränderungen der Erzählstruktur im Werk von Hans Richter 1916–1926." M.F.A. thesis, University of Munich, April 1986.

Hoßmann, Gisela. "Hans Richter 1888–1976. Das bildnerische Werk." Ph.D. diss., University of Cologne, 1985.

Kiefner, Viola. "Hans Richter (1888–1976). Zur Wechselbeziehung von Bild und Musik bzw. Ton in seinen Zeichnungen, Bildern und Filmen." M.F.A. thesis, University of Hamburg, 1988.

Lass, Barbara. "Hans Richter: Film Artist." Video interviews with Cecile Starr, Ursula Lawder, Standish Lawder, Bill Judson, Jonas Mekas, Don Crafton, Cleve Gray, and Arnold Eagle. M.F.A. thesis, New York University, 1982.

Weinek, Christian. "Emil Szittya. Leben und Werk im deutschen Sprachraum. 1886–1927." Ph.D. diss., Salzburg University, 1987.

Zurhake, Monika. "Filmische Realitätsaneignung. Ein Beitrag zur Filmtheorie, mit Analysen von Filmen Viking Eggelings und Hans Richters." Ph.D. diss., Heidelberg, 1982.

## Contributors

**Timothy O. Benson** is Associate Curator at The Robert Gore
Rifkind Center for Expressionist Studies at the Los
Angeles County Museum of Art. He has served as Assis-
tant Professor and Lecturer at several American universi-
ties. Dr. Benson's publications include *Raoul Hausmann
and Berlin Dada* (1987/1989) as well as numerous essays
published in catalogues and journals. He has contributed
essays to *Kurt Schwitters Almanach* (1986), *Dada/Di-
mensions* (1985), *The Avant-Garde and the Text* (*Visible
Language* [1988]), *Raoul Hausmann: 1886–1971* (1986),
and *Dada: The Coordinates of Cultural Politics* (1996). He
has also presented papers on German expressionism at
conferences throughout the United States and Europe
and has curated several exhibitions of expressionist art,
including a recent exhibition of the work of Emile Nolde.

**Bernd Finkeldey** recently curated the exhibition "Moskau-
Berlin/Berlin-Moskau 1900–1950" at the Museum für
Moderne Kunst, Berlin. He has also served as Assistant
Curator at the Kunstsammlung Nordrhein-Westfalen in
Düsseldorf and as Curator at the Galerie Januar, Bochum.
Since recieving his Ph.D. from the Ruhr-Universtät Bo-
chum in 1989 he has authored a broad range of articles
and essays, concentrating on international constructivism.
He has contributed several articles to the exhibition cata-

logue *K.I.: Konstruktivistische Internationale Schöpfer-ische Arbeitsgemeinschaft, 1922–1927, Utopien für eine europäische Kultur* (1992), and to *Europa, Europa: Das Jahrhundert der Avantgarde in Mittel- und Osteuropa* (1994).

**Stephen C. Foster** is Professor of Art History at the University of Iowa and Director of the Fine Arts Dada Archive and Research Center located there since 1979. Concentrating on European art of the World War I era, Professor Foster's publications include *Dada Spectrum: The Dialectics of Revolt* (1979) with Rudolf Kuenzli, *Dada/Dimensions* (1985), *The Avant-Garde and the Text* (1987) with Estera Milman, *"Event" Arts and Art Events* (1988), *The World According to Dada* (1988), and *Crisis and the Arts: The History of Dada* (eight volumes, 1996 ff.). Curator of numerous exhibitions, Professor Foster is currently preparing a monograph and exhibition on Berlin photomontage.

**Marion von Hofacker,** scholar and curator, has organized several exhibitions, including the first Richter retrospective, "Hans Richter: 1888–1976," for the Kunsthaus Zürich (1981), and "Hans Richter: Analogy in Film and Painting," at the German Film Museum, Frankfurt (1989). She is responsible for several additional gallery exhibitions and has contributed essays to exhibition catalogues on Dada, constructivism, and surrealism.

**Justin Hoffmann** is author of the recent *Destruktionkunst: Der Mythos der Zerstörung in der Kunst der frühen sech-ziger Jahre* (1995) and curated the exhibition "Süd-deutsche Freiheit: Kunst der Revolution in München 1919" (1993–94). He has contributed to numerous exhibition catalogues and curated many exhibitions pertaining to the relationship between war and the arts. Dr. Hoffmann is a critic for *Kunstforum, Springer, Artforum, Frieze, Artis,* and *Süddeutsche Zeitung.* He currently teaches "Art Systems" at the Academy of Fine Arts in Munich.

**Estera Milman** is Director of the Alternative Traditions in the Contemporary Arts collection and Curator of Intermedial Arts, University of Iowa Museum of Art. Her recent publications address topics as diverse as Pop and NO!art,

Dada, Futurism, Neo-Dada, and Mail Art. She is currently working on a book, *Dada and New York: Historical Realities/Historiographic Illusions* and serves as general editor for G. K. Hall and Company's *Modern Studies: An Interdisciplinary Approach to the Art of History.*

# Index of Names

Page numbers in italics indicate illustrations.